Comics and Conquest

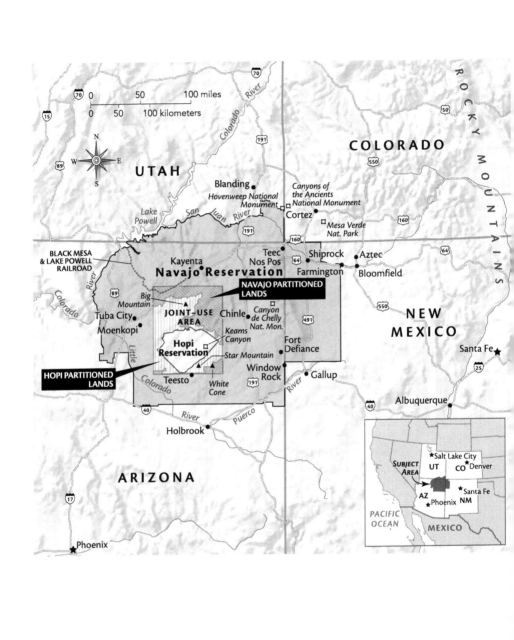

Comics and Conquest

*Political Cartoons and a Radical
Retelling of the Navajo-Hopi Land Dispute*

Rhiannon Koehler

Johns Hopkins University Press
Baltimore

Johns Hopkins University Press
2715 North Charles Street
Baltimore, Maryland 21218
www.press.jhu.edu

Library of Congress Cataloging-in-Publication Data

Names: Koehler, Rhiannon, author.
Title: Comics and conquest : political cartoons and a radical retelling of the
 Navajo-Hopi land dispute / Rhiannon Koehler.
Description: Baltimore : Johns Hopkins University Press, 2023. | Includes
 bibliographical references and index.
Identifiers: LCCN 2022058872 | ISBN 9781421447421 (hardcover) | ISBN
 9781421447438 (ebook)
Subjects: LCSH: Navajo Indians—Land tenure—Caricatures and cartoons. |
 Hopi Indians—Land tenure—Caricatures and cartoons. | Editorial
 cartoons—Navajo Nation, Arizona, New Mexico & Utah—History—20th
 century. | Indian newspapers—Navajo Nation, Arizona, New Mexico &
 Utah—History—20th century. | Navajo Nation, Arizona, New Mexico
 & Utah—History. | Indian land transfers—Arizona. | Indians of North
 America—Land tenure—Arizona. | United States. Act to Provide for Final
 Settlement of the Conflicting Rights and Interests of the Hopi and Navajo
 Tribes to and in Lands Lying within the Joint Use Area of the Reservation
 Established by the Executive Order of December 16, 1882, and Lands Lying
 within the Reservation Created by the Act of June 14, 1934, and for Other
 Purposes. | BISAC: HISTORY / Indigenous Peoples in the Americas |
 LAW / Land Use
Classification: LCC E99.N3 K64 2023 | DDC 979.1/004972—dc23/eng
 /20230613
LC record available at https://lccn.loc.gov/2022058872

A catalog record for this book is available from the British Library.

Special discounts are available for bulk purchases of this book. For more
information, please contact Special Sales at specialsales@jh.edu.

All proceeds from this book will go
to the American Indian College Fund

Contents

Acknowledgments

The yellowed copies of *Qua'Töqti*, a Hopi newspaper, were disintegrating before my eyes on a large oak table in Northwestern University's Special Collections. The newspaper has been rarely handled, seldom read, and barely cited in academic literature. But here it was: half of the conversation addressing the Navajo-Hopi Land Dispute. Also with me were editorial cartoons from the *Navajo Times* of 1973 and 1974, which told another story. The conflict came alive before me.

This project could not have been completed without the generous guidance, help, and support of many people and institutions. Invaluable conversations with many scholars shaped the historical methods I used to research and write this story. Historians Cara Anzilotti, Elizabeth Drummond, Teofilo Ruiz, Amy Woodson-Boulton, and Craig Yirush provided important insights and strategies for my embarking on a career in history, and to them I am grateful. Each of these scholars generously offered personal support and guidance as I worked on this project. Fellow UCLA graduate students Anna Accettola, Peter Chesney, Nicole Gilhuis, Elle Harvell, Ryan Hilliard, Preston McBride, Nana Osei-Opare, and Jeremiah Sladeck also helped shape my ideas, arguments, and writing.

To all of the above scholars I am grateful, but I owe my dissertation committee the largest debt of gratitude. My advisor, historian Benjamin Madley, guided me through numerous drafts, generously offered his unparalleled and inexhaustible editorial skills, and stood squarely behind me from the earliest phase of my idea through the completion of the project. Historian Robin D. G. Kelley helped me with my research strategy and spent countless hours discussing ideas and offering encouragement. UCLA History Department chair Stephen Aron, now president and CEO of the Autry Museum of the American West, provided crucial strategic suggestions and helped me conceptualize many of my arguments related to art and activism—an intersection that became the very heart of the book. Finally, this project would not exist without anthropologist Peter Nabokov. His unflagging guidance, energetic support, and fierce belief in my work saw me through the challenges of graduate school.

This book is built on hundreds of sources, many of which are hidden away in archives and special collections. The generous staff at the National Archives and at the libraries of Northwestern University, Northern Arizona University, and UCLA helped to make the book possible. I am particularly grateful for the guidance of Susan Lewis at Northwestern and Sean Evans, Carissa Tsosie, and Melissa Lawton at the Cline Library at Northern Arizona University. Sean and Carissa, especially, spent hours making copies of some of the most vital pieces of evidence for the book. For their kind help, I am thankful.

Embarking on a project like this at any time would be challenging, but the COVID-19 pandemic presented additional challenges. Many thanks to Tom Arviso Jr., former CEO and publisher of the *Navajo Times*, who spent a great deal of time corresponding with me and working with me remotely. He also generously allowed me to reproduce original images from the *Navajo Times* in this book. I am thankful for the guidance, information, and support offered by Karen Spilman at the Donald C. and Elizabeth M. Dickinson Research Center; Martin Schultz at the Musée d'Histoire de Berne in Switzerland; Nathan Sowry at the National Museum of the American Indian in Washington, DC; Angela Hoover at the Chicago History Museum; Molly Haigh and Brooke Contreras at the Charles E. Young Research Library's Special Collections; Erin Fehr at the Sequoyah National Research Center; Kendra Newhall at the Montana Historical Society in Helena; and Louise Neidorf at the Wilmette Public Library in Illinois. Thank you, too, to cartographer Glen Pawelski, who created the excellent map for this book.

The book would not have been finished without the support of the Diné community in the Four Corners region. I have already mentioned Mr. Arviso's help, and I want to acknowledge specifically the support of cartoonist Jack Ahasteen, who openly and vulnerably shared his family's experiences of relocation and provided valuable insights into his cartoons, and of *Navajo Times* editor Duane Beyal, who published an article I wrote about Jack Ahasteen. The generosity of these men will not be forgotten.

Research for this book was made possible by funding from the University of California, the Hoxie Fellowship, and UCLA summer graduate mentorships. To those who support the mentorships, the fellowship, and the University of California, I am grateful.

The support of my family and close friends also helped make this book possible. I would like to thank Robert K. Koehler, Sheri A. Reda, and William T. Koehler. Also Warwick Allison, Elizabeth Corrado, Daisy Franco, Linda and Greg Gulotta, Ashton Kennedy, Morene G. and Robert W. Koehler, Micki Reda, Ken Stephens,

and Christi and Michael Wessel. These kind people encouraged me to keep going when the going became difficult. I can't thank them enough.

Finally, I owe a large debt of gratitude to Christopher Rogers of Dunow, Carlson & Lerner Literary Agency, who helped get this manuscript into the hands of the fine people at Johns Hopkins University Press. At Hopkins Press, I have been fortunate to have a team of inspired and dedicated individuals committed to helping me make this project the best that it can be. I especially thank Laura Davulis, Ezra Rodriguez, and Kristina Lykke. I would also like to thank my copyeditor, Merryl A. Sloane, who improved this work in countless ways, and charley R Dejolie from Dinétah, who generously volunteered some of his time to consider my work. To them, I am most grateful.

Though I benefited greatly from the support, encouragement, advice, and input from scholars and friends, any errors or misinterpretations in this text are unintentional and mine alone. As I learned while writing this book, there is nothing perfect; there is only life.

Comics and Conquest

Introduction

There's no water, no jobs, no housing; people are living in shacks. I'm glad a lot of these things are coming up now. I've spent half my life worrying about it. —JACK AHASTEEN, *NAVAJO TIMES* CARTOONIST

In the aftermath of the Navajo-Hopi Land Dispute of 1974, Diné activist Roberta Blackgoat said, "No compassion is left for the motherland. We've become her enemy. Money does this. This is what I say. Our prayers lose their meanings when the land becomes an industry."[1] The Navajo-Hopi Land Dispute is a story about the power of extractive enterprise, about outsiders taking sacred lands, and about the horrors that Diné and Hopi relocatees faced at the hands of the federal government. But it is also a story of art, activism, and survival in which Indigenous people refused to comply with directives of the United States government aimed at pitting the Hopi and Navajo (Diné) against each other to facilitate their compulsory removal.[2] In this conflict, art-as-activism succeeded in the face of seemingly insurmountable political opposition from the United States government. The powerfully drawn editorial cartoons discussed in this book presented a multidimensional world with an underlying message that mobilized further resistance against United States interference in the affairs of sovereign Indigenous nations.

During the conflict, the Hopi and the Diné engaged in many different forms of activism in an effort to protect their cultures, traditions, and lands from being arbitrarily divided by the federal government. Though the roots of this fight run deep, this book focuses on editorial images published in 1973, when both the *Navajo Times* and *Qua'Töqti* (Eagle's cry) published political cartoons about the conflict, and 1974, the year that Public Law 93-531 passed. During these pivotal years

of the dispute, 1973 and 1974, artists had scores of political cartoons published in the tribal newspapers of the Diné, *Navajo Times* (Window Rock, Arizona), and of the Hopi, *Qua'Töqti* (New Oraibi, Arizona). The cartoonists who produced these images fought against the United States government's assault on sovereign space through satirical political interventions. Diné and Hopi editorial cartoons reveal that the Navajo-Hopi Land Dispute, widely portrayed as an intertribal conflict, was in fact rooted in Indigenous resistance to the United States government's continued attempts to seize valuable natural resources located in the heart of Dinétah and Hopituskwa, the Navajo and Hopi homelands.[3]

To be clear, the Diné and the Hopi have not always operated in perfect sociopolitical symbiosis. They have had disagreements over land use and land management, disagreements that were often highlighted in editorial cartoons printed in tribal newspapers, including the *Navajo Times* and *Qua'Töqti*. However, this particular dispute was not the result of intertribal animosity or ethnic differences. My research shows that it was instead caused by repeated non-Indigenous interventions into sovereign territory and continued attempts by United States officials to gain control of untapped natural resources across Dinétah and Hopituskwa.

This is a historical exploration of the relationship between Hopi and Diné political cartoons, Indigenous activism, land rights, resource extraction, and United States government interests in the late twentieth century. Specifically, I examine how political cartoons printed in the *Navajo Times* and *Qua'Töqti* represented crucial manifestations of Indigenous activism during the contentious Navajo-Hopi Land Dispute. These cartoons are important examples of anticolonial discourse that preserved and protected Hopi and Diné voices, cultures, and humor while challenging foreign incursions into sovereign Indigenous nations.

I consider Indigenous political cartoons to be evidence of cultural agency deployed in the public sphere. As a heretofore unexamined cache of Indigenous voices, Hopi and Diné political cartoons provide a new lens through which to view the dispute. These cartoons speak to twentieth-century colonialism and provide important evidence in support of historian Glen Sean Coulthard's argument for Indigenous "self-recognition" and rejection of colonial policies.[4] Furthermore, these editorial cartoons illustrate how cultural survival can exist within ongoing colonialism. In this book I ask, as does Mohawk anthropologist and theorist Audra Simpson, for Native American political interventions to be viewed within a framework of refusal to accommodate colonialist approaches toward Indigenous governance.[5]

The cartoons in *Qua'Töqti* and the *Navajo Times* reveal that the Diné and Hopi

peoples understood twentieth-century reservations in the United States to be threatened (and, in some cases, occupied) territory. The political messages in Diné and Hopi cartoons undermine the argument that the late twentieth century was an era of unchallenged political progress for Indigenous peoples. Furthermore, they make a compelling case for examining the twentieth century as an era of ongoing colonialism.

The grassroots political activism in the Four Corners region during the 1960s and 1970s took place amid a seismic shift in Native American history writ large. This era marked a turning point in the federal government's approach to American Indian affairs as the United States shifted its rhetoric away from termination and toward self-determination. Despite this shift, marked by President Lyndon B. Johnson's March 6, 1968, special address to Congress titled "The Forgotten American,"[6] the federal government continued to disenfranchise Native Americans in the Southwest and to value corporate interests over, for example, Diné and Hopi sovereignty. Still, Native activists continued to work together tirelessly in organized groups, including the National Council of American Indians (NCAI) and the American Indian Movement (AIM).

The NCAI and AIM ushered in a new political era by way of well-publicized demonstrations against legal and cultural injustices facing Native peoples.[7] The artists and activists of the Navajo-Hopi Land Dispute were part of this changing political landscape as they too agitated for the recognition and rights long promised by the United States government. This fight, which encompassed nationwide protests over education, health care, political autonomy, land use and management, and federal recognition, continues into the present, as natural resources and Indigenous land remain in jeopardy in the Southwest and across the United States.

The "New Indian History" and Reimagining the '60s and '70s

This book owes its existence to what historian Nicolas G. Rosenthal called works "beyond the New Indian history."[8] I also aim to contribute to a larger historiography that considers issues of agency, violence, gender, resistance, and survival.[9] Examining Indigenous political cartoons is a logical continuation of the New Indian history. As Rosenthal said in 2006, the development of the New Indian history had been fraught for decades.[10] A discipline marked by diversity and challenges to whiggish histories of the United States, the New Indian history often faced critiques from its own practitioners. In early 1982, for example, historian Reginald Horsman anxiously stated, "Native American history has never quite

thrown off the parochial air that dominated it when it was merely a subfield of an equally parochial frontier history."[11] Eleven years later, historian Daniel Richter made an even more dire prediction: "I fear . . . that the spate of publications at the turn of the decade heralds, not an exciting period of new departures, but the end of the line."[12] But they were wrong.[13]

Instead of dying, the New Indian history drastically expanded following Richter's dark prognostication. Historians James Brooks, James H. Merrell, and Jeffrey Ostler examined contentious relationships between Native peoples, colonizers, and the United States government.[14] By the 2000s, historians Melissa Meyer, Colleen O'Neill, and Brian C. Hosmer began to question the bright line dividing Native histories from histories of dependency, markets, labor, and economies.[15] As fresh avenues for inquiry abounded, new methodologies revitalized the study of Indigenous history. Indeed, as historian Ned Blackhawk mentioned in a 2011 essay, scholars from many different fields started to embrace "interdisciplinary, theoretical, and transnational" approaches to Indigenous history.[16] The field began to expand as scholars, such as historian Philip J. Deloria, questioned the very boundaries of the discipline—bringing issues of identity, citizenship, and sovereign autonomy into the academic fold.[17] However, despite the extreme growth of the field through the late 1990s and 2000s, one challenge has persisted: finding more Indigenous voices and incorporating them into new historical interventions.

In this book, I focus on a cache of Indigenous voices that has been completely overlooked. Historian Robert F. Berkhofer characterized the project of the New Indian history as motivated by scholars' desire to move Indigenous actors to the focal point of historical interventions.[18] Professor of social and cultural analysis Mary Louise Pratt characterized the study of self-produced political images as autoethnographic because "subjugated people [can] represent themselves, or tell their stories, to the dominant culture in response to the dominant culture's representation of them."[19] Indigenous editorial cartoonists challenge their representation as "other," present themselves as agents of change within their own autonomous sovereign nations, and simultaneously critique the ongoing colonialism in the United States.[20]

Twentieth-century Native history has benefited from scholars engaging with issues of off-reservation life, urbanization, and continued colonialism. Works such as historian Peter Iverson's 1998 *"We Are Still Here"* challenged the notion of the "disappearing Indian" and contributed to the now-accepted idea that the twentieth century saw a revival in American Indian populations and cultures.[21] Iverson contended that twentieth-century off-reservation experiences formed a larger pan-

Indian political consciousness, which extended to urban and rural spaces alike. Off-reservation Indigenous experiences were also a key component of historian Donald L. Fixico's argument that after World War Two, "urban Indians experienced common problems and experiences and came to view themselves more as 'Indians' and less as 'tribalists.'"[22]

While Iverson's text focused on the interplay between United States policy and Indigenous peoples, Fixico's work emphasized the tension between sociocultural alienation and the subaltern's struggle for survival in cities. Both Iverson's and Fixico's work referenced Natives' sociopolitical involvement in their communities— a conversation continued by Nicolas Rosenthal in his book *Reimagining Indian Country: Native American Migration and Identity in Twentieth-Century Los Angeles*. Rosenthal argued, "The frequent movements of American Indians throughout the cities, towns, and rural spaces of the United States call for 'reimagining Indian Country' beyond the reservations and rural communities where scholars, policymakers, and popular culture tend to conceptualize it."[23] Rosenthal's text is unique in its study of movement and patterns of resettlement and his juxtaposition of urban space against reservation space. This perspective is important for my study of Diné and Hopi cartoons, as political spaces referenced by Native illustrators often extend far beyond the boundaries of any reservation. In the Southwest, where reservation boundaries between Dinétah and Hopituskwa overlap, issues of movement and settlement have remained paramount through the twentieth century and into the twenty-first as issues of land use and land management continue to be addressed in United States public affairs.

The subject of environmental destruction and colonialism in the Four Corners region has been an interest of journalists, environmental scholars, filmmakers, and historians, who have published important New Indian histories and produced crucial documentaries related to the Navajo-Hopi Land Dispute. The work of historians Emily Benedek, David M. Brugge, Peter Iverson, and Marsha Weisiger; activist John Redhouse; environmental studies scholar Traci Brynne Voyles; environmental justice filmmakers Maria Florio and Victoria Mudd (directors of the 1985 Oscar-winning documentary *Broken Rainbow*); and journalists Jerry Kammer, Judy Pasternak, and David E. Wilkins were particularly relevant to my research on this conflict.[24] Each of these individuals investigated the intersections among cultural tensions, the politics of resource extraction, and evolving disagreements over Indigenous landownership.

Indigenous political activism, especially during the 1960s and 1970s, is central to the understanding of this story, which was a foundational expression of Indig-

enous decolonization efforts in the American Southwest. Perhaps most impor-
tant, as American historian and activist Roxanne Dunbar-Ortiz noted, this period
was indelibly marked by the United States' presence in Vietnam. As she argued,
Indigenous people—especially the fifteen thousand serving in the US military
overseas—saw discomforting similarities between their plight in the United States
and that of the Vietnamese people. This was made plain by the language of the
military itself, which often referred to happenings on the ground in Vietnam as
taking place "In Country." Short for "Indian Country," "In Country" literally meant
"behind enemy lines."[25] As news of the My Lai massacre and other atrocities made
their way home in 1968, it was clear to Indigenous activists that they too were
being treated like enemies of the state—and targeted as such—by the United
States. The understanding of this reality didn't erase long-standing intertribal con-
flicts. It did, however, provide a fresh look at the primary obstacle to achieving
true self-determination, and it increased the visibility of pan-Indian activists on
the national stage.

Other scholars across many disciplines have also suggested, directly or indi-
rectly, that the United States' presence overseas, paired with increasing hardships
across reservation and urban spaces at home during the 1960s and 1970s, served
as a catalyst for activism and created an environment ripe for change. Dennis
Banks, Ojibwa founder of the American Indian Movement; historian Daniel M.
Cobb; sociologist Stephen Cornell; Indigenous scholar Vine Deloria Jr.; anthro-
pologist Luis S. Kemnitzer; Oglala Lakota activist Russell Means; Comanche au-
thor and associate curator at the National Museum of the American Indian Paul
Chaat Smith; and Osage scholar and professor of American literature and culture
Robert Allen Warrior, among others, paint excellent pictures of the new spaces of
opportunity that presented themselves to political activists during this period and
of the successes—both legislative and cultural—that resulted from a refusal to ac-
quiesce to damaging policies and practices taking place across Native America.[26]

Without political agitation by groups like the NCAI, bills that were passed in
the 1970s (the Indian Education Act of 1972, the Indian Self-Determination and
Education Assistance Act of 1975, the Tribally Controlled Colleges and Universi-
ties Assistance Act of 1978, and the American Indian Religious Freedom Act of
1978) might not have found legislative favor.[27] Still, despite these positive develop-
ments—and despite new chapters of AIM being formed across the United States
through the late 1960s and 1970s—Native people continued to be subjected to
great harms by both corporate and political structures in the United States.

Those ongoing harms were why direct action was deemed necessary and why Indigenous leaders called on their people to join them in activities ranging from the mild, like creating the National Indian Education Association in 1969, to the extremely bold, like taking over Alcatraz Island in California from 1969 to 1971.[28] By the time two thousand protestors walked from San Francisco to Washington, DC, in 1978 to protest eleven anti–Indigenous bills, which aimed to close tribal schools and hospitals, limit hunting and fishing rights, and restrict tribal government, it was no secret to the country at large that Indigenous peoples were standing together to demand that the United States honor their human rights.[29]

It's a peculiarity of the subject of this book that many of the pan-Indian activist tactics and strategies of the 1960s and 1970s were not mentioned directly in the cartoons that uncovered the truth behind the Navajo-Hopi Land Dispute. However, the cartoonists, the papers they worked for, and the activism they depicted are part and parcel of a historical moment that was crucial to the ongoing effort to decolonize the United States. Furthermore, scholarship that has investigated these moments has elevated the voices of those determined to fight for their lands and, in many cases, their lives.

In this book I examine the crucial interventions made by political cartoonists in the daily lives and political decisions of people across Dinétah and Hopituskwa during the days of the Navajo-Hopi Land Dispute. My findings also emphasize the important interplay among journalism, visual culture, and Indigenous political activism.[30] The rich information presented in Hopi and Diné political cartoons contributes necessary layers to the historical understanding of Native life in the twentieth century. Yet these cartoons are more than an addition to the study of Indigenous political encounters. Indeed, Hopi and Diné history, as well as intertribal interactions throughout the dispute, cannot be fully understood without them.

Carlos Montezuma Breaks the Mold

There is significant historical debate about the origins of editorial cartooning. While Native peoples have a long history of creating politically and culturally motivated art, editorial caricature is deeply rooted in the development of ancient political regimes.[31] Governance studies scholar Stephen Hess and political theorist Milton Kaplan dated the first political cartoon to 1360 BCE, when a cartoonist caricatured the pharaoh husband of Queen Nefertiti in retaliation for the pharaoh's imposing monotheism on the Egyptian people.[32] Indeed, many early polit-

ical caricatures were artistic criticisms of political and religious leaders. According to historian Donald Dewey, European examples of political caricature can be found in ancient Greece (where Aristotle vehemently objected to what he called the "grotesque" formation of caricatured figures), in ancient Rome (frescoes at Pompeii), and in painted works from sixteenth-century Reformation Germany.[33] In each of these cultures, artists created caricatured figures to highlight perceived social and political injustices and used humor, exaggeration, and comparison in order to inspire the viewer to action.

United States political cartooning, distinguished from caricature by the "distorted representation of issues, situations, and ideas" rather than individuals, grew out of the iconographic satire often seen in early British publications.[34] In the United States, political cartooning has been entwined with the history of Native people since the colonial era. Politician and political theorist Benjamin Franklin's 1754 cartoon titled "Join, or Die," first published in the Philadelphia-based newspaper the *Pennsylvania Gazette*, depicts the divided colonies as a snake cut into eight segments (figure I.1). Franklin's cartoon was an explicit reference to the danger the colonies faced, given their lack of unity and their unstable relationships with Native peoples.[35] Despite the impact and success of "Join, or Die," political cartoons and caricatures rarely appeared in print until the late 1830s because it was uncommon for engravers to receive pay for their work, and newspaper editors rarely devoted expensive space to illustrations.[36] In fact, cartoon historian Frank Weitenkampf and historian Allan Nevins noted that before 1828, United States printers only published a total of seventy-eight political caricatures.[37]

Newspaper editors did increasingly publish images as technology advanced through the mid-nineteenth century. By 1867, New York's *Evening Telegram* regularly published editorial cartoons, but it was not until the 1880s and 1890s, with the invention of photoengraving, that illustrated publications became common.[38] Therefore, in 1916, when Indigenous activist Carlos Montezuma first began publishing political cartoons in *Wassaja*, the genre was still nascent.[39] The fact that political cartoons developed concurrently across multiethnic spaces allowed Indigenous people to have a role in shaping the development of commentary and cartoons in the early twentieth century.

Carlos Montezuma, born Wassaja, was a United States–educated Yavapai-Apache who was highly politicized by his years working as a reservation physician for the Indian Services (later called the Bureau of Indian Affairs). As a physician, he was familiar with the problems and privations that characterized Native

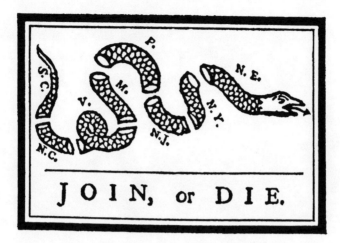

Figure I.1. Early political cartoons often included powerful visual imagery paired with succinct captions. Benjamin Franklin, "Join, or Die," *Pennsylvania Gazette*, May 9, 1754. Wikimedia

life on reservations. By April 1911, he had become active in the rights organization known as the Society of American Indians. In April 1916, he began publishing the newsletter *Wassaja*, and he included in the masthead what might be the very first Indigenous political cartoon.

Montezuma, in his debut issue, stated, "Had the Indian been treated as a man, without discrimination, in the beginning of the pale-face invasion, today there would be no Indian Bureau and the word 'Indian' would be only an obsolete name. The Indian problem is a problem because the country has taken it and nursed it as a problem; otherwise, it is not a problem at all."[40] To illustrate his point, Montezuma published a political image showing a Native man being crushed by a log emblazoned with the words "Indian Bureau" (figure I.2). The man, defiantly reaching out from under the log, looks up—still very much alive despite the Bureau of Indian Affairs' best efforts. The cartoon is particularly evocative because it depicts an Indigenous man in western clothes who retains the long hair and adornments associated with his culture. Montezuma, despite supporting economic and professional assimilation, decided to present this masthead figure as a caricature of himself and include undeniable markers of his own indigeneity.

In June 1917, Montezuma presented the desperate struggle to get the federal government to address the concerns of Native peoples (figure I.3). This cartoon

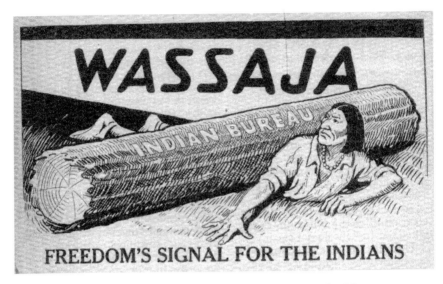

Figure I.2. The first published Indigenous political cartoon. Carlos Montezuma, "Freedom's Signal for the Indians," *Wassaja*, April 1916. Courtesy of Chicago History Museum, Catalogue No. ICHi-065457

juxtaposes white society, symbolized by the fortress-like building on the left of the image, with a traditional tipi, depicted on the right. Montezuma shows himself, wearing a bowtie, at the forefront of a multigenerational effort to break down the door of the Indian Office with a battering ram labeled "Freedom's Signal for the Indians." This cartoon is notable for its depiction of women as well as men leading the charge against the United States government and other institutions.

Wassaja was just one in a series of publications that featured images as political commentary in the twentieth century. The periodicals *Talking Leaf* (established 1935), *Navajo Times* (est. 1960), *Qua'Töqti* (est. 1973), and *United Tribes News* (est. 1974), among others, also published political images drawn by Indigenous activists and their allies.[41] The cartoons that are the focus of this book are an important strand of that larger discourse, which grew out of the long tradition of Indigenous artists responding to political crises. The images in *Wassaja* were a type of proto–political cartoon and did not feature the narrative strands or humor of the political cartoons with which I substantively engage. Nonetheless, *Wassaja* set the stage for future Native artists to display their perspective in the context of newspapers, control the representation of their image, and gain powerful footholds in various political conversations.

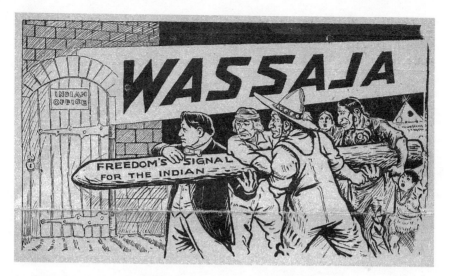

Figure I.3. The masthead of *Wassaja* often changed to reflect the most pressing issues for its subscribers. Carlos Montezuma, untitled political cartoon, June 1917. Courtesy of Chicago History Museum, Catalogue No. DN-i65457

Qua'Töqti **and the** Navajo Times

With or without cartoons, Indigenous press outlets have been an important element of the Indigenous American experience since 1828, when the first Indigenous newspaper, the *Cherokee Phoenix*, was published.[42] Though new periodicals cropped up throughout the nineteenth and early twentieth centuries as tribes marshaled available resources, it's no exaggeration to say that the number of Indigenous press outlets exploded right before the most contentious years of the Navajo-Hopi Land Dispute. During this period, journalists James E. Murphy and Sharon M. Murphy recorded the existence of thirty-nine Indigenous publications in Arizona, ten in Colorado, eight in Utah, and thirty-three in New Mexico, a stunning ninety Indigenous-created and Indigenous-centric periodicals in the Four Corners region alone, most of which began publishing in the late 1960s and early 1970s.[43] While the focus of Indigenous papers across the United States varied wildly, they commonly included local news, editorial columns, sports sections, letters to the editor, schedules of meetings, advertisements, and Indigenous language education.[44] Editorial cartoons, although occasionally appearing in various publications, were far less common than other features, with written editorial opinions, rather than visual ones, owning most of the available space in tribal newspapers.

Indeed, the *Navajo Times* and *Qua'Töqti* engaged in a historically unique conversation through the publication of Navajo-Hopi Land Dispute editorial cartoons. The *Navajo Times* started as a weekly newsletter published by the Navajo Tribal Council in 1959 but grew into a full newspaper by 1960. It became independent in 1972. The Hopi weekly *Qua'Töqti* started independently in 1973 and remained independent until it ceased publication in 1985.[45] Though the papers converged in their coverage of many issues, they served different purposes and of course did not speak for every Diné or Hopi person. In fact, there were enough Diné who opposed the *Navajo Times* perspective to warrant the publication of a competing paper. This competitor, *Diné Baa-hani*, specialized in ruthless critiques of the *Times* and its contributors. The editors of *Diné Baa-hani* believed that the *Navajo Times* was "governed by policies and resolutions passed by the council and heartily endorsed by the Administration. It more or less act[ed] as a dispersing agent for the power structure."[46] *Diné Baa-hani*, by contrast, styled itself as a truly independent newspaper. *Qua'Töqti* was not tied to any formal tribal power structure but was privately owned. It certainly did not speak for the entire Hopi people.

The *Navajo Times* and *Qua'Töqti* also served different groups within their communities. The *Times*, which at one point had a circulation of up to 14,000, was a newspaper for the Diné masses, while *Qua'Töqti*, which had a circulation between 3,700 and 3,800 in 1974, aimed to "keep the Hopi people aware of what's going on around their own reservation [and] . . . to be an instrument to better understanding between the white and Hopi cultures."[47] To that end, many of the editorial cartoons in *Qua'Töqti*, including those that referenced the land dispute, emphasized United States influences to a greater degree than those in the *Navajo Times*.

Political cartoons from *Qua'Töqti* and the *Navajo Times*, drawn by cartoonists Clare Thompson (Diné), Jack Ahasteen (Diné), and Phillip Sekaquaptewa (Hopi), are crucial examples of Indigenous activism. Their work presents an important challenge to any argument that characterizes the United States in the twentieth century as postcolonial. The information uncovered thanks to these cartoons and the information presented in the cartoons themselves make a compelling case for examining the United States as a locus of continued colonialism throughout the twentieth century—and into the twenty-first.

My analysis of the political cartoons in the *Navajo Times* between 1964 and 1974 and *Qua'Töqti* in 1973 (its first year of publication) and 1974 revealed that the Diné and Hopi never perceived each other in natural opposition nor as "owners" of the land in question. Rather, as Indigenous people, they saw themselves as sub-

jected to manipulation by federal authorities as the United States sought to increase its wealth by mining first the coal and then the uranium under Black Mesa in Arizona. Acutely aware of their land's value and the minerals and other resources on it, Diné and Hopi artists used political cartoons to assert their agency, identify the true instigators of the dispute, and counter the myth that the conflict had intertribal origins.

Political cartoons created by Native artists have been an unexamined window into Hopi and Diné self-conceptualizations as presented to the public. Though the cartoonists, especially Thompson, Ahasteen, and Sekaquaptewa, often presented a larger perspective, they were intellectuals, critics, and independent thinkers. Therefore, though their cultural and hereditary ties to their respective nations sometimes allowed them to speak for the Diné and Hopi writ large, their voices should not hold greater authority or authenticity than those of other Indigenous political activists, thinkers, or artists. Still, these specific political cartoons directly undermine the notion that unfettered intertribal animosity was the primary characteristic of Diné-Hopi relations in the late twentieth century. Rather, the cartoons present a constructive conversation in which intertribal alliances took center stage in a fight for cultural survival against opportunistic businessmen and political figures driven by avarice and greed.

In the end, the Diné and Hopi have survived. It is my hope that the justifications that allowed non-Indigenous corporate and political actors to poison sacred lands and forcibly remove thousands of people from their homes and homelands in the name of the Navajo-Hopi Land Dispute will not.

The Beginning

*Interdependence and Independence in the Four Corners Region,
1540–1868*

> It is like putting your hand down someone's throat and squeezing the heart
> out—that's how people are treated here.　　　—EMMA BAHE (DINÉ)

Historians often refer to the conflict that unfolded in the Four Corners re-
gion in the late twentieth century as the 1974 Navajo-Hopi Land Dispute,
but this is a *bilagáana* name, a white man's invention.[1] Like many such inven-
tions, this term obfuscates the complex truth regarding the inceptions of the con-
flict, the roles of non-Indigenous people in intertribal disputes, and the nuances
of the long-standing relationship between the Diné and the Hopi in the South-
west. Indeed, the discord that erupted in the late twentieth century was rooted
in United States political and industrial leaders' efforts to seize valuable land and
resources long shared by many Indigenous tribal nations.

Cosmological Origins and Sacred Beginnings

For the Diné, tribal identity is rooted in their sacred land, Diné Bikéyah. Var-
ious versions of Diné Bahané, the Diné creation story, have been told to Anglo
outsiders since Hastin Tlo'tsi hee, also known as Sandoval, first conveyed it to
linguist and ethnologist Pliny E. Goddard in 1923 and 1924.[2] Tlo'tsi hee later re-
told the story to ethnographer Aileen O'Bryan over seventeen days in November
1928.[3] O'Bryan subsequently published *Diné: Origin Myths of the Navaho Indians*
in 1956. For Hastin Tlo'tsi hee, discussing the Diné creation story was key to pre-
serving the Diné way of life. By sharing the creation story with outsiders, he en-
sured the survival of knowledge given to him by his grandmother Esdzan Hosh
kige and her ancestor Esdzan at a', a Diné medicine woman.[4]

Tlo'tsi hee's version of Diné cosmology begins with a detailed description of the five worlds of the Diné universe. His account takes the listener from the smallness and darkness of the First World, Ni'hodiłhił, to the world we live in, intimating that there are yet further planes of existence to experience.[5]

Tlo'tsi hee's tale is only one version of the Diné creation story. Some Diné ceremonialists describe the world we live in as the Fourth World; some present First Man and First Woman as leaders of groups rather than individuals; and some present Coyote, also known as First Angry, as the most important character for transmitting moral values to the Diné audience.[6] The diverse range of figures and competing focal points of Diné Bahané allow for a flexible narrative that can be used to describe and mold the values of a large, diverse national and cultural group. In every case, however, Diné Bahané moves beyond describing the traditional cosmos to explain and offer advice for overcoming life's obstacles, specifically those related to intertribal interactions.[7]

The major themes of the Diné creation story revolve around good and evil, harmony and balance (*hózhó*).[8] In this world, which historian Peter Iverson characterized as "encompass[ing] both beauty and difficulty," one major challenge is interacting with outsiders.[9] For the Diné, close relationships between neighbors reflect a deeper spiritual harmony deriving from the distant past when Northern Athabaskan speakers and Southern Athabaskan speakers united.[10] The creation story presented by Diné scholar AnCita Benally honors a time long ago, when Diné clans adopted newcomers and "pledged to maintain kinship and social alliances with them."[11] Diné Bahané, then, is much more than a religious framework or a spiritual story. It also serves as a guideline for engaging with outsiders in ways that support the harmony, balance, and promise of the future.

The Hopi creation story also tells of Pueblo people's emergence from other worlds, their subsequent migration, and their duty to maintain harmony throughout their homeland, Hopituskwa.[12] The most famous publication of the Hopi creation story, authored by novelist Frank Waters and Hopi artist Oswald White Bear Fredericks in 1963, incorporated testimony from thirty Hopi elders regarding their perspective on Hopi creation, history, and culture. The text, meant to appeal to non-Hopi audiences, discussed the four worlds of the Hopi and the importance of direction and archetypal characters in the creation story, and it presented the ceremonial cycle as a mechanism for ensuring cultural cohesion and spiritual health.[13]

There are many important parallels between the Hopi and Diné creation stories, starting with the darkness of the First World, known to the Hopi as Tokpela,

or endless space.[14] Both cultures describe a process of moving through incarnations and previous worlds to reach this one, and both stress the importance of creating life, understanding direction, and maintaining balance. Yet the Hopi creation story is unique in its depiction of an earth goddess, Spider Woman, and her relationship with Tawa, the sun god.[15] Scholars, including religious studies expert Armin W. Geertz, have noted that the interplay between opposites in Hopi stories "indicates there is a seemingly profound, systemized conformity and symmetry in Hopi cosmology."[16] Hopi cosmology, like Diné cosmology, is especially concerned with balance, with order, and with an understanding of the natural world's ability to guide individuals in a spiritually positive direction.

The similarities between Diné and Hopi origin stories and belief systems suggest that the Diné and Hopi peoples have long had a close relationship. Anthropologist Jerrold E. Levy argued that close proximity, times of political and environmental crises, and an emphasis on exogamy resulted in significant intermarriage and sustained cross-cultural encounters at least through the seventeenth and eighteenth centuries, particularly during times when the Hopi and the Diné were forced to accommodate acute material scarcity.[17] Instances in which Diné and Hopi people relied on each other created a complex relationship between the tribes and a precedent for intertribal solidarity in the face of social and material hardship.

The Diné and the Hopi have lived as neighbors since the first Athabaskan-speaking migrants arrived on the Colorado Plateau from what is modern-day northwestern Canada, around 1350 CE.[18] Some of these migrants settled to the northeast of existing mesa-top Hopi villages in modern-day Utah, Arizona, and New Mexico.[19] Despite having different cosmologies and ways of life, both Athabaskan-speaking and Pueblo peoples maintained strong relationships with the land and each other. With plenty of space for the Hopi to cultivate and the Diné to hunt, their social systems and fragile ecosystem remained in relative balance for centuries. But their mutual acceptance was jeopardized by Spanish incursions between 1540 and 1598.[20]

Desire and Conquest: Early Interventions

The European historical record of encounters with Native peoples of the Southwest began in 1540, when the explorer Francisco Coronado raised an army and started his journey to what is modern-day New Mexico.[21] Within a few short years of Coronado's attack on the Zuni pueblo of Hawaikúh, a new southwestern society emerged that blended the traditions of the Spanish, the Hopi, and the Diné.[22]

Intertribal relationships were forever altered by the introduction of European livestock, especially horses and sheep, and new opportunities for trade. As Iverson noted, "Such a society inherently embraced expansion. Once the people acquired a few horses they wanted or needed more horses—and more land for them. Once they obtained a few sheep, they understood the benefits of having more."[23] For the Diné and Hopi, the introduction of new people, new animals, and new goods meant reworking their existing relationships to the land.[24] Despite the introduction of horses and sheep, the Hopi and other Pueblo peoples remained primarily farmers. Unfortunately, the Pueblo tradition of living in relatively sedentary communities, once safe within the established social frameworks of Southwest tribes, now left them uniquely exposed to exploitation by newcomers who had the advantages of horses, firearms, and metal armor.[25]

Despite Spaniards' willingness to extract value from the Native peoples they encountered, not all Indigenous people were affected equally by the newcomers. As anthropologist Edward H. Spicer found, the more mobile the group—equestrian Diné, Utes, and Comanches, for example—the more difficult it was for Spanish agents of empire to control them. Archival records corroborate Spicer's work, revealing that throughout the sixteenth century the Hopi, who traditionally practiced sedentary cultivation and were therefore in much closer proximity to European invaders, remained in a position of relative vulnerability.[26] Forced engagement with invading Spaniards, together with the technical ability of Europeans to extract value from Indigenous peoples and lands, quickly created conditions of extreme hardship in the Southwest for Pueblo peoples.

The Spanish never intended peaceful cohabitation with the Indigenous peoples of the American Southwest. As historian Lynn Bailey put it, "Coronado's expedition came and went, leaving behind a reputation for brutality and ruthlessness—a reputation that later generations of Spaniards were to continue."[27] Indeed, Spanish oppression of Native peoples has been a focus for many prominent scholars.[28] However, key instances of intertribal cooperation and Indigenous resistance against colonizers shed light not only on colonization but also on the hereditary relationship between the Diné and the Hopi. Furthermore, the intertribal communication between Native peoples, their decision to resist their oppressors, and the historical memory of such revolts allow scholars to discern the patterns and pathways of accommodation across time and space to relieve the *bilagáana* of their guilt at the expense of Indigenous intellectual sovereignty.[29]

Specifically, the story of the 1680 Pueblo Uprising, though temporally removed from the 1974 land dispute, is instructive for three primary reasons. First, it re-

frames the historical relationship of Indigenous peoples in the Southwest with non-Native political actors as one marked by contingencies, uncertainties, and reversals in power. Second, the event set the stage for Diné and Pueblo peoples living side by side for the benefit of their communities against the interests of competing foreign governments.[30] Third, as anthropologist Michael Wilcox noted, it provides a counterbalance to the "black legend" of Spanish cruelty toward Indigenous people, which has been deployed by scholars across various fields to attack Spanish colonialism and defend Anglo-American colonial practices.[31]

Despite damning information in the historical record that reveals the extraordinarily violent nature of Spanish control over Indigenous peoples, scholars such as the still-cited archaeologist A. F. A. Bandelier, historian Herbert Bolton, and journalist Charles Lummis presented the ultimate impacts of European control of the Southwest as a net positive.[32] Though Bandelier, Bolton, and Lummis wrote long ago, their mythical narrative has been repeated into the twenty-first century. Indeed, a former secretary of the Department of the Interior and supervisor of the Bureau of Indian Affairs, Stewart Udall, a figure represented in Indigenous cartoons regarding the Navajo-Hopi Land Dispute of 1974, went so far as to say, "Only since the invention of the printing press has a successful campaign of defamation lasting centuries been waged against an entire people. That nation is Spain, and the campaign of calumny—known to modern historians as the black legend—made Spaniards pariahs and demeaned the character of Spanish people. This myth, I am convinced, has influenced earlier generations of scholars to cast a cold eye on the achievements of our Spanish Pioneers."[33] Udall, a perpetrator of the twentieth-century grab of Diné and Hopi lands, was well schooled in the tactics of domination that Spanish colonizers used to extract wealth and natural resources from Dinétah and Hopituskwa.

In many ways, the later efforts of the United States replicated the cycles of violence that resulted in the extermination of the vast majority of Indigenous nations in the seventeenth and eighteenth centuries. The fact that Udall not only praised European incursions onto sovereign Indigenous territory but also attacked scholars who viewed the Spanish colonial project as damaging to Indigenous peoples is all the more reason for scholars today to consider the long history of Spanish imperial incursions into Native lands and the equally long history of Indigenous resistance against such incursions in examinations of twentieth- and twenty-first-century Indigenous encounters.

More than a hundred thousand Puebloan people lived in New Spain in 1598, the year the Spanish Crown financed its first colonizing expedition to the South-

west.[34] Almost immediately after arriving in New Mexico, Juan de Oñate, the leader of the expedition, rousted families from their homes to make way for settlers. He then established a goods and labor tribute system to extract value from the Indigenous people and began forcing them to convert to Christianity.[35] His strategy involved giving local friars total control over Native lands and lives. Any evidence of resistance—or, indeed, evidence that Natives were unhappy in missions—was cause for brutal reprisal. In one 1655 incident, Zuni men lodged complaints with Spanish officials regarding the living conditions in the new missions. Upon finding "feathers or idols" in the possession of one of the men, Friars Velasco and Guerra answered the complaint by dousing with turpentine and setting on fire the offending man and his spiritual items, ultimately killing him.[36] Such was the brutality of the Spanish colonizers' rule over Indigenous people.

The Spanish targeted the Puebloan peoples more than the Diné for a number of reasons: Pueblo peoples lived in densely populated settlements whereas the Diné were mobile; the Pueblo population was significantly larger than the Diné population, which provided the Spanish with more laborers and converts; and Puebloans were farmers rather than herders, which meant that the Spanish could take food more easily from the Pueblos.[37] These factors motivated Spanish officials to instruct military officers and Franciscan missionaries to be ruthless in their domination over Pueblo people.

Brutal colonial strategies were a frontal assault against Pueblo people and their society. While many Puebloan traditions survived—historian Andrew Knaut's text is an excellent investigation of the presence of underground rituals throughout the seventeenth century—Puebloan people suffered tremendously at the hands of the Spaniards, particularly as their food stores were ravaged by the invaders.[38] The account of Fray Juan Bernal of April 1, 1669, reveals the extent to which Puebloans' lives were endangered by the Spanish: "In the past year, 1668, a great many Indians perished of hunger, lying dead [a]long the roads, in the ravines, and in their huts. There were pueblos (as instance Humanos) where more than 450 died of hunger. . . . Because of lack of money, there is not a *fanega* of corn or of wheat in the whole kingdom."[39]

Along with controlling Natives' land, food, housing, property, religion, and bodies, Spanish conquerors in the Southwest brought smallpox, measles, influenza, and tuberculosis, devastating Indigenous populations that had no natural immunity to such diseases.[40] Ultimately, Spanish control of the Southwest resulted in mass deaths of Puebloan people, an 80 percent population decline by 1680.[41]

Still, despite tremendous abuses by the Spanish, Pueblo people were not broken. By 1680, Indigenous leaders were aware that they held a temporary position of advantage: the colonizers' stores of food, military equipment, and gunpowder were dangerously low.[42] Knowing that Spanish mistreatment was unlikely to cease without direct intervention, Cochiti, Keres, Taos, Jemez, and Pecos leaders, among others, decided to launch a coordinated uprising against their oppressors. Two young Tewa runners named Omtua and Catua signaled the attack.[43] They used a signaling system made of knotted maguey fiber cord to alert far-flung pueblos that the uprising was to begin on the morning of August 11, 1680.[44] The Pueblo allies staged a successful revolt on the designated day, ultimately driving two thousand Spaniards out of New Mexico and killing another four hundred.[45]

Some surviving Spaniards returned to their former homes while some sought refuge with other Indigenous peoples, including the Diné, who lived in close proximity to Puebloan territory. Dr. Joseph H. Suina, a Cochiti Pueblo governor and professor who studies Puebloan history, said this about the revolt:

> For over eighty years, we endured until we could endure no longer the threats and acts of religious persecution introduced by the Franciscans and reinforced by the military. Then the unthinkable occurred. Pueblo communities, otherwise very independent of one another, united into a single force to cast out a common foe. . . . Historians tell us that this was the famous Pueblo Revolt of 1680. To my people it was the declaration of independence! That heavy-handed relationship of the Spanish towards the Pueblos was never to be again, even after their return in 1692.[46]

This declaration of independence should be viewed as the very public culmination of Puebloans' refusal to accept the terms by which the Spanish occupied their land. Pueblo peoples, despite their technological disadvantage, reclaimed command and control of their land and drove out their oppressors.

The sociopolitical environment among Indigenous tribes of the Southwest was relatively chaotic in the aftermath of the uprising. The region grew incredibly unstable, and the Spanish governor, Antonio de Otermin, unsuccessfully attempted to regain control the very next year, in 1681.[47] De Otermin's efforts, which included a series of fatal counterattacks and a retreat of 116 Pueblo allies, reveal the extent to which peace remained elusive and political allegiances remained uncertain.[48] Still, the pan-Puebloan identity that formed during the years leading up to the 1680 uprising was somewhat successful in creating a barrier between Native peoples and Spanish colonizers in the following decades.[49]

The mutual understanding that stemmed from this shared traumatic experience was a significant change in intertribal relations. Upon Spanish colonists' return to the Southwest in 1693, as Wilcox noted, "the terms and conditions of interaction between the [Indigenous] groups changed."[50] The Jemez, Keres, and Tiwa peoples had firmly established themselves in mountainous strongholds, making them difficult to conquer; old encomiendas and systems of tribute were dissolved; and religious freedom was upheld throughout Indigenous communities. Furthermore, from the mid-1690s through the early 1700s, the Zuni, Acoma, Laguna, Hopi, and Diné peoples often supported each other against Spanish recolonization efforts.[51] Working together allowed tribal peoples to present a strong front to returning Spanish forces and protect their autonomy.

While the Hopi and other Pueblo peoples enjoyed a period of relative calm in relation to the Spanish in the first half of the eighteenth century, Ute raiding in the years leading up to 1754 forced many Diné to relocate to the Cebolleta Mountains and the Chuskas, which were not traditional Diné lands.[52] Then, between 1754 and 1800, tribal politics also forced Pueblo people to relocate, which brought them in closer, more direct contact with the Diné.[53] It had been more than a century since the Spanish had introduced new livestock to the Puebloans and Diné, and in that time, despite hardship, both Diné and Hopi stocks had grown. One result of this renewed connection between Hopi and Diné in the years leading up to 1800 was an increased awareness of successful methods for sheep and goat herding, but it also meant that the Spanish and the Diné were in direct economic competition for available grazing land.[54]

While sheep provided a successful cash economy for the Spanish, they meant much more for the Diné. In anthropologist Walter Dyk's 1938 study of Diné clans and kinship, *Son of Old Man Hat*, the Diné man Left Handed recalled being told, "The sheep and goats are like your father and mother . . . so you must take good care of them. . . . Just pay attention to your food, and to your sheep and goats."[55] Left Handed's sentiment was echoed by Diné poet Luci Tapahonso's aunt. She said, speaking of her life in the nineteenth century, "[Sheep] were like our family."[56] On the most fundamental level, owning sheep and goats allowed a family to eat, to be clothed, and to provide for future generations. For men, it ensured their ability to provide for a family. For women, owning sheep allowed them to cross the threshold into adulthood and to make a living as a weaver. As one Diné activist, Roberta Blackgoat, mentioned in the late twentieth century, "The weaving loom is the place where I became a woman."[57] For the Diné, healthy livestock meant a healthy economy, a stable society, and a life in balance.

After 1800, as the Diné population increased, their economy became more oriented toward herding, which provided several significant advantages over farming. It provided a higher income, offered more ways to utilize resources from the ground, and allowed the herder to maintain mobility in the face of hostile neighbors (often the Spanish, the Comanches, and the Utes).[58] As the population grew and as herding became more ingrained in Diné culture, the need for larger herds became more pressing. The Diné, who had already faced significant economic hardship from intertribal conflicts and had a history of raiding their neighbors' stock pens, turned to raiding Spanish settlements for sheep. By 1800, as independent scholar John P. Wilson noted, Diné raiding had become so common that Spanish governor Fernando Chacón led five hundred men to negotiate a peace with the Diné.[59] This peace proved to be short-lived, however. Throughout the early nineteenth century, the Diné and the Spanish participated in a process of raiding and reprisals, even after the Mexican government attained power in the region in 1821.[60]

Despite changing ownership claims over the land, the Diné continued as best they could to maintain their pastoral way of life; their stocks of goats, sheep, and horses; and their relationships with other Native and non-Native people on the land. As Iverson argued, the continued Diné relationships with Spanish, Mexican, Pueblo, Ute, and other people in the early 1800s provided an important lesson not only for the colonizers but also for other Natives on the land: "Cultures are more likely to thrive not in isolation but through continuing contact, even conflict, with other groups."[61] For the Diné, outsiders led to the growth of their sheep, goat, and horse herds. They were also responsible for the introduction of weaving as an art form that could be monetized and the introduction of silver for tools and adornments.[62]

Weaving and silversmithing, while increasingly important to Diné culture, held a back seat to herding and raiding well into the mid-nineteenth century.[63] While raiding had a long tradition among Indigenous peoples of the Southwest, when the newly independent Mexican government gained control over the American Southwest in 1821, it supported colonists in engaging in reprisals against suspected sheep raiders.[64] The Mexican government's strategy accelerated a cycle of violence, which was inherited by the United States government after the Mexican-American War. The relationship between Indigenous peoples and whites was so volatile that Diné scholar Frank McNitt characterized the Mexican period in the Southwest (1821–1846) as one of constant warfare.[65]

Mexican rule in the Southwest ended after United States leaders claimed the

territory at the inception of the Mexican-American War in 1846. "Manifest destiny," a phrase coined by editor John L. O'Sullivan only the year before, demanded United States expansion. The cost of manifest destiny—Indigenous lives and land—was deemed acceptable by the United States.[66] United States leaders and settlers' efforts to control traditional land use practices, Indigenous economies, and Natives' perceptions of the United States government marked the beginning of the American period. Understanding the cross-cultural friction that characterized the early years of United States military occupation is key to grasping the political conditions that led to the Long Walk of 1864 and the US government's subsequent incursions into Native lands for the purpose of extracting wealth from Dinétah and Hopituskwa. Furthermore, this period reveals that the United States has been attempting to control Native livestock, resources, and populations from its very first contacts with Indigenous peoples.

The American Period: Another Intervention

Almost immediately after claiming New Mexico, the United States government attempted—ultimately unsuccessfully—to end the long tradition of Indigenous sheep raiding. United States officers tried to compel Diné leaders to sign the Treaty of Ojo del Oso, which prohibited Indigenous raiding. Their efforts failed.[67] Some Diné representatives signed the document, but many Diné kept raiding as usual. United States leaders failed to realize that the Diné tribe was composed of many autonomous bands and did not have a single leader. Therefore, signing a treaty with a small number of Diné leaders did not mean that the United States government had the approval of the entire tribe.[68] The general population of Diné did not consider themselves to be bound by documents signed by Indigenous leaders who represented only their own clans. Even those Diné who were aware of the signing would not have considered it to be a viable legal contract with any power to constrain their raiding practices.[69] This allowed the Diné to maintain control over their land and resources without being beholden to the interests of one leader. Politically, it created a significant barrier to United States leaders' efforts to control Indigenous activity.

Though the ineffectiveness of early treaties resulted in United States officials' growing frustration with Indigenous land use and cultural practices, historians often characterize the period 1846–1858 as one of relative peace. Yet despite (or perhaps because of) the lack of warfare, sheep raiding continued. Historian Richard Van Valkenburgh estimated that 450,000 sheep were taken from non-Native settlements in the four years leading up to 1850.[70] Historian Paul D. Bailey's num-

bers are more specific. Using the records of New Mexican congressman Hugh Smith, which included reports from the United States marshal for New Mexico, Bailey stated that "between October 1, 1846, and October 1, 1850, the Navajos and their Apache cousins had stolen 12,887 mules, 7,000 horses, 31,581 cattle, and 453,293 sheep" from non-Native settlements.[71]

The numbers were staggering. For United States officials, the loss of wealth was shocking. The answer seemed to be installing the United States' first military presence in Arizona. Thus, on August 17, 1851, US Army colonel Edwin Sumner arrived in Dinétah leading four companies of mounted troops, two companies of infantry, and one company of artillery to establish Fort Defiance.[72] The name of the fort referenced the fact that it was to be "built in defiance of the hostile Navajos and in the heart of their homeland."[73] The fort was supposed to stop sheep raiding but also to eliminate the need for United States officials to interact directly with Diné representatives. Instead, civil agents assigned to the Navajo tribe were to handle all cross-cultural interactions between the Diné and the United States.

The first civil agent with an interest in the well-being of the Diné, the fortitude to establish his home and agency on Indigenous lands, and the courage to establish a community center in the heart of an extremely volatile landscape was also the first civil agent to be murdered by Native people.[74] Unknown Indigenous warriors ambushed US Army captain Henry Linn Dodge in 1856 after he had spent three years working with both the US government and the Diné.[75] There is no evidence to support the assumption that Diné were responsible for Dodge's murder, but the white public at the time blamed the Diné.[76] The result was a decline in the relationship between future civil agents and their Diné charges. Even more problematic for the Diné, United States military leaders became willing to act in and around traditional Diné territory without consulting civil agents or Indigenous leaders at all.[77] Increasing violence on the land around Fort Defiance in 1856 and 1857 meant that few were surprised when a true conflict broke out in 1858 after a visiting Diné man killed the Fort Defiance commander's slave.[78] The relationship between the Diné and the whites on their land continued to worsen through 1860.

Powerful resistance and the continuation of Indigenous authority persisted as the relationship between Diné and whites deteriorated. Indeed, the Diné and the Hopi retained control over the contested land. Yet correspondence between the governor of the New Mexico Territory, Abraham Rencher, and an unnamed captain reveals the impunity with which military officers were free to act on behalf

of the United States government. On May 1, 1860, Governor Rencher wrote, "I have to state to you, as I have stated to others that you have a right to defend ourselves and our property against the Navajoes [sic], or other marauding Indians. . . . If in each pursuit, it becomes necessary to kill the Indians who have committed such offenses, you have a right to do so."[79] As Rencher's correspondence shows, United States officials adopted a policy whereby Indigenous people did not enjoy the same level of legal protection as whites. There is no mention of the unnamed captain being under pressure to meet any sort of evidentiary burden before killing an Indigenous person, and Rencher was clear that he valued white property over Indigenous lives.

Rencher's position was shared by many other United States military personnel. The 1850s and 1860s were characterized by so much conflict between US forces and Indigenous peoples that many historians use the term "Navajo wars" to describe the period.[80] Denoting US incursions into Indigenous territory as "wars" suggests that the resultant deaths and large-scale removals were the product of justifiable violence. Characterizing the period this way also obfuscates the work of non-Indigenous politicians working for peace.

Despite the militaristic strength of Rencher's position, it was not universally accepted among his peers. Some leaders of the US Army thought that this policy could lead to an unjustifiable war, which might ultimately result in the wholesale extermination of the Diné and the humiliation of the United States government. Colonel Thomas T. Fauntleroy wrote, "The greatest embarrassment arises from the facts that many of the claims set up against the Indians for plundering, stealing stock &c., are either fabricated, or to a considerable degree exaggerated, and if war is to [be] commenced upon the simple presentation of these claims, the cause for war becomes interminable, or *the Indians must be extirpated*."[81]

To Rencher's subordinates, it was clear that the national goal was to disenfranchise and dominate Indigenous peoples regardless of widespread misinformation regarding Indigenous lawbreaking. Fauntleroy, deeply unhappy with the precedent set by Rencher and those operating within Rencher's framework for acceptable behavior, was nonetheless powerless to stop the tide from turning against the Diné in the Southwest.

A Change in Policy: Establishing Reservations

The change in United States policy that first resulted in the construction of the temporary reservation called Bosque Redondo—and then, in 1868, the construction of new legal boundaries that defined the limits of the Diné reservation—is

directly responsible for twentieth-century conflicts over land management and land use in the Four Corners region. In fact, much of the land in the Southwest that was manipulated and controlled by treaties, the establishment of reservations, and white settlement in the nineteenth century was the same land that was contested during the 1974 Navajo-Hopi Land Dispute. The United States government's antagonistic stance in the nineteenth century was aimed at forcing the Diné and other Indigenous people in the Southwest to abandon their cultural practices and, ideally, give up their land. Instead, the battle that began in the 1860s was a precursor to the conflict in the 1970s and the discord that persists today in the region.

The United States military's approach to the perceived Indigenous threat in the Southwest became especially aggressive in 1862, when James Henry Carleton became commander of the Department of New Mexico and the New Mexican Volunteers.[82] Carleton knew that United States government policy toward Indigenous people had recently undergone a major shift and that the Department of the Interior was building temporary reservations all over the country to contain Native tribes and facilitate their cultural assimilation.[83] He was also aware of the problems that Diné practices and policies were causing with the Anglos in the Four Corners region. He believed that the solution to the growing conflict was to establish a temporary reservation in the Southwest where the Diné might be transformed and assimilated through controlled agriculture and stock raising.[84] In Carleton's eyes, the fact that the Diné would likely be moved away from valuable resources and white Americans to a remote corner of the New Mexico Territory was just another reason to establish the reservation quickly.

Carleton's solution was perfect for leaders in Washington, DC. In the eyes of United States politicians, the continuing Indigenous presence on the frontier was a problem that needed to be solved as quickly as possible while spending the least amount of money as possible. Washington believed that the roughly $3 million per year that the United States government was spending on controlling the Indigenous peoples in the Southwest was unacceptably high.[85] The alternative to continuing to spend this type of money was to send "Gentleman Jimmy" and his field commander, Colonel Christopher "Kit" Carson, to begin rounding up troublesome Natives and interning them at Fort Sumner in east-central New Mexico.[86] From September 16, 1862, to March 1863, the Mescalero Apache tribe was targeted and forced to move to the new temporary reservation. Carson and his troops bore responsibility for the devastating campaign, which resulted in the

loss of life, land, and property, to compel the Mescalero Apaches onto their new reservation.

The Diné faced a similar fate in the 1860s in their own forced removal to a temporary reservation that functioned as an internment camp: Bosque Redondo. This move was intended to facilitate Diné assimilation and conversion to Christianity. The idea was a failure on every measurable level. There were two types of violence that attended the Bosque Redondo experiment: the violence of removal and the violence of the place itself. Both strands of brutality trace back to the fact that Bosque Redondo was never meant to be long-term housing for the Diné. As historian Edmund J. Danziger Jr. noted, Carleton sent the Diné to Bosque Redondo based on a unilateral decision he made in September 1863 "despite the fact that he had not worked out the details or won the approval of civilian authorities for his scheme."[87] The federal government, which was unaware of Carleton's plans, had no extra resources to provide for the Diné. Carleton, in order to gain Washington's support for the forced removal, told his superiors that he believed there was gold and silver on land occupied by the Diné.[88] Get the Diné off their land, and the silver and gold would be free for the taking. The fact that many United States officials considered the Diné to be dangerous and undesirable only made forced removal easier to accomplish.

In October 1863, the commissioner of Indian affairs, William P. Dole, wrote in his annual report that the Diné were "the most powerful and hostile tribe within [their territorial] limits. . . . Little progress has been made in reducing them in submission to the authority of our government, and they prove themselves a source of constant vexation and alarm to all our exposed settlements."[89] For the United States, the combination of potential gold and dangerous Natives was enough to warrant support for the forced removal of the Diné at the hands of Carleton and Carson to Fort Sumner, which the Diné called Hwéeldi, the Land of Suffering.

Bilagáana scholarship, even today, often obfuscates the brutal realities of the three-hundred-mile Long Walk to Bosque Redondo. This is partially because military historians tend to focus on strategy and statistics and partially because until recently key Diné voices were missing from the historical record. Diné scholar Laura Tohe explained that some of the estimated nine thousand Diné survivors and their kin may choose not to recall traumatic experiences even to those closely linked through kinship ties. She said: "Sometimes stories might be withheld until one earned them, paid for them, or could prove oneself worthy of receiving a

story. [Furthermore,] while the people might know stories, they could choose to not tell them because they are too horrendous and could cause harm when remembered."[90]

Despite the history of trauma and the danger associated with sharing personal stories with outsiders, many Diné men and women have shared their experiences of Hwéeldi and the Long Walk. They help to explain the contentious relationships among the Diné, the Hopi, and the United States government and the fraught relationship between the United States and the Native peoples of the Southwest during the Navajo-Hopi Land Dispute of 1974.

United States officers' 1864 decision to evict vulnerable families from their homes without warning and force them to march to a barren, ill-prepared parcel of land was an act of unforgivable violence in the eyes of the Diné and the beginning of what they call the Fearing Time.[91] Perhaps worse than the physical round-ups was Kit Carson's decision to use his personal relationship with the leader of the Mouache Utes, Ka-ni-ache, to enlist experienced Ute scouts who could reveal the whereabouts of known refugees or escapees.[92] Carleton approved of Carson's idea and quickly hired ten Mouache Utes, along with other volunteers, to reveal the likely hiding places of Diné outside the bounds of their traditional lands. Altogether, by June 1863, when the preparations for the Navajo campaign were complete, Carson had amassed a body of 736 armed men to help him in his mission.[93]

Diné resistance, however, resulted in a significant delay in rounding up Diné families. As late as January 1864, many Diné had yet to make the Long Walk to Bosque Redondo.[94] Diné resistance to United States incursions took many forms: raids on Bosque Redondo in December 1863 and July 1864 resulted in a simultaneous boost to Diné resources and a loss of wealth from administrators and Mescalero Apaches at the reservation. In July 1864, for example, the Diné collected sixty Mescalero horses and an undetermined number of cavalry mounts before disappearing south of Bosque Redondo.[95] These attacks were necessary for Diné subsistence, to be sure, but they also were a challenge to Carleton and Carson's efforts to exert power and control over Indigenous peoples.

There were reprisals for Indigenous raids on livestock and other property at Bosque Redondo, some of which cost the Diné their lives.[96] Despite these deadly retaliations and the continued hunting of Diné in their own lands, military officials remained publicly adamant that interning the Diné at Bosque Redondo was going to increase the Diné quality of life in the long term. Brigadier General James Carleton's September 6, 1863, letter to Brigadier General Lorenzo Thomas,

in which he stated that his army's purpose was to "feed and take care of them [at Bosque Redondo] until they have opened farms and become able to support themselves," is one surviving record of that sentiment.[97] Despite the prevailing rhetoric, Carleton's campaign continued to create conditions that made it impossible for the Diné to support themselves on or off a reservation. Carson's scouting parties, for example, prevented the Diné from harvesting their crops in the fields, establishing hunting parties, or building fires that were necessary for their survival. Carleton and Carson knew of the disastrous impact of their presence in the winter of 1863–1864, and yet they continued to pursue the Diné.[98]

Often, Carleton and Carson's maneuvers during this period resulted in the separation of families and the destruction of clan units. Laura Tohe's Diné grandmother told one such story that informed the cultural memory of the Tsénahabiłnii clan. She remembered: "One day the soldiers came and the family ran away. They hid wherever they could. The next day the girl went home to see if her parents were still alive. When she got home her home was burned down and the place was still smoking. Then she saw the heads of her mother and father on the fence posts. The girl left after that."[99]

Occasionally, people escaped the worst of the physical and psychological torture meted out by American forces. Some of Annabelle Redhorse Benally's family of the Naaneesht'ézhi clan, who hid in the canyon of Tsékooh hah zhoozh when the soldiers came, were spared the hardships that attended daily life at Hwéeldi, for example.[100] Still, soldiers like the ones Laura Tohe's grandmother encountered were ruthless in their efforts to track down and corral all existing Diné in the region, an area supposedly (and fictionally) filled with gold and silver.

The Diné were aware that the foundational reason for their forced relocation was resources: livestock, land, and imaginary gold. John Beyale Sr. of the Nihooáanii clan succinctly put it this way: "It has always been the white men and the Mexicans fighting for the land. . . . The battle over land started a long time ago with different tribes such as the Comanches, Blackfeet, Utes, and Mescalero Apaches with the white people and Mexicans. To this day, the struggle for land continues."[101] In the days leading up to the Long Walk, the *anaí* (enemy) continued raids on private homes, rounding up men, women, and children and forcing them to head to Fort Sumner.[102]

The walk itself was terrible and treacherous. The winter of 1864 was marked by snow drifts and gale-force winds. The Diné, many of whom were without adequate clothing, shelter, or food, were vulnerable to disease and the weather.[103]

Those who made the journey across the desert landscape during the summer were equally miserable because of the elements and the harsh conditions created by Carleton and his men.[104]

In the eyes of United States military officers, marching Indigenous people to Hwéeldi was only half of a two-pronged project. The second goal, for Carleton, was to use the visual of parading conquered Natives during the Long Walk to impress New Mexicans with the campaign's efficacy.[105] In January 1864, Carleton was reeling from negative reports from officials in the Southwest, such as one written by the superintendent of Indian affairs from New Mexico, Michael Steck, who questioned Carleton's ability to support the Diné at Bosque Redondo.[106] Therefore, highly visible maneuvers, such as marching the Diné to Fort Sumner via Fort Union and Santa Fe (trips of 498 and 436 miles, respectively), was a way for Carleton to flaunt his power, control, and determination to see his project through—at the expense of the well-being of the Diné.[107]

For those who survived Carleton's Long Walk, arrival at Hwéeldi only brought new and greater challenges. As historian Gerald Thompson put it, "The problems of providing food, shelter, and clothing overshadowed everything and proved to be even more taxing than the opponents of the policy had predicted."[108] In short, there was little food, no shelter, and no means to support cultural survival for the Diné.

The failures of Bosque Redondo were public and humiliating. After a year of damning reports about General Carleton's ill-prepared reservation in regional news outlets, Santa Fe's *Weekly New Mexican* had enough. In December 1864, the paper issued a shocking editorial, calling General Carleton "Major Pomposo," a glaring insult to his character, and accusing United States Army forces of participating in a contractor's scam in the creation of Fort Sumner in Bosque Redondo.[109]

Images of Bosque Redondo do resemble a contractor's scam: in the main, the camp featured little to no infrastructure for a large group of clearly destitute people (figure 1.1). Carleton estimated that by October 1863, Bosque Redondo held 8,354 people with "3,048 horses, 6,962 sheep, 2,757 goats, and 143 mules" and very few stores.[110] By 1867, the consensus in Washington was that the situation was untenable.[111]

There were various proposals in Washington about how best to address the situation, but most of the salient ones, including those made by General William Tecumseh Sherman and Navajo agent Theodore Dodd, revolved around giving up on Bosque Redondo as a suitable place for the Diné.[112] As Sherman put it, "I found

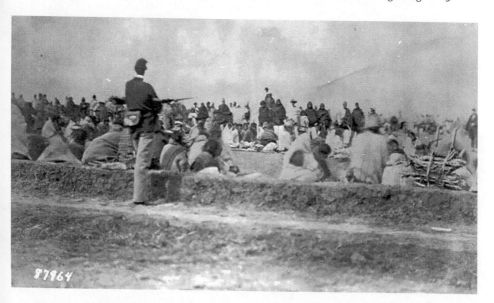

Figure 1.1. Navajo captives under armed guard at Fort Sumner, Bosque Redondo, New Mexico, circa 1864–1868. Anonymous, untitled photograph, n.d. Courtesy of United States Army Signal Corps and the Palace of the Governors Photo Archives, New Mexico History Museum, Santa Fe (NMHM/DCA), Negative No. 028534

the Bosque a mere spot of green grass in the midst of a wild desert, and that the Navajos had sunk into a condition of absolute poverty and despair."[113]

Sherman met with the Diné on May 28, 1868. Barboncito, the Diné spiritual leader, made a public appeal for his people's return to Dinétah. When asked about Bosque Redondo, he said, "Our Grandfathers had no idea of living in any other country except our own and I do not think it is right for us to do so as we were never taught to."[114] After listening to the Diné and examining the conditions at Bosque Redondo, Sherman decided on May 29, 1868, that the Diné would be returned to their homeland. The Treaty between the United States of America and the Navajo Tribe of Indians was proclaimed and signed on August 12, 1868, and by the middle of the following June, many Diné had begun another long walk—this time, back to Dinétah.[115]

Divide and Conquer

Misinformation and Manipulation across Dinétah and Hopituskwa,
1868–1964

Much of what we [the Diné] faced with the Hopi nation was something
created by the federal government. —PETERSON ZAH (DINÉ)

Immediately upon their return to their homeland, the Diné resorted to stock
raiding in order to survive.[1] After years of starvation and internment, Diné
families needed sheep, goats, horses, mules, oxen, and burros to build up their
herds. The Diné did not discriminate when it came to raiding: the animals came
from Hopis and other Puebloans, Utes, Mescaleros, Anglos, and any other stock-
owning individuals who were on the land.[2] Though stock raiding created inter-
tribal instability, letters from US Army officers like Major Charles McClure sug-
gest that the federal government had an interest in downplaying any intertribal
conflict in the region after the Bosque Redondo disaster. As McClure wrote to the
assistant adjutant general for the District of New Mexico, Major William Kobbe,
on February 15, 1870, "Only one or two cases of murder and theft have occurred
which can be traced to [the Diné]."[3] The United States government, which had
just spent a very large amount of money on the Bosque Redondo debacle, had no
interest in spending more money attempting to curtail traditional Diné raiding
practices. The result of Diné herding and raiding was twofold: their stock in-
creased from about four thousand sheep and goats in 1868 to over seventeen thou-
sand sheep and goats in 1870, and the relationships between the Diné and the
Indigenous groups they raided deteriorated.[4]

Rather than support a diplomatic solution to concerns over raiding and land-
ownership, the United States further complicated the questions about land use in
the Four Corners region. President Chester A. Arthur's 1882 executive order stated

that a 2,472,095-acre reservation in the Four Corners region should be set aside "for the use and occupancy of the Moqui [Hopi] and such other Indians as the Secretary of the Interior may see fit to settle thereon."[5] Without any specific reference to the Diné, who were indeed settled on these lands by the federal government after the Long Walk, the 1882 order further complicated the issue of who had a rightful presence on the land. For the Hopi, the fight in the following decades focused on solidifying their exclusive rights to the region, despite the ambiguous language in President Arthur's executive order.

Practically speaking, the 1882 order changed little of day-to-day life for raiders across Dinétah and Hopituskwa. An 1888 letter written by the secretary of the Indian Rights Association, Herbert Welsh, on behalf of the Hopi to William F. Vilas, the secretary of the Department of the Interior, reveals the extent to which the Hopi remained dissatisfied with continued Diné presence on the land. Welsh wrote that the Hopi were concerned with "continual intrusions and depredations of the Navajos, who steal their corn, their melons, their horses, and who in many cases have settled upon their reservation and treat the [Hopi] lands as though they belonged to them."[6] After twenty years of contending with Diné raiding and settlement, the Hopi turned to Washington for assistance.

By then, United States officials were aware of the competition for resources in the area. As historian Robert S. McPherson argued, the 1880s were a time when some Indigenous territory was being overrun by "Mormon and gentile settlers, cattlemen and sheepherders, [as well as] Navajos and Utes."[7] The potential for wide-scale intertribal conflict set off by Diné raiding was a significant threat to the security of the region, especially given the previous decades of social unrest, which resulted from the presence of the Diné and the Hopi in close quarters. Rather than allow such a conflict to occur, Vilas sent troops to remove the Diné from contested lands in December 1888. Once Vilas's troops arrived, however, he considered the harsh weather and the rugged landscape and opted for inaction: another forced removal seemed impossible for the time being.[8] Therefore, competition for resources and fighting over stock raiding continued.

Despite Vilas's decision not to act, United States officials remained concerned about the deteriorating relationship between the Hopi and the Diné. Over the next two years, Washington received more reports of the overlapping land use of the two tribes. It was a conundrum, as Indian commissioner T. J. Morgan noted in 1890. On one hand, the Hopi had more land than they would likely ever need to support the tribe through farming while the Diné suffered from a dearth of land on which to graze livestock. On the other hand, the United States recognized the

land as belonging to the Hopi—despite the fact that it had once been the homeland of the Diné. There was no easy solution.[9]

The Diné population continued to grow and spread onto more lands that the Hopi considered to be theirs, including mesa tops. The situation did not go unnoticed by the federal government. In 1900, Hopi Indian agent Charles Burton reported in protest that the Diné had taken "the best watering places, best farming and best pastureland, and a great deal of trouble grows of this. It should not be tolerated for a day."[10] Yet two factors resulted in continued inaction by officials in Washington, DC. First was the possibility of violence, which might accompany evicting the Diné from their ancestral homelands. Second, the United States government had always anticipated the Hopi would eventually move from the mesa tops to other agricultural environments, and if conflicts over the mesa tops persisted, there was a chance that such conflict could instigate that move.[11]

Some Hopi families did indeed respond to the changing social climate of the Four Corners region by attempting to move away from the contested lands, but there were no better areas available for settlement. Furthermore, Hopi culture is community based, and such relocations could cause significant harm to the families and social structure of those Hopi groups attempting to leave the mesas.[12] Washington was aware of the complicated socioecological factors that prevented wide-scale movement. On November 14, 1901, President Theodore Roosevelt issued an executive order giving the Diné public domain lands along the banks of the Colorado River.[13] By granting the Diné new lands, the federal government hoped to deescalate tensions in the region and satisfy the needs of the growing Diné economy, which was increasingly based on herding.

The challenges that faced Indigenous peoples (including the Diné and the Hopi) in this period were compounded by major structural changes occurring in the United States government. The Indian Service began to be filled with civil service agents rather than appointed officials; changes to the names and roles of the Navajo agencies began winding through the courts; and new but untested regulations regarding Indigenous gambling, child marriage, and trade were making their way through the United States court system.[14] This rapidly changing political and geographic landscape resulted in continued intertribal instability in the early 1900s.

The Fight for the Land

By the first decade of the twentieth century, an army of new United States officials attempted to quantify Indigenous land use to better facilitate federal ad-

ministrative control over Native lands. Congress had two primary interests: first, curbing government spending on Indigenous peoples; and second, finding out more about valuable resources on lands that had been initially granted to Native peoples precisely because they were supposedly worthless. A 1909 US geological survey, though, told a different story, especially of lands occupied by the Diné and the Hopi. The survey, to the horror of United States officials, estimated that there were 8 billion tons of recoverable coal under Black Mesa.[15] With the price of coal rising to $11/ton (about $359/ton in 2023 dollars) in some United States cities in 1909, decision-makers in Washington suddenly developed a keen interest in the welfare and occupancy habits of both the Diné and the Hopi.[16]

Federal reports in the years following the 1909 survey reveal that United States officials were eager to establish a clear understanding of what land from the 1882 reservation remained supposedly unused. Beginning in 1918, Bureau of Indian Affairs superintendents in the Four Corners region made recommendations regarding Indigenous land use that implied that the Diné and Hopi had more land than they needed. The first of these superintendents, Leo Crane, argued that the Hopi only lived on 600 square miles of the lands designated for them and that the existing reservation in the Southwest included a total of 1,600 unused square miles.[17] While Crane's figures did not result in any governmental action restricting tribal land use or reversal of earlier land allocations to the Diné and the Hopi, they set a precedent for reports made by successive Hopi superintendents, which all essentially argued that the Hopi—and, in some cases, the Diné—had more land than they needed. Of the three superintendents who followed Crane, none suggested that the Hopi be allocated more than 1,200 square miles, a significant reduction considering that the 1882 executive order set aside 2.5 million acres (roughly 3,850 square miles) for the Hopi and other Indigenous peoples.[18]

Federal interest in the Four Corners region increased again in 1921, when corporate prospectors found oil in the San Juan area of Dinétah. The Midwest Refining Company had an interest in the oil but no legal way to extract it because an informal council of Diné had no interest in leasing land to the company for oil exploration and drilling.[19] Two years later, Secretary of the Interior Albert Bacon Fall, reasoning that the royalties from gas and mineral leases should benefit *all* Diné, not just those on the impacted land, created a Navajo Tribal Council made up of supporters of mining and extractive enterprise and then declared that their opinion should stand for the interests of the entire tribe.[20]

Fall was an unpopular leader. In fact, as Iverson noted, by the time the first meeting of the Diné tribal council took place in June 1923, he had been forced out

of his position.[21] Still, the federal government chose not to dissolve the puppet Navajo Tribal Council. It is true that some council members' opinions regarding land use and land management reflected the interests of the larger tribe. But in most cases, documents signed by the Navajo Tribal Council approving outside incursions into Dinétah reflected the United States' interests rather than the interests of the Diné.[22]

Throughout the first decades of the twentieth century, United States officials were desperate to quantify Diné and Hopi land use on the reservation for two reasons. First, large numbers of Diné families were settled with their herds on public domain lands in New Mexico and Arizona, effectively costing the United States money.[23] Second, beginning in 1926, members of the Hopi Tribe began appealing directly to Congress to remove the Diné from the 1882 reservation. These appeals were made more complicated by a barrage of dissenting voices, both Indigenous and white, which argued against removal. Hopi Indian agent Leo Crane, for example, had written back in 1918 that the Hopi should not be allowed to eject the Diné. He argued that should the Diné be removed, the land would remain unused as the Hopi would instead take part in "snake dances, basket dances, clown dances, and the 10,000 other displays he uses as an excuse [for] why he should not be on the range."[24] Crane's voice competed with the hundreds of Hopi requests to expand their holdings and remove Diné livestock from contested lands. Publicly, Washington policy makers issued a statement in which they refused the Hopis' requests. Privately, as Crane's correspondence shows, United States officials had very little interest in the well-being of Diné or Hopi individuals.

The debate over joint use of the Four Corners region continued through the Indian New Deal of the 1930s, when the federal government remained extremely interested in promoting Indigenous assimilation. The issue of herding and ranging among the Diné, which had resulted in supposedly unfairly sequestering the Hopi, became the most-discussed issue related to stock ownership in the region. In 1930, the commissioner of Indian affairs, Charles J. Rhoads, asked the superintendent of the Southern Pueblo Agency, Chester E. Faris; special commissioner H. J. Hagerman; Fort Defiance extension agent A. G. Hutton; and field representative H. H. Fiske, among others, to investigate the slow-boiling conflict between the Diné and the Hopi.[25] The reports that Rhoads received were not unified except that many took note of overgrazing on lands set aside for Indigenous use in 1868. But whereas Hutton argued for bolstering tribal herds and against dividing the 1868 reservation, other experts, including Hopi superintendent Edgar Miller, argued for dividing the land between the Diné and the Hopi.[26]

Ultimately, environmental concerns rather than humanitarian concerns precipitated United States intervention in Indigenous lands. A 1929–1930 study on overgrazing showed that in order to arrest the devastating erosion that was making agricultural production on Black Mesa impossible, the Navajo tribe would need to reduce its holdings from 1.3 million sheep units to 400,000 sheep units.[27] This study, and others like it, did not include any discussion of the importance of sheep for the Diné culture and economy. For the Diné, it was as if someone came in and unilaterally decided that half of their livelihood was no longer justified. This study on overgrazing did not find any significant harms related to Hopi livestock ownership.

Perhaps the most influential environmental report during this period was BIA agent William Zeh's land use report of 1930. In his study, Zeh claimed that the Diné overgrazed on shared reservation lands. He estimated that the Diné had "1.3 million sheep and goats living on less than 12 million acres of land."[28] He also noted that horses and cattle, not included in the survey, were likely contributing to further overgrazing. Zeh's report sent shock waves through Washington. Officials rejected his proposal of increasing reservation space and instead opted for a policy of forced stock reduction with an unsubstantiated carrot of potential new lands for the Navajo if they complied with the government's reduction policies.[29]

In 1932, after two years of formal negotiations, federal officials began working on a three-pronged solution to what they characterized as an Indigenous problem. The government's initial goal was to incorporate the dissenting Pueblo voices on First, Second, and Third Mesas to establish a cohesive perspective regarding the persistent Hopi request for an exclusive reservation. Also, Washington began what would be a decades-long policy devoted to controlling Diné and Hopi grazing practices across Dinétah and Hopituskwa. Finally, United States leaders established boundaries in the disputed space through congressional bills in order to control future discussions regarding Hopi and Diné settlements on reservation lands.[30] Commissioner of Indian affairs John Collier (who served in this role from 1933 to 1945) believed the only way to control grazing practices was to severely limit the Diné's ability to own livestock.[31] Collier was shocked by the extent to which livestock had proliferated on the Diné reservation since 1868, when the tribe owned roughly twenty thousand sheep units.[32] For Collier, Diné overgrazing demanded immediate action.

As historian Lawrence C. Kelly argued, John Collier was not a central perpetrator in the development of the Navajo-Hopi Land Dispute. Still, his interventions exacerbated what was already a tenuous situation.[33] He failed to understand

the full impact of United States intervention onto shared lands, and his answer to the problem of environmental degradation worsened the relationship between the Diné and the Hopi. Collier, however, considered his intentions to be positive. He was seeking through his stock reduction proposals to reverse the acute material scarcity on tribal lands. As Collier wrote in his annual report of 1933, "It is clear that the allotment system has not changed the Indians into responsible, self-supporting citizens. . . . We can categorically say that the immediate problem is not that of absorbing the Indians into the white population, but first of all lifting them out of material and spiritual dependency and hopelessness."[34] In this statement, Collier embodied the persona of the paternalistic conqueror and did not deny that assimilation remained the ultimate goal. To the Diné, Collier's plan virtually guaranteed cultural annihilation. To the United States government, Collier's stock reduction proposals sounded like the surest way to guarantee economic relief in the Four Corners region.

Though stock reduction was ultimately the most impactful component of Collier's plan, he also proposed acquiring new lands for ninety thousand landless Indigenous people, creating a credit system that would target the needs of Indigenous people, democratizing the bureaucracy that controlled Indian affairs on the reservation, and limiting boarding schools in favor of day schools.[35] While some of Collier's suggestions were implemented by the federal government (such as investing more money in day schools than boarding schools), Washington dropped his proposal of acquiring and consolidating Indigenous lands in favor of further dividing existing reservation lands. Officials hoped that ranging Indigenous people might be compelled to adapt to sedentary agricultural practices. Collier's proposal for reducing stock to protect the fertility of grazing lands was adopted and taken to an extreme.[36]

The federal government opted for a policy that Peter Iverson characterized as "instant" stock reduction.[37] The plan initially relied on voluntary cooperation but also used Navajo police through the Indian Service to force owners, regardless of the size of their herd, to sell up to half of their stock. This policy unfairly burdened those who owned less than one hundred animals. Furthermore, because Collier's plan assumed voluntary cooperation, the policy was applied unevenly across the reservation, targeting those owners who happened to be in convenient proximity to Indian agents and the Indian Service. The result was wide-scale passive resistance among the Diné, who generally avoided complying with Collier's orders.[38]

This is not to say that the Diné were unaware of the harms of overgrazing.

Indeed, in a 1934 Diné tribal council meeting at Fort Defiance, Arizona, Jim Shirley, an alternate from the southern part of the reservation, said, "We cannot get by, we cannot profit by having livestock when our range is deteriorated. Therefore, we need to develop our soil that we may be able to take care of our livestock, and, therefore, we cannot put the livestock before the land. . . . If we have the land, we have everything."[39] For the Diné, protecting the land was key, and it was also a matter of sovereignty and self-determination: blindly following Collier's policy without regard for the immediate needs of the people would not serve the long-term interests of the tribe.

In the end, Collier's policy was not the success he had hoped for. By the fall of 1935, despite large-scale stock purchases by the federal government, the number of mature sheep, goats, and horses had only fallen by about 175,000. Collier had achieved under 40 percent of his goal.[40] From the perspective of Washington officials, the refusal of the Diné to cooperate and the Indian Service's inability to enforce Collier's policy were problematic. Without stock reduction, there was only a slim chance of the Diné rejecting pastoralism in favor of sedentary farming. The failure of the initial stage of stock reduction implied that Washington's goal of assimilating the Diné was failing.

In desperation, US officials moved to enforce legislation that would decrease the herds of off-reservation Natives throughout the Southwest: the Taylor Grazing Act of 1934. The hope was that overgrazed ranges would recover, and reservation Natives would see the benefits of adhering to stock reduction policies. Although the Taylor Grazing Act gave the federal government power to regulate grazing on public lands and therefore impacted the wealth of off-reservation Hopi and Diné families, it did little if anything to change traditional grazing and herding practices.[41] Furthermore, no quantitative study was ever conducted to examine the experiences of Native people impacted by the Taylor Grazing Act and those who witnessed its enforcement. In the meantime, the quality of the soil in the Southwest continued to deteriorate. By the mid-1930s, Washington officials decided that they needed more information regarding the state of the land on reservations across the United States, and they needed more control over Indigenous land.

One of the first projects assigned to the Soil Conservation Service after it was established in 1935 was to complete a comprehensive study of the environmental and geological state of the Four Corners region in order to more successfully manage water, soil, and livestock.[42] While the Soil Conservation Service's findings were important, the service's most lasting impact was the decision to divide the

Diné and Hopi Reservation into eighteen land management districts, each of which the federal government treated as its own administrative unit. Collier initially wanted to bring the Hopi and Diné together to establish the boundaries for the administrative districts, but when the Hopi refused to participate, he simply told them that he would create the borders for the administrative districts without their input.[43]

In 1936, as a result of the Soil Conservation Service's research and the worsening relationship between the Hopi and their non-Indigenous representatives, Washington policy makers made the first move toward partitioning the reservation between the Diné and the Hopi. The US leaders established an exclusive Hopi grazing area of 499,248 acres centered on Hopi mesas, which was called District 6.[44]

The creation of grazing districts was originally meant to assist the United States government in controlling individual Diné herd sizes based on the carrying capacity of the owner's land.[45] Individual stock owners received permits for their sheep, the number of which was supposed to correspond to government records of stock ownership. The permit system lasted only a year, and it was a fiasco. Owners who had concealed their stock ownership or who had accidentally had their stock counted with those of relatives during the livestock census of 1937 did not receive permits once they were issued in early 1940, and mistakes were commonly made by the issuing authorities. Only one thing was clear in early 1940: there were still enough sheep to damage the land, but far from enough sheep to adequately provide for the material and spiritual needs of the Diné.[46]

Sociologist Floyd Allen Pollock interviewed Diné ranchers in the early and mid-1940s to get their perspective on Collier's stock reduction policies. Despite the prevailing economic logic during the 1930s, which stated that reducing stock would ultimately raise prices and support the market (with the added bonus of forcing Natives' assimilation), the actual impacts of such reduction proved to be disastrous. One Diné woman, recorded as Mrs. J. D., noted in 1940, "Eight years ago we had our sheep and were so happy and we knew we could give our children what they needed. Collier is at the bottom of all our trouble. . . . If Collier came out here on the Reservation today he would be killed, for people feel that he has ruined them, even the morals of our children."[47] Stock reduction meant that many Diné families did not have enough to eat on a daily basis and did not have any way of guaranteeing their children's survival.[48] The cultural and economic harms of the government's stock reduction policies put the survival of the Diné nation at risk. The results were so extreme and so damaging that New Deal agencies began

to fund projects on the reservation to ensure that families would have enough resources to survive.

In an effort to ameliorate some of the financial harms of stock reduction, the United States government employed Diné through the Soil Conservation Service, the Civilian Conservation Corps, and the Indian Service to begin improving existing infrastructure across the reservation.[49] While these efforts provided some economic relief and increased the average Diné household's income, they did not solve the land problem nor the competition for water and resources across shared lands. For the Diné and the Hopi, Washington's approach to land and resource management did not provide significant material benefits. Instead, it changed existing boundaries and continued the intertribal conflicts. The creation of District 6 ultimately failed to solve the problems of acute material scarcity experienced by both tribes.

Through the 1930s and early 1940s, the Hopi continued to petition for the permanent removal of their Diné neighbors. Although federal officials recognized much of the 1882 reservation as ancestral Diné lands and refused to expel the Diné, the Hopi requests worried some members of the US Senate, who anticipated continued intertribal conflict as a result of the two nations sharing limited resources.[50] Still, Washington had little interest in the dispute or in establishing exclusive land rights in the Four Corners region. When oil and gas companies began showing a clear interest in resources under Black Mesa, however, things changed. To access those resources, the companies needed to know who owned the land. Big oil and gas were the true reasons that the United States government embarked on a project to establish which tribe owned the mineral rights to Black Mesa.[51] The government determined in 1946 that the Hopi and the Diné held coextensive rights to the minerals beneath Black Mesa because they shared the land.[52]

From the mid-1940s, the fight for land rights and mineral rights became closely entwined. Though some tribal interests remained centered on grazing and land distribution, Hopi and Diné tribal councils and representatives tended to keep mineral development at the forefront of discussion.[53] Beginning in the early 1950s, the Hopi lawyer John Boyden of Salt Lake City began publicly recorded discussions with the Bureau of Indian Affairs in which he suggested mineral leases as the answer to Hopi financial concerns and disagreements over land use.[54]

As United States government interference in Native land use continued, the Diné economy struggled. Decades of stock reduction programs, erosion, and continued incursions onto Dinétah by energy interests threatened Diné pastoralism.[55]

The economy needed to diversify in order to survive. The problem was that outside of trading posts and railroad work, economic opportunities on the reservation remained exceedingly limited.[56] The situation became critical after World War Two, when returning Diné veterans became, as historian Colleen O'Neill said, an "additional layer of culture brokers."[57] The postwar change in population on the reservation impacted the Diné community in two ways. First, many returning veterans decided that they had a better chance of financial survival off the reservation. Second, those Diné men who remained on the reservation questioned the traditional agricultural practices that had led many members of their extended kin networks into poverty.[58]

The end of World War Two also marked significant changes to the Diné economic landscape on a policy level. In 1945, John Collier was forced out of his position as commissioner, and in 1953, House Concurrent Resolution 108 passed, officially ushering in a termination policy in which, as Bailey and Bailey noted, "all government responsibilities towards Indians as tribal members [ceased]."[59] By the early 1950s, the Bureau of Indian Affairs was offering Indigenous families fifty dollars to relocate to cities off the reservation in an effort to promote assimilation through a reliance on wage labor economies rather than pastoralism.[60]

Indeed, federal policy through the 1950s was, as O'Neill argued, shifting from what Collier called his "cultural pluralist" model to one that was strictly assimilationist in nature. For the Diné who were living off-reservation, the federal standpoint mirrored their quest for economic prosperity through wage labor.[61] Industry was fighting at the same time to make its way onto Diné lands. Coal companies persistently studied the amount of minerals that might be successfully mined from the Four Corners region, and with each study Peabody Coal funded, the estimated amount of coal beneath Black Mesa grew. By the late 1960s, the Arizona Bureau of Mines estimated that Black Mesa likely held more than 20 billion tons of high-grade, low-sulfur coal rather than the 8 billion tons originally estimated in 1909.[62]

Dispute in the Courts

Many of the political cartoons discussed in the following chapters center on issues of intertribal relations, colonialism, resource extraction, and stock reduction. A significant number of the cartoons also explicitly reference court battles over tribal land rights and landownership. For both the Diné and the Hopi, United States legal interventions highlighted the inherent injustice in the allocation of land and the administration of Hopituskwa and Dinétah. *Healing v. Jones*, the 1962

decision that lit the fuse for the fight that led to the partition of the reservation in 1974, is crucial to understanding the Navajo-Hopi Land Dispute.

The shifting economic patterns of the 1950s and 1960s were extremely threatening for the Diné who were fighting to adhere to their traditional ways of life. Both the Hopi and the Diné struggled as a result of federal intervention and sometimes blamed each other for their economic hardship. Diné tribal chairman Peterson Zah remembered the 1960s and 1970s as a time when both tribes were "going after each other."[63] However, Zah was careful to note two other things that are important when studying this dispute. First, the dispute had a life-span of over a hundred years, stretching before and after the 1974 partition agreement. He also noted that the dispute originated not with an intertribal conflict but with the federal government.[64] Though the Diné and Hopi initially looked to the United States judicial system to solve the dispute, it became clear by 1962 that further government and corporate interventions would only deepen existing intertribal disagreements.

The first major court case over tribal land use on the 1882 reservation took place in Prescott, Arizona, in 1960. The Hopi instigated this legal action because the Diné population and herd growth was increasingly encroaching on traditional Hopi tribal space. In their 1960 complaint, the Hopi claimed that the entirety of the 1882 reservation should belong to them. They cited President Chester Arthur's executive order and argued that Hopi land was being overrun by the Diné and their herds of sheep, goats, and horses. The Diné countered that the Hopi had a right to District 6, which amounted to about 20 percent of the 1882 reservation, but the Diné should have direct and sole ownership over all of the other lands.[65]

A United States district court reached a decision in *Healing v. Jones* on September 28, 1962.[66] In *Healing*, the court awarded all of the grazing area known as District 6 to the Hopi, while the remaining land was to be shared as a Joint-Use Area between the Diné and the Hopi.[67] *Healing v. Jones* was supposed to resolve the Navajo-Hopi Land Dispute. Instead, intertribal conflicts intensified. The Hopi considered their 911,000-acre partition area to be woefully inadequate for meeting their needs.[68] The Diné remained convinced that energy interests would continue to pursue partitioning the Joint-Use Area and believed that corporate investment in Black Mesa and white involvement in issues of Native land claims were putting Diné interests third—after the interests of US corporations and the Hopi.[69]

Many Hopi leaders, however, also had a contentious relationship with the federal government. Wayne Sekaquaptewa, later the publisher of the Hopi newspaper

Qua'Töqti, noted that the primary interest of the United States government was to "keep us in our 'primitive' state and display us to the world as some primeval culture out of the past."[70] Sekaquaptewa, like many other Indigenous people, was well aware of the hardships caused by repeated incursions into Indigenous sovereign space. The United States had a history of assimilationist politics, but in the 1960s that goal was secondary to the goal of conquering space and utilizing natural resources.

Many Hopi and Diné people's concern about the resources on reservation lands intensified after the creation of WEST (Western Energy Supply and Transmission Associates) in 1964. This utility coalition had the backing of many municipalities and Los Angeles Department of Water and Power representative James Mulloy. Mulloy referred to WEST's mandate as the "Grand Plan." The idea was to boost United States energy output by creating a network of nuclear plants in California and coal-fired plants across the Four Corners region. The members of WEST hoped to complete this vision by 1985, working with United States legislators to ensure that municipal power authorities took advantage of every possible avenue for resource extraction in the Southwest.[71]

The Indigenous fight to protect resources on reservations throughout the 1960s and 1970s was complicated by the long history of Native people working with white energy interests. In fact, when asked about the motivations of outside energy interests and the federal government in 1956, Navajo tribal chairman Paul Jones had stated, "We believe they and most of their personnel are sincerely devoted to the solution of problems."[72] The Hopi Tribal Council had operated under the legal advice of John Boyden, often approving extractive enterprises supported by non-Indigenous leadership.[73] Yet by the mid-1960s, the tide was turning. Many Indigenous leaders, traditional and otherwise, disapproved of expanded resource extraction on protected lands and were willing to publicly advocate on behalf of their tribe. As the cartoons penned by both Diné and Hopi artists show, many Indigenous leaders considered the collusion between energy interests and the federal government to be yet another attempt by the United States to engage in economic colonization by stripping both the Diné and the Hopi of their land, sovereignty, and power.

Indigenous publications and print culture beginning in 1973 revealed the complicated relationship between the Hopi and the Diné. Their editorial cartoons clearly portrayed the intricacies of intertribal relationships, the importance of humor in political interventions, and an understanding of the continued colonialism across Hopituskwa and Dinétah.

Fourth World Activism

Editorial Cartoons in the Navajo Times *and* Qua'Töqti, *1964–1973*

> The Hopis and the Navajos cannot be expected to resolve the situation between themselves when it is a problem created by the Federal Government, an external force whose lack of regard for upholding its own constitutional standards has brought about this conflict.
>
> —STAFF, QUA'TÖQTI

H ope was in short supply across Dinétah and Hopituskwa in the years leading up to and immediately following *Healing v. Jones* (1962).[1] *Healing* threatened Diné and Hopi mineral rights and tribal sovereignty. Throughout the litigation, Hopi and Diné activists attempted to legally claim the land they believed to be rightfully and traditionally theirs. Peter Iverson characterized this litigious period as one of intensified dissension between the Hopi and the Diné.[2] The increasingly impassioned intertribal competition for recognition, land, and resources led to a new period of activism and discourse in Hopi and Diné newspapers and other print media. This period also set the stage for renewed conflict between both tribes and the United States government and spurred a positive reformulation of the relationship between the Diné and the Hopi.

From 1964 to 1973, editorial cartoons in the *Navajo Times* and *Qua'Töqti* emphasized sovereignty, the legal history of the conflict, the identities of those responsible for the land dispute, Indigenous beliefs and ideology, and the projected future for Diné and Hopi people on the land. The *Navajo Times*, in particular, relied on editorial images to contest the newly constructed boundaries of the Diné reservation. By centering the conversation on these themes, Diné and Hopi newspapers refocused the dialogue surrounding the dispute on issues that were most important to the Diné and the Hopi, the people directly impacted by the conflict. Concerns regarding corporate control, resource extraction, United States political maneuvering, and intertribal differences were also important parts of the dis-

cussion in Indigenous spaces but tended to be explored within the confines of the five main themes mentioned above. Ultimately, the messages in these cartoons challenged the motives for United States government encroachment on Hopi and Diné sovereign spaces.

Raymond Nakai and Radical Changes for Dinétah

When Raymond Nakai gave his inaugural address as the Navajo tribal chairman in 1963, his audience was ready for times to change. Nakai was a newcomer to tribal politics and from a humble background. Still, as the *Arizona Republic* reported, the Diné believed that "he speaks for the Navajos."[3] The election had proved this to be true: he defeated the incumbent tribal chairman, Paul Jones, and the college-educated former code talker Sam Billison by nearly 1,900 votes.[4]

As soon as Nakai took office, he suggested radical changes to the Navajo Nation. He proposed a written constitution with a bill of rights that would guarantee freedom of speech, association, and religion.[5] He asked the Diné to bolster the permanent tribal scholarship fund, to increase on-reservation employment, and to establish a Navajo chamber of commerce. Perhaps most important, he made his people a promise. He said, "I shall never voluntarily surrender the ancient sovereignty of the Navajo people, or barter it away bit by bit, to private interests or other governments."[6] Nakai, in one elegant sentence, put the Hopi, Diné lawyers, United States officials, and Peabody Energy on notice.

For the Diné, Nakai's intention to protect tribal sovereignty was especially significant after the disappointment of the *Healing v. Jones* decision. The media had led many Diné to expect an unqualified win. Former chairman Jones had even released a statement to the *Navajo Times* stating that the legal team of Norman Littel, Joseph McPherson, and Edward Plummer had made their Hopi competition look "ridiculous."[7] Yet in the decision, the court failed to come to a pro-Diné judgment. While recognizing the Diné and Hopi history of joint occupancy, the court maintained, "It will now be for the two tribes and the Government officials to determine whether, with these basic issues [of use and occupancy] resolved, the area lying outside District 6 can and should be fairly administered as a joint reservation. If this proves impracticable or undesirable, any future effort to partition the jointly-held area, by agreement, subsequently authorized suit, or otherwise, will be aided by the determination in this action of the present legal rights and interests of the respective tribes."[8] *Healing* solved virtually none of the problems foundational to the ongoing Diné-Hopi conflict. Perhaps even worse, the

decision did little to provide any assurances that the Diné and the Hopi might be able to protect their ways of life and their traditional use of grazing lands.

The Diné took an activist approach to the court's decision. The *Navajo Times*, through the audacious interpreter and cartoonist Clare M. Thompson Sr., published a series of images lampooning the *Healing* decision, the United States government, the Hopi, and the conditions brought about by the Navajo-Hopi Land Dispute.[9] These pieces of artistic political commentary initiated a rich intertribal discourse that lasted for years and consistently emphasized Diné-Hopi relations.

The Conversation Begins

Clare Thompson, who signed his cartoons "Tom-Tom," made use of polysemic images, which are representations constructed (and, in some cases, clearly labeled) to convey multiple meanings to the reader. This tactic helped Thompson to create editorial cartoons that told multiple stories with the main figures often inhabiting shifting and flexible landscapes. In figure 3.1, Thompson creates a landscape that he would often repeat and reenvision in later cartoons. He portrays the instability of reservation space through uneven lines and a ragged horizon. The straightest line in figure 3.1 is the one separating District 6 from the executive order area. The land is depicted as bordered and bound and is home to livestock, a Hopi man, a Diné man, lawyers (one depicted as a dog, the other as a coyote), and tribal councils (rendered for the Diné as a horse and the Hopi as a mule). Thompson constructs every detail in this image to stand for a particular purpose; even the labels that define the Diné man, the Hopi mule, and the Diné horse hold messages. Drawn to resemble price tags, they imply that the Diné Districts 3, 4, 5, 7, and 8 and both tribal councils were all for sale in 1964.

The two primary characters in this cartoon are the men representing Hopi traditionalists and the Diné land districts themselves. They seem to have an affinity for one another that transcends the boundary of the executive order land and District 6. The two men grasp each other's hands in apparent friendship and approach each other with smiles. Thompson accentuates tribal differences by dressing the Hopi and Diné men in divergent clothing and jewelry. And yet the goodwill between them—even in the face of variations in worldly wealth and landownership—is front and center, commanding the viewer's immediate attention.

Despite the apparent friendship between the Hopi and Diné men in figure 3.1, the true message revolves around intertribal discord. By labeling the man in District 6 as a "Hopi Traditionalist," Thompson indicates that there is another rela-

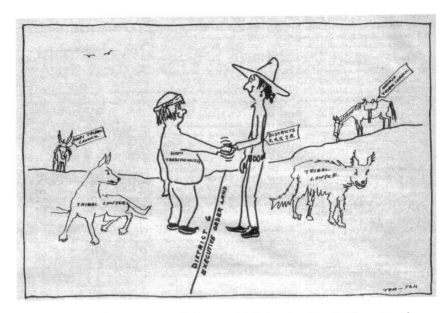

Figure 3.1. Clare Thompson, untitled pen-and-ink drawing, *Navajo Times*, March 19, 1964, 4. Courtesy of Sequoyah National Research Center, University of Arkansas at Little Rock

tionship that warrants consideration here: the relationship between the Diné and the group that white scholars have labeled Hopi "Progressives." Traditionalists (Ayiave leaders) in the Hopi community tended to be opposed to the tribal council in their approach and politics, while Progressive leaders tended to support the council.[10] These were not the only two factions in Hopi society, but they were arguably the most powerful groups at the time of this cartoon's publication. As anthropologist Bruce A. Cox noted in 1970, "What the [Hopi] Progressives stand for, then, is generally what the Traditionalists oppose: oil exploration, roads, land claim suits, and installation of utility lines in the villages."[11] By obfuscating the identity of the Progressives in the figure of the mule (on far left), Thompson juxtaposes the humanity of the Traditionalists' approach with what he considered to be a less favorable response to intertribal conflict.

The Hopi themselves likely would have also depicted strong differences between the Traditionalists and the Progressives. As anthropologist Justin Richland argued, "Hopis have always been deeply engaged in diagnosing the epistemological lines and limits between each other, relying on complexities of relatedness

(*wiwta*: 'connections') and tradition (*navoti*: 'teachings') to do so in ways that come to give Hopi knowledge the form of property."[12]

Euro-American attention and motives were another dividing line between the Traditionalist and Progressive perspectives. The division is so strong in figure 3.1 that the perspectives are rendered as different species. Yet, most important, the two perspectives are shown as connected. Despite the continuing conflict over land and intertribal volatility, the cartoon emphasizes that there remained a strong bond between the Diné and the Hopi.

Of course, as Cox noted, intertribal friendliness was predicated in part on a shared conception of what Hopi Traditionalists and the Diné considered to be appropriate land use and management. Thompson's cartoon reveals that the division of the land itself, tribal lawyers' interests, and both tribes' use of livestock increasingly threatened this peace. Thompson depicts the Hopi tribal lawyer as a fierce, well-groomed, muscular dog. In contrast, the Diné tribal lawyer is shown as a ragged, hungry, neglected animal. This likely reflected, in part, the struggle that the Diné had in the 1960s in removing one prominent white lawyer, Norman Littel, from his position on the Diné political stage, despite the tribe's overwhelming desire to fire him.[13] Littel, in his disbelief and embarrassment, likely embodied the ragged desperation of the Diné coyote depicted in this cartoon.

A lawyer who had been comfortable in the fact that he had a long history representing the Diné when Raymond Nakai took office in 1963, Littel had cast what historian Peter Iverson characterized as a "long shadow" over the Diné tribal council, administrative proceedings, and any legal decisions the tribe made. It was not only Diné leaders who questioned Littel's integrity. In January 1964, regional newspapers reported that the secretary of the interior and trustee for the Diné, Stewart L. Udall, had suspended Littel's contract with the tribe over questionable "special fees" Littel had charged for handling Indigenous claims cases.[14] For the Diné, a group with limited resources and a long history of difficulties in their relationship with the United States government, Littel was at best a questionable ally.

Nakai agreed with Udall that Littel needed to depart, but Littel claimed to be blindsided by Nakai's and Udall's stance against him. As the *Salt Lake Tribune* reported, Littel considered himself to be a champion of the Diné.[15] He was hurt and offended by Nakai's efforts to remove him from his position. Thus, Littel lashed out at every opportunity in a vain attempt to preserve his professional position—and the benefits that came from representing a tribe that held valuable oil and

natural gas leases.[16] These leases were foundational to the Nakai-Udall-Littel conflict. In November 1964, the *Pittsburgh Press* characterized the feud as part of a larger "battle over what could be the richest untapped oil land in the U.S."[17] By removing Littel, the Diné hoped to find legal representation that would act in their best interests in issues of sovereignty, land, and the brewing intertribal dispute.

By emphasizing space, borders, resources, and political actors, figure 3.1 foreshadowed the consequences of forced land division. Land and mineral leases, forced stock reductions, and contentious relationships with legal representatives and politicians resulted in extreme hardship for many Native peoples throughout the late 1960s. Peabody Energy, well aware in 1964 of the value of the minerals beneath Black Mesa, was still two years away from obtaining the hundred square miles of strip-mining leaseholds that it would use in the following decades.[18] Still, as the presence of the tribal lawyers in figure 3.1 suggests, even short-term leases seemed to line the pockets of white lawyers at the expense of Indigenous social cohesion.[19]

For the Diné, daily hardship stretched back to stock reduction initiatives from the early twentieth century. Even initiatives that had no proverbial teeth, such as the 1928 federal order that levied a fifteen-cent-per-head tax on Diné herds of more than a thousand, reflected the federal government's move toward limiting household income for many Diné families.[20] Robert McPherson argued that the 1960s and 1970s were a time when "material visions of wealth" inspired action among Indigenous communities in the Southwest.[21] In this case, "visions of wealth" meant using the land to support growing herds and having the resources to do so in a traditional manner. This was the goal for the Diné and Hopi of the Four Corners region.

In 1964, the issue of dividing the Joint-Use Area was a multipronged question for the Diné. Many remained concerned about sharing land with the Hopi. But as the cartoon in figure 3.1 depicts, there was no expectation of Diné-Hopi animosity. The broader question had to do with both groups needing to protect their tribal sovereignty—and the Diné fear that they would be forced to implement further stock reductions. McPherson characterized this anxiety as spatial, citing the different needs and experiences of Diné individuals living at "the core" (Window Rock) and "the periphery" (rural tribal spaces).[22] In 1964, the Diné and the Hopi were aware of the fight for their sovereignty and their survival. Yet they remained willing to reach across the boundary of District 6 and the executive order area to shake hands.

In April 1966, intertribal relationships deteriorated as United States officials

began the first forced relocations of Diné families living in District 6. Though the US Supreme Court had affirmed in 1962 that the Hopi had exclusive rights to District 6, many Diné did not recognize the authority of the Supreme Court to legislate on Indigenous land. Therefore, many did not move from space that they considered to be historically and traditionally Diné. As a result, the Hopi appealed to the assistant secretary of the interior for public land management, Harry R. Anderson, and the superintendent of the Hopi Agency, Clyde W. Pensoneau. As the *Arizona Republic* reported on April 5, 1966, "Assistant Secretary Harry R. Anderson told Clyde Pensoneau, superintendent of the Hopi Agency at Keams Canyon, to serve eviction notices on the Navajo squatters. He said he was acting at the request of the Hopi Tribal Council."[23] For the Diné, the United States government's willingness to protect the Hopi at the expense of the well-being of the Navajo was a significant betrayal. The polysemic images in figure 3.2 underscore the injustice the Diné felt as they fought forced removal.

The Diné's right to own property and reside on Dinétah remained at the center of Diné representations of the land dispute throughout the 1960s. In figure 3.2, a figure labeled "C. Pensoneau, B.I.A." drags a Diné family toward the District 6 line, away from a figure labeled "H. R. Anderson," who holds a whip labeled "Secretary of Interior" while frowning at the desperate family. The caption reads, "Hopi Lands: Another trail of tears?," suggesting that the Diné understood that forced relocation was another way for the federal government to access valuable natural resources at the expense of Diné survival.[24] It also implies that the United States government's interest in the disputed land would likely transcend their allegiance to the Hopi, and it would ultimately champion white-owned interests (in this case, the extraction of valuable minerals on the land). Thompson's editorial image suggests that the federal government's ultimate goal was to empty the coal-laden land of all Hopi and Diné people.

Nunna Daul Tsuny (Trail Where They Cried) is the Cherokee term for what English speakers call the Trail of Tears. Following the Indian Removal Act of 1830, more than forty tribes were forced on arduous journeys from their homes to reservations in the West.[25] The journey alone was perilous. The severe weather, food shortages, lack of shelter, attacks by United States soldiers, and rampant spread of disease made it deadly for thousands. Historian Russel Thornton estimated that for the Cherokee, the journey resulted in somewhere between four thousand and eight thousand deaths and that "more than 10,000 additional Cherokees would have been alive from the period 1835–1840 had the Cherokee removal not occurred."[26] Cartoonist Clare Thompson, by referencing this atrocity, conveyed that

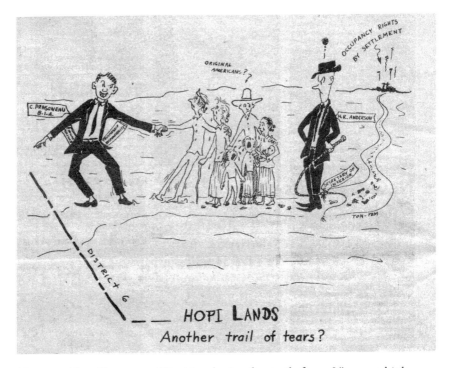

Figure 3.2. Clare Thompson, "Hopi Lands: Another trail of tears?," pen-and-ink drawing, *Navajo Times*, April 21, 1966, 18. Courtesy of Sequoyah National Research Center, University of Arkansas at Little Rock

mass death was also likely to attend any forced removal of Indigenous people. It was not, for the Diné, only grazing land that was at stake. Their lives were at stake as well.

Suggesting that impending removal would be akin to the Trail of Tears also implied that the Diné were aware of the rhetoric used to justify the Nunna daul Tsuny. Indeed, President Andrew Jackson, when defending his policy, stated that "under the protection of the Government and through the influence of good counsels, [the removal would help the Cherokee] cast off their savage habits and become an interesting, civilized, and Christian community."[27] For the Cherokee, that meant losing their culture, their religion, their identity, and their sovereign right to govern themselves. The Diné, as this cartoon reveals, understood the same "civilizing project" to be at play in the contest over land and resources across Dinétah and Hopituskwa. They also knew that Native peoples were not likely to benefit from any white initiatives aimed at instigating yet another forced removal.

The question posed at the center-top of figure 3.2, "Original Americans?," is connected to the idea that removal and assimilation could make Indigenous people "more American." Thompson's final statement, which hovers over a coal plant in the upper right-hand corner of the cartoon, reads "Occupancy Rights by Settlement." These captions suggest that the Diné believed the United States to be manipulating its connections with the Hopi in order to remove them from Dinétah, continuing the federal government's long tradition of forcibly removing Indigenous people from their homelands. Furthermore, the captions imply that US officials could claim Diné land and the valuable resources on it based on the area's apparent vacancy. The depiction of the United States government manipulating Indigenous occupancy on protected lands in order to extract minerals is an early representation of what environmental historian Traci Brynne Voyles termed "wastelanding."[28]

Voyles defined wastelanding as a two-step process: first, "the assumption that nonwhite lands are valueless, or valuable only for what can be mined from beneath them, and [second,] the subsequent devastation of those very environs by polluting industries."[29] This unpalatable undertaking invites secrecy, yet the messages in figure 3.2 show that the Diné were aware of the process as it was unfolding. Thompson's cartoon reminds the viewer of his people's long-term habitation in the Four Corners region while the depiction of the Diné in tears suggests their emotional and spiritual connection to Dinétah.

Finally, the trail of coal and the threat of Anderson's whip evoke the violence inherent in another forced removal. Indeed, the brutality of the Long Walk, in which soldiers forced the Diné from their homes and many died, was horrifying. For the Diné, whose culture preserves many traumatic memories of United States interference, the whip-bearing US official in the April 21, 1966, cartoon would have evoked strong memories of just how far the federal government had historically been willing to go to obtain valuable resources from Diné lands.

Coal, perhaps the most understated character in figure 3.2, was one of the most important. In this early cartoon, Thompson set the stage for what became a long-running discussion of the intersections among energy interests, United States politicians, and forced removal. It was well known by 1966 that coal was plentiful on Black Mesa. In fact, the promise of Arizona coal had been central to the imagination of US political figures since 1909, as discussed in previous chapters.[30] The question of how to reach the vast deposits of valuable low-sulfur, soft-bituminous coal had long remained unanswered.[31] By the 1960s, technology had improved enough to provide a fiscally promising if environmentally devastating answer to

the question of how the United States could profit from the subterranean coal under Dinétah and Hopituskwa: strip-mining.

There was one problem, however, with the strip-mining solution: Diné and Hopi people still lived on the land in question. Peabody Energy needed them to vacate the land in order to strip-mine Black Mesa. Author Emily Benedek in her research was careful to ward off any conspiracy: she argued that there is no evidence of coal companies engaging directly in the removal of Indigenous people from Black Mesa.[32] Despite the lack of a smoking gun pointing to Peabody's culpability, energy interests were very important to the political careers of Arizona and New Mexico politicians, as was the promise of wealth from the hard-to-reach coal deposits. As figure 3.2 suggests, energy interests and the lure of millions of dollars contributed to the wastelanding on Black Mesa that began in the 1960s.[33]

Overall, the April 21, 1966, cartoon presents the Diné understanding of the intersection between Indigenous sovereignty and mineral leasing on (supposedly) protected lands. The Pensoneau character dragging the Diné off their land suggests that Thompson was well versed in the strong connection between the Hopi Tribal Council and mineral leases on Hopi lands.[34] The villains here are not the Hopi or the Diné. Rather, the greedy men working for the secretary of the interior and the BIA are to blame for the forced removal and relocation of Diné families. The fight, just ramping up in 1966, was about sovereignty and broken promises but also about survival. The Diné knew that they were under attack from multiple angles and that unless something drastically changed, their homeland was at risk of being destroyed.

For the Diné, there was a significant disconnect between the real dangers they faced in the 1960s and the stated American Indian policy of the United States government. In 1968, President Lyndon B. Johnson publicly established a new policy of self-determination: "I propose, in short, a policy of maximum choice for the American Indian: a policy expressed in programs of self-help, self-development, self-determination."[35] This rhetoric promised the dawn of an era in which the United States honored Indigenous sovereignty. But despite Johnson's stated aim, US officials continued to support resource extraction, white political interests, and potential forced removal for the people of Dinétah and Hopituskwa.

By March 1969, the situation in the Joint-Use Area was increasingly dire. Cartoons in the *Navajo Times* became even stronger in their condemnation of outside interference in Indigenous affairs, and Thompson began explicitly discussing the legal limits to tribal sovereignty and the abuse of Diné interests by their non-Indigenous supposed allies. In figure 3.3, titled "The Rainbow Is Now Broken!,"

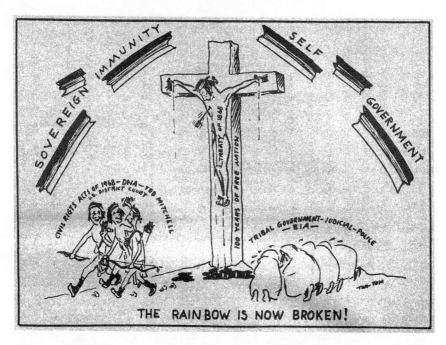

Figure 3.3. Clare Thompson, "The Rainbow Is Now Broken!," pen-and-ink drawing. *Navajo Times*, March 6, 1969, 4. Courtesy of Sequoyah National Research Center, University of Arkansas at Little Rock

Thompson uses a Diné and Hopi prophecy to highlight the tragedy of United States interference on Dinétah.

According to Diné and Hopi cosmology, the Whirling Rainbow Prophecy promises a positive future in the face of hardship. The prophecy says that during this time, "a new tribe of people shall come unto the Earth from many colors, classes, creeds, and who by their actions and deeds shall make the Earth green again. They will be known as the warriors of the rainbow."[36] This prophecy and variations on it are shared by the Diné, the Hopi, the Cree, and other tribes.[37] The Whirling Rainbow Prophecy is a unifying proclamation that promises spiritual deliverance during a future, as a Cree woman foretold, when "the earth [would be] ravaged and polluted . . . the birds would fall from the air, the waters would be blackened, the fish [would be] poisoned in the streams, and the trees would no longer be, mankind as we would know it would all but cease to exist."[38] In the face of this destruction, the rainbow and the Whirling Rainbow Woman will bring hope and renewal, a new life for an endangered world.

By invoking this prophecy, Thompson explicitly recognizes that the conditions of destruction foretold in the distant past are now an immediate threat. Furthermore, the figures in the lower left-hand corner of the cartoon (labeled, among other descriptors, as "US District Court") are drawn as individuals who could have ensured the fulfillment of the prophecy but instead destroyed the potential for unity and rebirth and are allowing the destruction of many of the natural resources across Dinétah and Hopituskwa. Last, while the conditions for the prophecy have not been fulfilled, the destruction of the rainbow also references the destruction of Indigenous worldviews, which traditionally bound Diné and Hopi communities together.

Ever a master of polysemic images, Thompson also uses the rainbow to point out the negative impact of the United States' sovereign immunity on tribal governments. Thompson's cartoon shows that the United States' ability to act with impunity in protected spaces has destroyed the Diné government's capacity to effectively support traditional spiritual practices or even allow individuals the freedom to perform everyday tasks on Dinétah. As an article in the *Harvard Law Review* noted the year before this cartoon was published, "The BIA possesses final authority over most tribal actions as well as over many decisions made by Indians as individuals. BIA approval is required, for example, when a tribe enters into a contract, expends money, or amends its constitution." The article went on: "Although the normal expectation in American society is that a private individual or group may do anything unless it is specifically prohibited by the government, it might be said that the normal expectation on the reservation is that the Indians may not do anything unless it is specifically permitted by the government."[39] In 1968 and 1969, extensive legal constrictions on Indigenous sovereignty created a less than hopeful atmosphere across Dinétah about resolving the land dispute.

Complicating the problem of the limited legal agency for Native people, as figure 3.3 suggests, was Ted R. Mitchell, a Harvard-educated attorney working as a Legal Aid provider for the Diné. (Mitchell is one of the three celebratory figures in the lower left-hand corner of the cartoon.) Mitchell, with his Mormon background and newcomer status on the reservation, was not the ideal figure in the eyes of many Diné to be heading Dinébe'iina Nahiilna be Agaditahe (DNA), the reservation-based Legal Aid program funded by President Johnson's War on Poverty initiatives.[40] In 1967–1968, the DNA began working with heirs of land allotments in Tuba City—proving that Mitchell was ready and willing to begin negotiating land settlements on behalf of the Diné.[41] As the cartoon clearly shows, at least some Diné did not fully trust Mitchell.

The power of the March 6, 1969, cartoon rests in large part on the characterization of the 1868 treaty as Christ. The arrow in the chest of the Christ figure shows that Thompson perceived the benefits of the treaty—the ability for the Diné and the Hopi to engage in self-government and reside on lands set aside for their perpetual use—to be nullified by United States officials acting as administrative agents for legal processes concerned with reservation spaces. The cross, which is labeled "100 Years of Free Nation," shows that the autonomy of all Indigenous peoples, in the eyes of the Diné, was threatened by United States legislation—such as the Indian Civil Rights Act of 1968—which took power away from Native people and placed it squarely in the hands of United States government officials.[42]

The Indian Civil Rights Act was especially problematic for the Hopi and Diné because—despite Lyndon Johnson's expansive public rhetoric supporting Indigenous self-determination—it allowed federal courts to intervene in intratribal disputes, which had been previously prohibited.[43] For the Diné, this significantly reduced their already-compromised tribal government's power and the power of Navajo law enforcement officials to establish authority on tribal lands. Furthermore, it meant that Washington no longer had to mask any vested interest it might have in playing up the conflict between the Diné and the Hopi; US jurisprudence had significantly shifted, granting politicians the authorization to act in a much broader capacity across Dinétah and Hopituskwa. Prior to 1968, the power to resolve intratribal conflicts had rested with the tribes themselves. Despite problematic interventions by the federal government, tribal elders and tribal governments had retained sovereignty. But now, intratribal disputes became an opportunity for United States officials to gain control over Indigenous lands and supersede the power of tribal governments. Suddenly, creating or intensifying fissures within the Diné and Hopi tribes became beneficial for United States officials, who could use the "intratribal" characterization of any dispute as a justification for intervention.

Limitations on Natives' power and authority following the passage of the Indian Civil Rights Act of 1968 were so extreme that in the eyes of the Diné, there was a risk of eliminating their legal presence on Dinétah altogether. In the November 11, 1971, *Navajo Times* cartoon titled "Navajo Nation: Ariz.–New Mex.–Utah," Clare Thompson depicts Black Mesa as completely overrun by mining interests and *bilagáana* laws. The left side of the background in the image is entirely occupied by abbreviations corresponding to neighboring states' energy interests, and Black Mesa itself is overshadowed on the right side of the cartoon by Peabody Energy's four major smokestacks, which shoot pollution deep into the sky. Thompson presents corporate interests and state interests as opposing forces

closing in on the foreground, where the legal advocacy group for the Diné (DNA) cowers behind a western figure threatening a Total Gas & Electric (TG&E) representative with a sign noting "Go'n sue you. Get!"

The absence of Indigenous figures in the cartoon emphasizes the extent to which the dispute had become largely about the extractive potential of the land. This cartoon challenges the interpretations of the dispute that emphasize intertribal enmity as a root cause. As figure 3.4 shows, for the Diné and Hopi inhabitants of the land, concerns regarding sovereignty remained paramount. Furthermore, the position that the DNA holds in the cartoon—significantly lower and less prominent than the figure wielding the *real* legal threat—shows that tribal interests, in the eyes of Thompson, were subordinated to coal interests on nearly every level.[44]

Political and living conditions were chaotic for many Diné and Hopi on Black Mesa during the late 1960s. As the cartoon insists, Diné and Hopi individuals were living in a globalized world and yet were fighting for basic rights of self-governance. By calling out state interests of Nevada, California, Utah, and other locales and by presenting the threat of a lawsuit as akin to a western-style threat of assassination, Thompson recreates the ideological cacophony that surrounded members of the Diné tribal nation. And while the bullying and negotiating occurred in the supposed name of fairness and justice for all Natives, coal plants continued to operate on leases negotiated only with the Hopi, polluting the land, poisoning the water, and contaminating the air. As figure 3.4 shows, in the tumult and confusion of all the competing interests, the Diné themselves were nowhere to be found.

The federal government became a significant character in both Diné and Hopi political cartoons in the years leading up to 1974. In figure 3.5, published on January 29, 1970, Thompson emphasizes the importance of Washington, DC, Congress, the BIA area office, the secretary of the interior, and the Indian commissioner in resolving the conflict. In this cartoon, the Capitol building is the goal at the end of a footrace and has been situated on top of Black Mesa, leaving the viewer with no question as to the importance of coal and the role of Congress in the dispute. Furthermore, runners, some wearing cowboy hats, are burdened with scrolls of evidence and briefcases, and they carry a banner that proclaims their primary interest: the "Hopi-Land Dispute." The implication is that those carrying the banner consider all of the land in question to be Hopi land rather than as space shared between the two tribes. That banner also indicts the relative friendliness

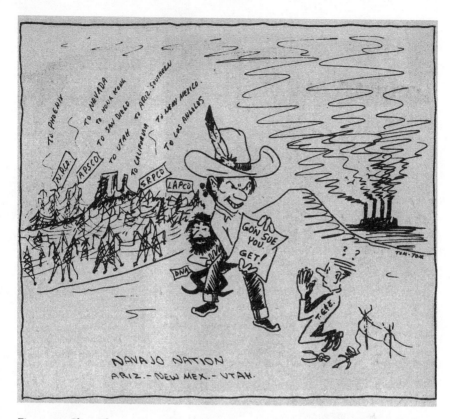

Figure 3.4. Clare Thompson, "Navajo Nation: Ariz.–New Mex.–Utah," pen-and-ink drawing, *Navajo Times*, November 11, 1971, 18. Courtesy of Sequoyah National Research Center, University of Arkansas at Little Rock

of the Hopi toward corporate mining and governmental interests, which the artist links to increased intervention in the Four Corners region.

By 1970, it was clear that the potential for expansive coal mining on Black Mesa was at the heart of the dispute. Still, few knew Peabody Energy had legally obtained leases for mining on eighteen thousand acres of Black Mesa; both Peabody's plans and the extent of the expected damage to the land remained unknown to the public at the time.[45] In 1970, all the Diné knew was that the Black Mesa mine was slurrying coal to the Mohave Generating Station via a 273-mile pipeline, and the owners needed increasing amounts of land, resources, and money to make the operation financially viable in the long term.[46] For the Diné, as figure 3.6

Figure 3.5. Clare Thompson, untitled pen-and-ink drawing, *Navajo Times,* January 29, 1970, 5. Courtesy of Sequoyah National Research Center, University of Arkansas at Little Rock

suggests, it had become clear that although the tribe received money from the mineral leases, the company's real interest was in claiming what land remained in the name of future corporate profits and the ever-expanding energy needs of the United States. The race was on—and it was trampling the sovereign rights of two tribal nations that, without corporate and federal interference, might have been able to resolve their differences more easily.

As fraught as the political fighting was in 1970, the situation worsened in the coming years. The cartoon titled "What Next?" (figure 3.6) reveals that the Diné were concerned with the legal trajectory of the land dispute by early 1972. In Diné eyes, United States jurisprudence had exacerbated the harms of intertribal conflict. This cartoon argues that the United States' legal efforts to control Indigenous actions had failed to address the root of the problem and instead prevented Diné and Hopi leaders from acting in their nations' best interest. Thompson depicts this conundrum by showing a Diné man bound head to toe with a rope labeled with US government legal actions: the 1882 executive order, the *Healing v. Jones* decision, Supreme Court denial (of Native American cases), and the *Hamilton v. Nakai* decision.[47] For the Diné in early 1972, *Healing, Hamilton,* and the

Figure 3.6. Clare Thompson, "What Next?," pen-and-ink drawing, *Navajo Times*, February 10, 1972, 14. Courtesy of Sequoyah National Research Center, University of Arkansas at Little Rock

Supreme Court's seeming indifference to Navajo and Hopi concerns were foundational to the tribe's objection to the 1882 executive order. By explicitly naming these cases in the cartoon, Thompson reiterates the importance of protecting Diné and Hopi sovereignty and also points out the threat to that sovereignty from the long history of outside intervention in tribal affairs.

The longest-running problem for the Diné, as articulated in figure 3.6, was Chester A. Arthur's December 16, 1882, executive order, which set aside 3,863 square miles (2.5 million acres) "for the use and occupancy of the Moqui [Hopi] and such other Indians as the Secretary of the Interior may see fit to settle thereon."[48] President Arthur's executive order had proved disastrous for both the Diné and the

Hopi. The order failed to identify the "other Indians" in question, made no provisions for land use and management to protect traditional cultivation and grazing practices, and failed to recognize the legitimacy of Diné and Hopi land claims, which had been established by centuries of occupancy. This executive order was just another way for the United States government to gain access to and control of Indigenous lands while preventing Indigenous peoples from expanding their settlements.

From the (deeply misdirected) perspective of politicians engaged in late nineteenth-century Washington, DC, affairs, Arthur's executive order read like a good-faith effort to address shocking reports of the hardships facing Indigenous peoples in Arizona. One Indian commissioner, Vincent Colyer, had written to the Department of the Interior on October 3, 1871, that the "Apache Mohave" (Yavapai) in Arizona were "in considerable numbers destitute in a starving condition, having no boundaries defining their homes, their country [is] overrun by hunters who kill their game, and not unfrequently kill the Indians."[49] Intervention in this case was considered a humanitarian act on the part of the federal government; later in the same correspondence, Colyer declared a reservation within which the peaceful Yavapai were to be "protected, fed, and otherwise cared for."[50] The 1882 boundaries for the Hopi might be able, in the eyes of federal policy makers, to address at least some of the concerns voiced by US Indian agents stationed in the Southwest. For the Hopi and the Diné, the 1882 executive order presented a significant threat to sovereignty and self-determination.

In "What Next?," Thompson's choice to depict the 1882 order as the root of Diné problems reflects the legal trajectory of the executive order. Specifically, the cartoon references Congress's decision to pass the Omnibus Tribal Leasing Act of 1938, which placed the authority for regulating and leasing tribal lands to mining corporations in the hands of the secretary of the interior.[51] The 1938 act said nothing about rights to the profits from mineral deposits on tribal land deeded to Indigenous peoples prior to 1938 and therefore set the stage for *Healing v. Jones.* That case asked if the Diné should have legal rights to coal deposits on tribal land given their long history of occupancy or if the Hopi should be able to claim those rights given that the federal government had deeded the land to them in 1882. Both tribes had an interest in making as much money from the coal on their land as possible, and both believed that they at least deserved the right to control the extent of extraction. The courts agreed in *Healing* that, to some extent, both tribes had rights to the land (and the resources on it), but the decision in *Healing* seemed to actively promise future litigation by leaving the question of land use in the Joint-

Use Area up to the tribes.[52] It is little wonder that the legal decision is depicted in the cartoon as yet another strand in the rope constraining the Diné.

Although a specially convened three-judge federal court in Prescott, Arizona, had heard *Healing*, there was little question after the decision that both tribes felt their arguments merited further judicial review. The US Supreme Court, rather than engaging with issues of land use, tribal sovereignty, and resource management, simply upheld the lower court's decision without comment.[53] For both the Hopi and the Diné, this was denial: a refusal on the part of the Supreme Court to participate in ending a decades-long dispute, a denial of US government responsibility, and a denial of Indigenous agency and sovereignty.

As figure 3.6 suggests, the Diné were disappointed and immobilized by nearly every legal avenue they pursued to end the continuing dispute over tribal land use and management. In *Hamilton v. Nakai* (1971), an appellate court granted the Hopi petition for a writ of assistance to forcibly reduce Diné livestock in the Joint-Use Area.[54] Limiting stock was problematic for the Diné, but it was not the most harmful outcome of the decision. The most damaging aspect of the decision impacted both the Diné and the Hopi and dealt with sovereign immunity.

The doctrine of sovereign immunity states that "neither the United States nor any state may be sued without its consent."[55] The *Hamilton* decision, though, stated that Congress had the right to waive tribal sovereign immunity, effectively opening the land dispute to many future protracted legal battles.[56] As figure 3.6 reflects, the rights and status of Indigenous nations as sovereign were significantly constrained by the *Hamilton* case. The decision publicly revealed what the Diné and Hopi had known since the first broken treaties with the United States government: Indigenous sovereignty—the rights of tribes to self-rule—was both separate from and unequal to the sovereignty enjoyed by the United States of America.[57] Rather than being honored as powerful sovereign nations with the right to ensure their future security, the domestic dependent status of Indigenous nations remained firmly entrenched in the United States legal system.

Thompson had been depicting the problems with the doctrine of sovereign immunity since March 1969, suggesting then what he overtly argued later: the ideological platform upon which the United States justified its global dominance was predicated on a belief that non-Western nations, peoples, and platforms were less civilized than their white counterparts. By 1971, the year of the *Hamilton* decision, Diné communities had every mark of "white civilization": infrastructure, education, health services, entertainment centers, legal support, police, and a functioning press. No logic could attempt to justify Congress's decision to revoke the

basic sovereign protections that would allow the Diné and the Hopi to engage with the United States on equal footing. And yet, by 1971, it was clear that the United States had no interest in honoring the sovereignty or self-determination of any tribal nation.

As Indigenous sovereignty suffered, so too did the relationship between the Diné and the Hopi. Figure 3.7 harks back to the March 19, 1964, cartoon (figure 3.1) in which a Diné and Hopi man shake hands across the border dividing District 6 from executive order land. By March 1972, the situation had changed dramatically. In this depiction, while the broad visual construction remains very similar to Thompson's 1964 cartoon, there are several key differences. First, the land in figure 3.7 is shown in much starker relief than in the 1964 image, where the landscape is not shown in detail. Second, while livestock outnumbered people in the earlier cartoon, here the livestock is limited to a single horse. Third, the BIA, absent in the first cartoon, appears in the 1972 cartoon as a tertiary focal point in the lower right. From this cartoon, it is evident that the key concerns for the Diné and the Hopi had to do with livestock and land management rather than the extractive potential of the land, which was at the forefront of United States political consciousness.

Black Mesa, which did not appear in the 1964 cartoon, is a commanding presence in figure 3.7, occupying much of the territory labeled as Hopi land but cut off from the Diné by the border dividing District 6 from the land set aside for Diné and Hopi use in 1882. The smoking piles of coal atop Black Mesa point to the wealth accompanying legal control over the land in question. Since 1966, that power had rested largely with the Hopi.[58] Figure 3.7 focuses on the relationship between the Diné and Hopi men rather than identifying the individuals responsible for coal leasing, but the presence of the coal on the Hopi side of the border suggests that the Diné by 1972 were well aware of the economic inequities in Indigenous space.

The Hopi are depicted as individuals motivated by money. The Hopi figure in this cartoon has a dollar sign in his thoughts and coal in his back pocket, and he has literally dug his heels into the ground in order to drag what is labeled a "Navajo Horse" into District 6, away from Dinétah. While sheep were the lifeblood of Diné communities, horses were associated more closely with wealth. Though horses were practical sources of transportation and meat, they also indicated prestige.[59] The fact that the Hopi man is not attempting to remove sheep or goats from Diné hands shows that his interest (at least in part) is in wealth. What may look,

Figure 3.7. Clare Thompson, untitled pen-and-ink drawing, *Navajo Times,* March 23, 1972, B14. Courtesy of Sequoyah National Research Center, University of Arkansas at Little Rock

therefore, like a two-sided tug-of-war is in fact an image of a Hopi grab for Diné resources.

In the midst of the contest for resources, the BIA is depicted as a slow, ancient tortoise in the lower right-hand corner of the cartoon. The tortoise pays no attention to the question mark in the thoughts of the Diné, the struggle for the horse, or the coal that seems to underlie the Diné and Hopi struggles. The use of the tortoise reflects the power of the BIA but also its slowness, disconnectedness, and tendency to withdraw into itself in the face of conflict. The solitary nature of the tortoise paired with the fact that neither the Hopi nor the Diné figure registers its presence suggests that the bureau had become largely irrelevant to the resolution of the conflict between the two tribes.

While intertribal differences contributed to the hardships experienced by the Diné and Hopi in the Joint-Use Area, Thompson and the *Navajo Times* clearly

believed that those conflicts were not at the root of the land management crisis facing Indigenous peoples in the Southwest. As of 1972, the year before the Hopi began publishing *Qua'Töqti*, the *Navajo Times* clearly argued through its cartoons that the fight for sovereign control of Dinétah was part of broader struggles with United States law, corporate interests, and white politicians.

By emphasizing the borders and boundaries imposed by the United States, the cartoons in the *Navajo Times* asked the reader to reflect on the role of the United States as a force for continued colonization. The federal government was engaged in supporting a corporate, extractive colonial enterprise on Diné and Hopi lands. United States leaders and members of the corporate-political elite infringed on Indigenous sovereignty by pitting against each other financially impoverished peoples with limited economic options in increasingly constricted spaces. The many detailed representations of the border between District 6 and the 1882 executive order area published in *Navajo Times* political cartoons from 1964 to 1973 suggest that sovereignty was a primary concern for Indigenous actors during this time. As Indigenous scholar Vine Deloria stated in 1992: "If our struggle is anything it is the struggle for sovereignty and if sovereignty is anything it is a way of life. That way of life is not a matter of defining a political ideology or having a detached discussion about the unifying structures and essences of American Indian traditions. It is a decision, a decision we make in our minds, in our hearts, and in our bodies to be sovereign and to find out what that means in the process."[60]

In the case of the Diné and the Hopi, interventions by the United States government and various extractive enterprises affected traditional ways of life and were the primary infringements on tribal sovereignty. These impacts, as Deloria argued, were as damning to the continuation of Diné and Hopi lifeways as were threats to space, grazing land, water rights, coal, and uranium.[61] By examining the dispute through political cartoons, historians can see which issues were most important to the Diné and the Hopi. The cartoons reflected the issues that were the most pressing, illustrated how Diné and Hopi people responded to the news, and challenged the conventional political narrative about the conflict. The struggle was one of sovereignty and Indigenous people's fight to maintain their traditional land use and property rights in the face of changing economic circumstances on the reservation.

Beginning in 1973, the year that a true discourse between the *Navajo Times* and *Qua'Töqti* began, Diné and Hopi concerns about the political interests of the United States intensified. The cartoons published that year focused almost exclusively on the development of the relationships among the United States govern-

ment, Indigenous leadership in general, and the Hopi and Diné tribal nations specifically. There is tragedy in these cartoons, but there is also hope and humor. As historian Roxanne Dunbar-Ortiz noted, this hope is part of the legacy of Indigenous nations in the twentieth century. She argued that all "Indigenous peoples offer possibilities for life after empire, possibilities that neither erase the crimes of colonialism nor require the disappearance of the original peoples colonized under the guise of including them as individuals."[62] As the published cartoons show, the Diné and the Hopi fought through the press, clearly articulating the power differential between Indigenous and white leadership, questioning the motives and authority of influential figures in the land dispute, and in a long-standing tradition of intertribal relationships, unapologetically lampooning each other in the name of justice and survival.

Despite the increasing urgency of land settlement negotiations, the *Navajo Times* only published one cartoon related to the Navajo-Hopi Land Dispute in 1973 (figure 3.8). In that cartoon, Clare Thompson presents Dinétah as occupied territory. Rather than via a military occupation, Dinétah is being physically trampled by US congressman Samuel Steiger (R-AZ). Steiger, who had previously been elected to the state senate as the result of a friend betting him five dollars that he lacked the nerve to run for office, was known for legislatively supporting unregulated strip mining and damming the Grand Canyon.[63] His interests had little in common with those of the Diné.

In "He Is at It Again—" Thompson portrays Steiger as a devil, his outward gestures promising peace while his shadow reveals his true demonic nature. Rather than embracing a measured, thoughtful response to a complicated political question, Steiger became, Kammer argued, "a central part of the Hopi campaign that exaggerated the dispute in order to arouse public emotion and Congress against the Navajos. He challenged Navajo claims that relocation would be cruel and insisted that the provisions of his bill for relocation assistance were 'excessively generous.'"[64] The bill to which Steiger referred was a measure introduced on October 6, 1971, that, if it had passed, would have authorized Congress to divide the Joint-Use Area and remove any Diné residing on the so-called wrong side of the boundary. Worse for the Diné, Steiger proposed removing an additional 140,814 acres from Diné hands and giving that land to the Hopi.[65] Despite these measures, Steiger told a reporter in 1964 that he believed that helping people was "all that really matters."[66]

Figure 3.8 reveals that Steiger's true identity cast a hellish shadow over the Navajo Reservation. Furthermore, the title of the cartoon, "He Is at It Again—,"

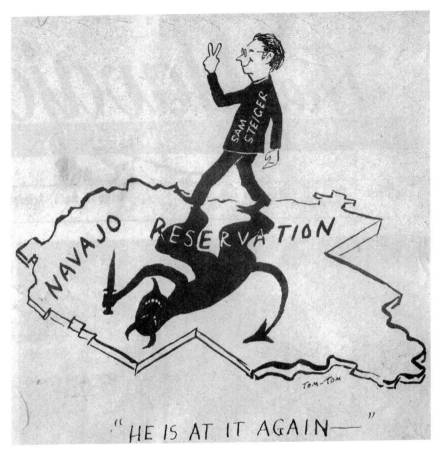

Figure 3.8. Clare Thompson, "He Is at It Again—," pen-and-ink drawing, *Navajo Times*, February 22, 1973, A2. Courtesy of Sequoyah National Research Center, University of Arkansas at Little Rock

suggests that the Diné were aware of Steiger's long history of working against their interests. Steiger took no pains to hide his one-sided agenda, telling the *Gallup Independent* in 1972 that he "thought the Hopis should get the land which the courts said they had a right to."[67] Far from impartial, Steiger also had no concern for environmental justice. He was in many ways the enemy of both tribes. He may have worked toward granting the Hopis more land at the expense of the Diné, but a quick look at Steiger's legacy leaves little doubt that neither the Hopi nor the Diné could safely place their concerns regarding tribal well-being in his hands.

Indeed, Steiger's activities as a member of the House of Representatives re-

veals his shortsighted approach to settling the disputed land question. The Hopi and Diné congressional struggle started with HR 11128, a 1972 House-passed bill sponsored in the Senate by Barry Goldwater and Paul Fannin (both R-AZ), which proposed dividing the Joint-Use Area but failed to provide relocation assistance for Native people forced from their land. The bill, to which both Diné and Hopi representatives publicly responded, never became law. The issues it raised, however, continued to be explored in future legislative sessions. The next year, Steiger introduced HR 1193, another effort to partition the land.[68] Steiger's bill authorized Congress to divide the Joint-Use Area and, within a decade, forcibly remove all Diné and Hopi individuals not residing on the appropriate side of the partition line. It also proposed removing 140,814 acres of land from Diné possession and transferring it, along with all usage rights, to the Hopi.[69]

This time, Steiger's bill provided financial assistance for relocation, but it still would have amounted to another forced removal for Diné and Hopi people and the further loss of land and mineral rights. It was unacceptable to the Diné. Hopi Tribal Council lawyer John Sterling Boyden, a pillar of Utah politics, believed that if relocation were taken out of the hands of the federal government, the Diné and Hopi might come to a consensus more easily. Boyden, like Steiger, did not properly consult with the Hopi or the Diné before coming to these conclusions about what was best for their welfare and their land.

Concerns over land use and land management were just as pressing for the Hopi as they were for the Diné. The first cartoon ever published in Qua'Töqti, Phillip Sekaquaptewa's "Riding Fence: In His Heart He Knows Who's Right" (figure 3.9), references the Native American political contest for United States senator Barry Goldwater's support, which took place between 1971 and 1973. While the title suggests that the Hopi had some faith in Goldwater's allegiance to their tribal community, the characterization of the Republican senator by Sekaquaptewa suggests otherwise. Goldwater is positioned between Senator Paul Fannin and Congressman John J. Rhodes, both of whom appear as crows, which represent stealth and danger and are known for eating the dead. Also pictured as a crow is the former United States secretary of the interior, Stewart Udall. Fannin, Rhodes, and Udall are quite literally "on the fence," and where Goldwater plans to ultimately dismount remains in question.

Though Goldwater has a human form and appears to be getting down from the fence on the side of the Hopi, "Riding Fence" clearly calls his dependability as a political ally into question: his saddle remains on the fence, and he is still in the act of dismounting. The fence is a key symbol because Goldwater's position

Figure 3.9. Phillip Sekaquaptewa, "Riding Fence: In His Heart He Knows Who's Right," pen-and-ink drawing, *Qua'Töqti*, July 19, 1973, 2. Courtesy of Sequoyah National Research Center, University of Arkansas at Little Rock

in the Hopi community was inextricably entwined with the issue of fenced land. "Riding Fence" underscores this point: the violent, barbed-wire fence is the most significant feature of the image other than Goldwater. In the years leading up to the publication of this cartoon, fences had become a significant problem for the Hopi. Diné ranchers, in order to maintain and protect their herds, had for years fenced off segments of the Joint-Use Area. The Hopi believed that this was in direct violation of the order presented in *Healing v. Jones*. As the commissioner of Indian affairs, Louis R. Bruce, who was Indigenous himself, wrote in a November 24, 1972, memo, "This fencing is being built without the consent of the Hopi Tribal Council. This Bureau is cognizant of its responsibility to uphold the decision of the Supreme Court in *Healing v. Jones*, which decision granted an equal one-half undivided interest in the Executive Order Reservation of 1882, exclusive

of Grazing District No. 6, which is solely owned by the Hopi Tribe."[70] In the eyes of the Hopi, as presented in figure 3.9, the Diné were attempting to subvert *Healing* by limiting Hopi use of the Joint-Use Area rather than adhering to the ruling.

Conflict over land use and land management, fencing included, was at the forefront of Arizona and New Mexico politics in the early 1970s. Hopi politicians, along with Sam Steiger, continued to publicly advocate for Diné removal. By 1972, the Diné, in response to this threat, had begun meeting with every politician they could in hopes of finding political allies. This first *Qua'Töqti* editorial cartoon appeared the year after Navajo tribal chairman Peter MacDonald (born Hoshkaisith) convinced Democratic presidential nominee George McGovern to support the Diné cause. After hearing MacDonald's plea, McGovern expressed dissatisfaction with forced removal and promised MacDonald that he would only support a solution that prevented any families from being "needlessly" removed from the land in question. As a result, MacDonald went on record saying that unless the Republicans could provide as much support as McGovern, he would be forced to support the Democratic candidate, rather than his friend Barry Goldwater, in the upcoming United States presidential election.[71]

Hopi leader Wayne Sekaquaptewa traced Goldwater's support of the Hopi to this incident: Goldwater viewed MacDonald's public support for McGovern as a personal betrayal. Wayne Sekaquaptewa said that Goldwater's advocacy for the Hopi was a response to MacDonald's enthusiasm for the Democratic candidate and that Goldwater "was sitting on the fence before that."[72] Phillip Sekaquaptewa directly referenced this encounter in his cartoon by literally replicating Wayne Sekaquaptewa's statement regarding Goldwater. There is little wonder, then, that the *koshari* (Hopi clown) figures in the bottom right-hand corner snicker at this potential new ally. "He's going to be *very* sore!" the figure on the left notes, in a clever double entendre regarding the MacDonald betrayal. "He's been riding a *long* time," his companion answers, suggesting that Goldwater had long refused to choose a side in the Diné-Hopi dispute. Nevertheless, in July 1973 the Hopi were willing to take whatever political support they could find in what had become a damaging and drawn-out dispute. As the *koshari* figures make clear, although the Hopi took Goldwater's reluctant support, they did so with eyes wide open to the disheartening truth that political maneuvering in Washington, DC, had a far greater sway over the fate of Hopituskwa than did any local representatives.

In Hopi culture, sacred clowns serve many purposes. They are protectors of tradition, but they can also be entertainers, scouts, warriors, or magicians.[73] For the Hopi, sacred clowns are representatives of the underworld and this world. And

just as the underworld, for the Hopi, is a mirror image of this world, clowns can entertain their audience by acting out ways that life should *not* be lived, presenting the opposite of respected behavior in order to impart life lessons as well as deliver comedic relief.[74] In the situation presented in "Riding Fence: In His Heart He Knows Who's Right," these figures make it clear that genuine personal allegiances should not be political tokens exploited by professional politicians in order to pursue personal vendettas.

Koshari use humor as their primary strategy for correcting social behavior. As artist and curator Barton Wright noted, the role of the *koshari* is to "isolate the core of a current event and reduce it to the ridiculous. . . . Any form of humor that can be brought into play to produce laughter will be utilized, but it will always be within the parameters of the traditional scenario."[75] The sacred clowns underscore the solemnity and importance of events and individuals' conduct by poking fun at them, cloaking in humor the need for attention to or action on a particular subject.

Not all Hopi clowns are depicted in the same way or serve the same function. The clowns in *Qua'Töqti* are called *pai'yakyamü* in the Hopi language, and they are also (perhaps more commonly) called *kossa* in the Tewa language. They are figures known for their buffoonery.[76] These sacred clowns, usually depicted as unmasked and striped with soot or corn smut, traditionally perform funny skits for audiences at spring and summer ceremonial dances.[77] The humorous component of these figures cannot be underestimated. As the journalist Jake Page noted, "Laughter is a gift, joy another form of prayer. For the Hopi, a smile is sacred."[78] The clown figures in cartoons serve all of the functions I have mentioned: they bring awareness of social problems to their audience; they point out the way that life should be lived; and, most important, they interject an element of humor (and, therefore, prayer) into fraught political commentary. They offer, indeed, a particularly Hopi point of view and thus help to shed crucial light—in the context of political cartooning—on how Hopi people viewed the land dispute. The cartoons are invaluable representations of Hopi voices commenting on a difficult political climate.

In a July 26, 1973, cartoon titled "Old MacDonald has a farm . . . ," Sekaquaptewa calls into question livestock ownership on joint-use lands as well as tribal affiliations through his use of the brand −N (pronounced bar-N) in the image (figure 3.10). Despite this serious topic, the *kossa* in the lower right-hand corner provide comic relief, linking Chairman MacDonald to the popular nursery rhyme and re-

Figure 3.10. Phillip Sekaquaptewa, "Old MacDonald has a farm . . . ," pen-and-ink drawing, *Qua'Töqti*, July 26, 1973, 2. Courtesy of Sequoyah National Research Center, University of Arkansas at Little Rock

citing the old adage "The grass is always *greener* on the other side!!"[79] Despite their levity, the sacred clowns do not detract from the seriousness of the Hopi complaint in this cartoon, which accompanied a front-page article on the same issue.

The incongruity of "Old MacDonald has a farm . . . ," in which Navajo chairman MacDonald stands happily in front of confiscated tribal livestock, clearly reflected the competing positions of the Diné and the Hopi with regard to livestock on joint-use lands. The Hopi believed that the Diné were not reducing livestock across the 1.8-million-acre Joint-Use Area despite Judge James A. Walsh's October 17, 1972, order to do so. As a result, the Hopi asked the US District Court of Arizona to hold "Navajo Tribal chairman Peter MacDonald 'in contempt of court for his neglect and refusal to comply'" with the legal orders.[80] Larry Ruzow, a legal representative for the Diné tribe, stated publicly, "The Navajo Tribe does not own

any livestock, to the best of my knowledge, within the Joint-Use Area, so it doesn't own any livestock to reduce."[81] Ruzow's refusal to address the issue of privately owned livestock is not mentioned in the article.

Waiting on the decision in a contempt-of-court suit put both the Diné and the Hopi in difficult positions. MacDonald might not end up imprisoned, but as the cartoon suggests, he should not have access to the livestock confiscated by the Hopi Tribe in response to Navajo trespass. Furthermore, District 6 was in peril. In the cartoon, a dead sheep, its eyes crossed out and its tongue hanging from its mouth, is tethered to a post pointing to District 6 but with another sign labeled "Welcome to District 3: Joint-Use Area." The sheep is also branded –N, indicating that its ownership is Navajo. This sheep foreshadows the threat to all Diné sheep should the issue of livestock on joint-use lands remain unresolved.

Sekaquaptewa's 1973 cartoons in *Qua'Töqti* reveal his unease with the paternalism inherent in the legal guidance provided by attorney John Boyden to the Hopi Tribe. A cartoon titled "Going to play with the big kids" (figure 3.11) depicts Boyden as a giant next to the Hopi leader he takes by the hand. The image evokes a parent-child relationship, with the child being walked toward a process that will allow both of the main figures "to achieve Hopi rights." Boyden is drawn so large that he cannot physically fit in the frame—his head is not even shown. The *kossa* figure, labeled "Hopi Tribe" and dragged along by the Hopi leader, suggests that while tribal elders held to traditional values, those values were quite removed from the actions of the Hopi Tribal Council.

In 1973, Boyden gave a speech to Secretary of the Interior Rogers C. B. Morton and others, which was published in the August 2 issue of *Qua'Töqti*. During that encounter, Boyden's folksy, down-home demeanor failed to articulate what was really at stake for the Hopi in the land dispute. Rather than discussing issues of livestock, land use, and traditional ceremonial practices, Boyden focused on the legality of the 1882 order, arguing that the United States "set aside the Executive Order Reservation for the Hopi people alone. There was no intention of having the Navajos here."[82] Perhaps Boyden anticipated a rebuttal mentioning the second part of the executive order, which set aside the land for the "Moqui and such other Indians as the Secretary of the Interior may see fit to settle thereon," for he also argued that "the court held that no Secretary of the Interior ever said, 'I settle any Navajos on here.'"[83] Boyden ignored or remained unaware of the complicated history of settlement on the joint-use lands.

Boyden's plea for exclusive Hopi use of the Joint-Use Area missed nearly every mark. Toward the end of his speech, after asking Congress to partition the Joint-

Figure 3.11. Phillip Sekaquaptewa, "Going to play with the big kids," pen-and-ink drawing, *Qua'Töqti*, August 2, 1973, 2. Courtesy of Sequoyah National Research Center, University of Arkansas at Little Rock

Use Area, he said, "This is the only way it can be done because we're outnumbered and every time we had agreements; even, for example, to haul wood, we go out into the areas of where we're entitled to get it and where our superintendents had signed on both sides, the Hopi would load up his wood, the Navajos in numbers would come along and tip over the whole wagon."[84] Rather than presenting the conflict as one that could be arbitrated and settled and ultimately result in increased goodwill between the two tribes, Boyden presented it as a hereditary conflict in which they had to be forcibly separated in order to ensure any kind of protection for the Hopi. It is no wonder, given his perspective, that the *pai'yakyamü* in figure 3.11 proclaims, "I hope these two know what they are doing!!!"

The *pai'yakyamü* had good reason to question Boyden's integrity. A March 1979 Indian Law Resource Center report found documents that "strongly indicated" that Boyden had a financial stake in the affairs of energy companies during the same period that his firm, Boyden, Tibbals, Staten & Croft, represented Peabody

Coal (now Peabody Energy).[85] The report included evidence linking Boyden and his firm with the Hopi from 1951 through 1978. Problematically, the Martindale-Hubbell attorney directory for 1966 and 1967 listed both the Hopi Tribe and Peabody Coal as clients of Boyden, Tibbals, Staten & Croft.[86] These affiliations represented a clear conflict of interest for the law firm. The report concluded, "Throughout the 1960s . . . the Hopi Tribal Council was represented by attorney John S. Boyden, who had been authorized by the Secretary of the Interior to take legal action as general counsel on behalf of the Hopis."[87] Indeed, Boyden had extensive access to and knowledge of Hopi interests, proprietary documents, and resources while acting as a named partner in a firm supporting corporate extractive enterprises on protected Indigenous lands.

In an October 24, 1978, letter, Boyden defended his professional past: "[I] have represented the Hopi Tribe for a good many years and have never represented any other client whose interests in the subject matter were averse to the Hopi [T]ribe at the time of such representation."[88] Perhaps he justified this statement because he and his firm worked contractually for Peabody Coal and Kennecott Copper. Still, Boyden's long-term, repeated involvement with both the Hopi and energy companies suggests that his professional ethics may have been compromised. In rebuttal to Boyden's claims, the Indian Law Resource Center cited documents linking Boyden to the 1968 Peabody Coal–Kennecott Copper merger, including the banks that financed it; the interests of the Hopi Tribal Council in the 1950s and 1960s; and Aztec Oil and Gas. The center's work produced significant doubt as to whether Boyden was truly aligned with the long-term interests of the Hopi people.[89]

For the Hopi, looking to elected politicians for a reprieve from the onslaught of moneyed interests offered further disappointment. One politician in particular, John Bertrand Conlan, former Arizona state senator (1965–1972) and then United States representative (1973–1977), was disinterested in maintaining an impartial relationship to the tribes in the Four Corners region. Conlan, whose constituents included both Diné and Hopi individuals, admitted on August 23, 1973, that his motivation for cosponsoring a Diné "buyout" bill with New Mexico representative Manuel Lujan Jr. was based on a long-standing feud with his political opposition, Samuel Steiger.[90] When directly asked about his decision to support HR 7716, which would have traded payment for Hopi relocation, Conlan's first response was "Ask Sam Steiger."[91]

In "Conlan's Hopi initiation" (figure 3.12), rather than embracing the traditional rite of passage, Conlan is shown running away from his Hopi constituency,

Figure 3.12. Phillip Sekaquaptewa, "Conlan's Hopi initiation," pen-and-ink drawing, *Qua'Töqti*, August 23, 1973, 2. Courtesy of Sequoyah National Research Center, University of Arkansas at Little Rock

back toward his mobile office. Conlan wears a smugly passive expression, apparently unaware or unbothered by the anger his presence instigates. The *pai'yak-yamü* note, "Now he knows how it really is!" and "This is *supposed* to make him a *grown-up!*" Conlan's indifference suggests that there is little potential for him to grow as a person or as a representative.

Conlan's general lack of awareness regarding his responsibility to Hopi society was evident through nearly every encounter he had with the Hopi. Instead of showing his support for Hopi *and* Diné concerns, he ignored Hopi communities and was disinterested in the Hopi political perspective. In one speech, he defended his absence from Hopituskwa: "All I can say is that no one ever invited me to come;

neither the editor of the newspaper, nor anybody else." He went on, "I represent 500,000 people. Three-tenths of one percent are Hopis. They are not the only people I represent."[92] For the Hopi, the problem was not numbers, but the fact that Conlan's political suggestions had more to do with rebutting Steiger than finding a real, long-term solution to the problem of who had rights to the Joint-Use Area.

Steiger's initial bill, a $16 million initiative, would have divided the Joint-Use Area equally, removed Diné families on Hopi land, and compensated the Diné families who had to relocate. Conlan's plan in response was almost the mirror image of Steiger's bill. Conlan's legislation provided the Diné with an $18 million interest-free loan to buy land from the Hopi, who would then have to relocate.[93] Neither bill served the interests of the Diné or the Hopi. Both plans would have resulted in relocation and were financially infeasible. Furthermore, the personal conflict that had been long brewing between Steiger and Conlan only worsened the feeling for the Hopi that they were being treated as pawns in a game of political chess. As one *Qua'Töqti* editorial emphasized, "Conlan can play political games with which ever friend or foe he chooses, but not when it involves giving away something that is not his to give away. The Hopi-Navajo dispute is too important an issue to use as a tool to get back at Steiger."[94]

The Navajo-Hopi Land Dispute forced both tribes to fight a two-front ideological war: one was against the proposals for removal, which did little to serve their interests, and the other was to prevent their supposed allies from using the conflict on Indigenous lands to guarantee their own financial gains. Both *Qua'Töqti* and the *Navajo Times* had good reason to devote entire pages to the failures of politicians: their elected representatives were far more interested in their own political stances and careers than in providing assistance or even high-quality debate on the issue of the land dispute.

In "Navajo Monopoly," published in *Qua'Töqti* on August 30, 1973 (figure 3.13), Sekaquaptewa uses the image of a Monopoly game to take on the subject of Navajo tribal chairman Peter MacDonald's integrity. This cartoon clearly falls into the Indigenous tradition of lampooning the "other"—in this case, using the *pai'yakyamü* to proclaim MacDonald's bad luck ("He keeps landing on the *wrong squares!*" "*Snake-eyes!*") while insinuating that MacDonald should go to jail for contempt charges. Sekaquaptewa had explored MacDonald's supposed contempt of court in an earlier July 26, 1973, cartoon. While that cartoon engaged the issue of livestock, "Navajo Monopoly" suggests that MacDonald had a pattern of circling the same issues regarding the land over and over again—backward. This cartoon

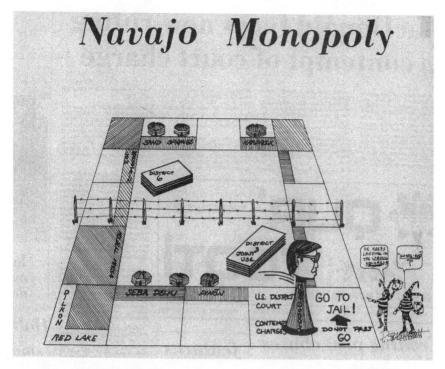

Figure 3.13. Phillip Sekaquaptewa, "Navajo Monopoly," pen-and-ink drawing, *Qua'Töqti*, August 30, 1973, 2. Courtesy of Sequoyah National Research Center, University of Arkansas at Little Rock

refers to the continued investigation of Diné land practices following Judge James A. Walsh's October 14, 1972, court order in which he ordered the immediate reduction of livestock on the Joint-Use Area. Questions regarding the Diné's willingness and ability to follow this order resulted in an August 25, 1973, noncompliance hearing, which was discussed a few days later in *Qua'Töqti*.[95]

At the hearing, Hopi attorney John S. Boyden attacked MacDonald and a member of MacDonald's staff for his actions from 1972 to 1973. As *Qua'Töqti* reported, Boyden asked "questions regarding the failure of the Navajo Tribe to reduce livestock in the Joint-Use Area of the 1882 Hopi Executive Order Reservation; and why revenue from joint-use lands was deposited in the general fund of the Navajo Tribe instead of in a separate escrow account; and why there is continued construction of new homes by Navajos on the joint-owned lands."[96] In the eyes of the Hopi, MacDonald was on the verge of landing on the "Go to Jail!" space on the Monopoly board; his actions, from the Hopi perspective, were indefensible.

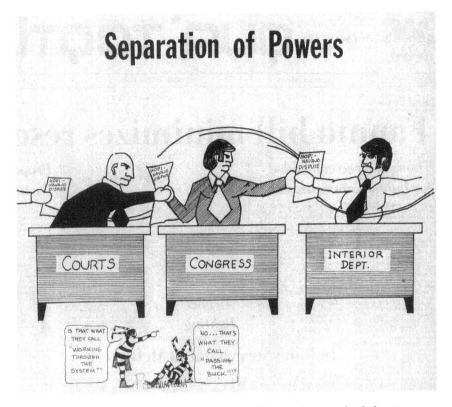

Figure 3.14. Phillip Sekaquaptewa, "Separation of Powers," pen-and-ink drawing, *Qua'Töqti*, September 20, 1973, 2. Courtesy of Sequoyah National Research Center, University of Arkansas at Little Rock

As "Navajo Monopoly" suggests, the primary issue in the noncompliance hearing had to do with land rather than livestock. Sekaquaptewa uses the symbolism of traditional Monopoly game pieces to comment on the far-reaching impact of Diné development. The "hotels" (here, Diné hogans) placed on the spaces of Piñon, Hardrock, Sand Springs, and Seba Delki (now Seba Dalkai) present an image of MacDonald as a developer colonizing Hopi space. The barbed-wire fence cutting through the board reflects an even division of space between the two tribes—a division ignored by the hogans built on both sides of the fence.

The monopoly board in figure 3.13 symbolized the importance and power of financial interests in the land dispute. As the September 20, 1973, *Qua'Töqti* cartoon titled "Separation of Powers" (figure 3.14) suggests, money likely superseded all other interests in the dispute. In "Separation of Powers," Sekaquaptewa shows

the courts, Congress, and the Interior Department linked in a great chain of co-operation, the land dispute passed from one to the other without so much as a second glance. The *pai'yakyamü* character on the left asks, "Is that what they call 'working through the system'?" and his companion answers, "No . . . that's what they call 'passing the buck'!!!" For the Hopi, the United States government had done little more than throw the failure of intertribal resolution into stark relief. "Separation of Powers" argues that the land dispute, if left in the hands of United States politicians, was likely to be passed on and unresolved forever. Even more important, it shows the degree to which the federal government created and maintained the dispute.

The Hopi remained primarily concerned about the continued abuse of their lands through federal intervention and inaction. As one *Qua'Töqti* editorial noted, "This land is our mother and it will provide us sustenance so long as we respect it and do what she requires of us. . . . Our progenitors built a great civilization around this one point."[97] This Hopi perspective was quite similar to the Diné vantage point. As Diné Pauline Whitesinger explained, "The reason we will not relocate is because the land has become a part of us. She is our mother. The sun is our father. . . . This is what the culture says."[98]

With money, land, and power at stake and no relief provided by federal authorities, the Hopi and the Diné were at an impasse. In the final months of 1973, virtually no progress was made toward resolving the land dispute. Both the Diné and the Hopi were threatened by an uncertain future. Despite the very real disagreements between the Hopi and Diné, by the end of 1973 it was clear that the cartoonists of both *Qua'Töqti* and the *Navajo Times* believed that the land dispute was a manufactured one, created by United States politicians, mining interests, and imperial interests in order to strip both tribes of their sovereignty. For members of these nations, a future including fully realized Indigenous self-determination in the Four Corners region seemed increasingly unlikely.

Discourse and Discord

The Conversation between the Navajo Times and Qua'Töqti, 1974

The land dispute is not a land dispute between tribes. . . . The federal
government . . . has assisted in setting up the Navajo Tribe and Hopi Tribe
against each other.　　　　　　　　　—HARRISON LAPAHIE (DINÉ)

Editorial images published in *Qua'Töqti* and the *Navajo Times* in early 1974
revealed that Hopi and the Diné had many shared concerns regarding the
future of United States interference in their traditional homelands, even as they
also visually articulated persistent intertribal hostility, which continued to color
the public's perception of the conflict. Many of these shared concerns were high-
lighted in editorial cartoons published in Indigenous newspapers, including in
Thompson's untitled January 31, 1974, image published in the *Navajo Times*.

In figure 4.1, a Diné man proclaims, "You have for many moons taken all my
good lands—my sheep—my horses—my cattle—my grass—my water *and* have
left me only the rocks. *Now* you come to *claim* the rocks too!" If, as environmental
historian Traci Brynne Voyles argued, the uranium mine is the front end of nu-
clearism, the back end is depicted in this image, where Natives suffer at the hands
of extractive enterprise.[1] Here, a Diné woman and child are depicted as likely ca-
sualties of the federal government's appropriation of Indigenous space. And in-
deed, the eyes of the men to the right of the glowing uranium are lit with avarice.
They are labeled "U.S. Reclamation," "Sec. of Interior," and "B.I.A."

While 1974 was a pivotal year for uranium mining across Black Mesa, the Diné
characters' frustration in this cartoon likely stemmed from the long history of white
miners' encroachment on protected lands. Representatives of the Union Mines
Development Corporation, which scoured Indigenous lands looking for molyb-
denum, vanadium, and tungsten, important components of the United States war

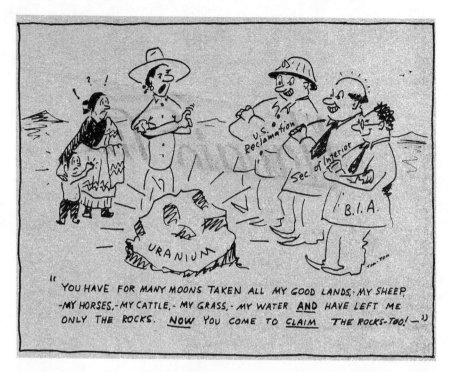

Figure 4.1. Clare Thompson, untitled pen-and-ink drawing, *Navajo Times*, January 31, 1974, A8. Courtesy of Sequoyah National Research Center, University of Arkansas at Little Rock

machine, had first appeared on Diné lands in 1943 during the Second World War.[2] The cartoon printed in *Qua'Töqti* on February 7, 1974, titled "A Race into the Future . . ." (figure 4.2), alludes to this long history of white encroachment on Indigenous space, clearly linking technological development with white Americans' continued efforts to control Indigenous resources.

"A Race into the Future . . ." depicts a sleek automobile in which a fashionable young Diné woman wearing an expensive hat points toward the former Navajo Reservation. A Hopi man riding his *moro* (donkey) remains barely ahead of her. The *pai'yakyamü* assist the Hopi man in his journey toward the Hopi Reservation. One of the *pai'yakyamü* points a guiding hand toward home while the other holds the donkey by a lead. The Diné woman states, "My progressiveness, big investments and lots of money have brought me this far . . ." Her Hopi counterpart replies, "My faithful old 'moro' here has faltered at times, but has kept up the pace as I plan ahead . . ." Together, these statements underscore the importance of

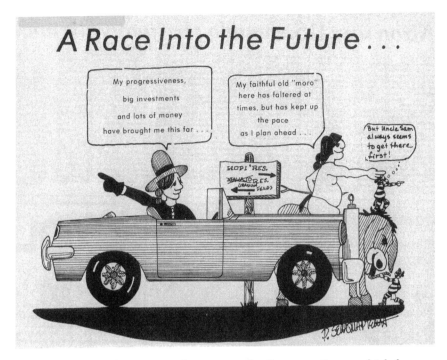

Figure 4.2. Phillip Sekaquaptewa, "A Race into the Future . . . ," pen-and-ink drawing, *Qua'Töqti*, February 7, 1974, 2. Courtesy of Sequoyah National Research Center, University of Arkansas at Little Rock

tradition to the Hopi, the downside of materialism, and the threat facing Hopi-tuskwa. These statements also reveal Sekaquaptewa's distaste for the Diné's comparatively better financial status due to their willingness to, the cartoon suggests, trade their land for money.

The values embodied by the Diné woman in her car are all related to material wealth. Her place in the world is defined by unstable ideas regarding "progressiveness" and the expected returns on investments. Her character is ungrounded and unconnected to anything other than her finances. By contrast, the Hopi man is concerned with maintaining his traditional lifeways in the face of outside pressures to "upgrade": from nakedness to clothing, from donkey to car, from traditional material goods to "big investments." Tellingly, despite these pressures, he remains ahead of the automobile—and happy. The stark juxtaposition between the two main characters in this cartoon is a prime example of a key complicating factor in the narrative of the dispute as shown in Sekaquaptewa's, Thompson's, and

Ahasteen's images. The Hopi and Diné were imperfect allies—sometimes even competitors at direct odds—who were faced with the reality that they were both being exploited and undermined by the same outside forces.

Indeed, both characters in "A Race into the Future . . ." are being outpaced by another figure: the invisible Uncle Sam. As one *pai'yakyamü* states, despite the race into the future between white tourists, businesspeople, and the Diné and Hopi, "Uncle Sam always seems to get there first!" In this case, the future has changed the Navajo Reservation into uranium fields, as noted by the directional sign. The Hopi man is riding in the opposite direction of the fields, but the Diné woman seems to be intent on turning around. This cartoon represents a shared understanding that the primary blame for uranium mining on tribal territory was to be placed with United States government officials and the BIA.

Placing salient political commentary in the mouth of the *pai'yakyamü* suggests that the humor of the cartoon is meant to exist alongside its devastating warning. There is also a message to the Hopi community reading this cartoon: do not give up your lifeways or traditions in the face of the material promises made by representatives of industry because the US government's interests will always prevail. Since the *pai'yakyamü* are sacred, so too is their message. The anthropologist Elsie Worthington Clews Parsons recalled in her 1929 monograph an unnamed Tewa man saying of the *pai'yakyamü*, "the way you have to do is to make fun so that the people will be happy."[3] This perspective on the value of humor in the face of difficult situations holds true across many different Native communities. As one Lakota man, Lame Deer, noted when discussing the importance of sacred clowns for Indigenous peoples, "To us a clown is somebody sacred, funny, powerful, ridiculous, holy, shameful, visionary. He is all this and then some more. Fooling around, a clown is really performing a spiritual ceremony. He has power. It comes from the thunder-beings, not the animal or the earth. In our Indian belief, a clown has more power than the atom bomb. This power could blow the dome off the Capital."[4]

In figure 4.2, the *pai'yakyamü* are depicted as the opposite of the force driving uranium mining on Hopi and Diné lands, the opposite of the core of an atom bomb. The *pai'yakyamü* are more powerful than uranium, or United States business interests, or white investors. The *pai'yakyamü* could, as Lame Deer suggested, "blow the dome off the Capital." The Hopi in this image are at once an ally to the Diné, a transgressor of white cultural norms, a warning to other Indigenous peoples, and the winner of an undefined race into an unknown future.

On the surface, these images seem to have little to do with the land dispute,

but they reveal the extent to which activist-artists emphasized the tribal understanding of the root cause of the conflict—United States government interests. These cartoons looked to a potential future shaped by the dispute to show what was at stake for the Diné and Hopi people of the region. The dispute is a hidden character in these images, foreshadowing the coming fight. This is not to say that Thompson and Sekaquaptewa eschewed depicting intertribal conflict and competition in favor of attacking the federal government. In fact, the intertribal lampooning—sometimes escalating into intertribal animosity—continued throughout 1974 very much as it had in the cartoons of the previous decade.

Editorial cartoons published in *Qua'Töqti* and the *Navajo Times* dynamically shaped the opinions and perspectives of many Diné and Hopi people. These cartoons reveal that Thompson and Sekaquaptewa considered white political leaders to be the true instigators of the dispute. And the cartoons painted a bleak picture of the future for Indigenous peoples of the Southwest post-partition, suggesting that the Navajo-Hopi Land Dispute was another opportunity for non-Indigenous politicians and energy executives to achieve their own objectives.

Sekaquaptewa rarely let the issue of coal disappear from his *Qua'Töqti* political cartoons in 1974. In "David-tewa and Goliath," he used a component of a common Hopi surname to compare the Hopi battle with labor unions to the fight between David and Goliath (figure 4.3). The Philistine, labeled "unions," is tall, ugly, hairy, and white. He wields an impressive and terrifying mace. Yet the *pai'yakyamü* are not terrified. They take coal—the very property he desires—and use it as the weapons of the weak, which are destined, as the title of the image suggests, to defeat Goliath.

Visual layering is important to "David-tewa and Goliath." This multidimensional artistic strategy allows three conversations to take place across one landscape. While the *pai'yakyamü* occupy the foreground, joyfully preparing a slingshot for their Hopi hero, the midground is occupied by the Hopi. In the midground of the cartoon, Goliath defends his intrusion on Hopi land, insisting, "I'm only protecting my interests out here little guy." His competition, David-tewa, hurls coal at Goliath and proclaims, "You're protecting your interests, but I'm protecting myself." Through this cartoon, Sekaquaptewa articulates his agreement with Navajo tribal chairman Peter MacDonald, who publicly argued, "Congress and the courts look at the dispute from the political and legal aspects and not necessarily from the stand-point of what would be best for both tribes."[5] Interestingly, despite the cartoon's obvious depiction of intertribal friction and despite the desperate conditions across Hopituskwa, this cartoon still refrains from depicting the Diné as

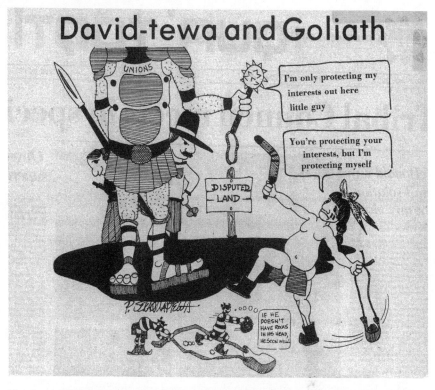

Figure 4.3. Phillip Sekaquaptewa, "David-tewa and Goliath," pen-and-ink drawing, *Qua'Töqti*, February 28, 1974, 2. Courtesy of Sequoyah National Research Center, University of Arkansas at Little Rock

the cause of problems on disputed land. The cause is still Goliath, the emissary of the United States government.

In the background, a Diné couple hides behind white Goliath. Perhaps these Diné would be a threat in their own right—but Sekaquaptewa is insinuating that the Diné are hiding behind and are protected by white interests. Peeking out from behind their defender, the Diné smile slyly at the possibility of encroaching on Hopi lands. Sekaquaptewa's depiction of the union character as the villain Goliath is in keeping with traditional understandings of labor interests among both the Hopi and the Diné. In fact, MacDonald had a long history of opposing unions in favor of right-to-work laws in the Southwest.[6]

MacDonald's position, shared by Sekaquaptewa, likely stemmed from the long history of mining companies taking advantage of Indigenous laborers. Records

from Gallup American Coal Company from the mid-1940s, for example, show that Native workers' wages were between fifty-seven cents per shift and sixty-seven cents per shift compared to non-Indigenous laborers' wages of eighty to eighty-six cents per shift.[7] What constituted "Indian work" remained unspecified in the company's records, but economic historian Colleen O'Neill suggested that "Indian work primarily consisted of marginal surface labor and/or maintenance duties such as making repairs on company houses."[8] Rather than offering increased protection and elevated wages, mining companies had a history of using their power to institutionalize inequality in the labor force—certainly, as this cartoon suggests, not in the best interests of the Diné or the Hopi.

Still, despite the shortcomings of unions and their labor policies, a job for many Hopi and Diné men was generally better than no job at all. By the 1970s, unions had an increasingly large presence in the lives of Diné and Hopi miners. Membership was a prerequisite for being hired at the Navajo Generating Station, the Four Corners Power Plant near Shiprock, New Mexico, Peabody Coal on Black Mesa, and the Pittsburg and Midway Coal Company near Window Rock, Arizona.[9] The fact that national labor agreements trumped Arizona's right-to-work laws left many Diné and Hopi laborers with little choice, despite their low wages: join unions or face unemployment. Inequality remained, to be sure, but the lure of making a living and the possibility of performing wage labor while maintaining traditional Indigenous lifeways meant that even working for the unions (Goliath), the average Hopi worker (David-tewa) still survived. In fact, the money made from coal mining was a weapon, one that had the potential to preserve and protect traditions and land, destroy the unions, or draw outside interlocutors into the long-standing conflict.

Despite the wealth of coal that existed on shared land and the opportunities for advancement that such wealth implied, unions remained a barrier to long-term financial success for Diné and Hopi laborers. As the cartoon suggests, labor unions failed to serve the best interests of the Hopi. Even more problematically, labor unions' lack of legal support for their Native members further destabilized the legislative landscape across Dinétah and Hopituskwa. By 1973 and 1974, the contest for Natives' rights to their traditional lands was primarily being fought on the congressional floor, but both the Diné and the Hopi needed more powerful legislative and legal support if they retained any hope of finding judicial favor. Unfortunately, United States political representatives were not on the side of Native peoples.

In the wake of his failed bid to pass HR 1193, discussed in the previous chap-

ter, United States representative Sam Steiger persuaded Utah Democratic congressman Wayne Owens to put forward HR 10337, which proposed a partition of the Joint-Use Area overseen by an Arizona federal court rather than Congress.[10] Though HR 10337 provided funds for relocation and switched the site of administration to a local venue, it did not guarantee housing for people who would be displaced as a result of the legislation. Ultimately, the bill failed to address even the most basic issues with which Indigenous people would have to contend following a forced relocation.

Republican New Mexico congressman Manuel Lujan echoed Diné and Hopi concerns in his outrage over the political impact of HR 10337. He blamed the volatile situation across the Southwest on the United States government. Despite continual Department of the Interior hearings regarding the dispute, there was little progress by the spring of 1974. As Lujan told the *Navajo Times*, "We are making the Navajos pay with this suffering because the Bureau of Indian Affairs and the Department of the Interior have not lived up to their responsibilities. It was the responsibility of the Department to see that the land area was equitably divided so that not too many Navajos moved in or too many Hopis." He went on to reprimand the federal government for its newly ignited interest in the conflict, reminding his superiors of the origins of the Diné reservation. Lujan said, "If any member of this chamber is acquainted with the Navajo Reservation, he will know that it is poor land that was given to them because nobody else wanted it."[11] Lujan's statement addressed three important things. First, it was immoral and reprehensible to make the Diné pay in any way for their own forced removal after first allocating them land that the United States deemed essentially worthless. Second, the statement implied that the US government had material interests in the land that superseded their interest in resolving the land dispute. Third, it condemned the legislation itself, suggesting that the proposed bill had little to do with the interests of the people on the land.

Despite his powerful public rhetoric, Lujan was far from the answer to Diné prayers. As one of the architects of a buyout proposal, he had contributed to the ethos of land commodification and proved to the Diné and Hopi that non-Indigenous politicians failed to understand the relationship they shared with the land. Ultimately, in an effort to stop the Owens bill, the Diné allied themselves with the AFL-CIO, reversing a long-standing tradition of anti-union activity on the reservation. This tactic, however, did not prevent the May 1974 passage of the bill sponsored by Wayne Owens, which virtually guaranteed the eventual partition of the Joint-Use Area. The bill did succeed in driving another wedge between the

Hopi, the Diné, and the white politicians in Washington, making intertribal tensions even more prominent throughout 1974.[12]

Fraught negotiations and the sheer number of legislative proposals regarding partition meant that weeks and even months before the Owens bill passed, both tribes were concerned about the weight of representatives' words and the meaning behind United States politicians' rhetoric. Though local politicians like Lujan made appearances in *Qua'Töqti* cartoons, Sekaquaptewa continued to emphasize the national scope of the problem by depicting Uncle Sam as the archvillain. From the Diné perspective, intertribal skirmishes and even Diné-white political maneuvering took a back seat to the larger problem: the propensity of federal officials to act in their own best interests at the expense of Indigenous peoples.

In the March 21, 1974, editorial cartoon titled "Minority Rules" (figure 4.4), Uncle Sam holds 140,000 well-clad Diné on his lap in a position of favor, seemingly teaching them to read out of a text labeled "Property Rights under the Law." He uses 6,000 impoverished Hopi as a footstool while he proclaims the message: "I have a soft spot in my heart for minorities. I do my best to protect them." The *pai'yakyamü* figure in the lower left-hand corner recoils from a swift kick from a boot labeled "Lujan," while saying, "He must have learned that from John Conlan." Meanwhile, the oppressed Hopi figure notes, "I need protection from the majority minority!" For Sekaquaptewa, the fact that political decisions were based on population numbers was unfair, especially since, from his perspective, the Diné had a more favorable relationship with Uncle Sam.

The reference to United States representative John Conlan (R-AZ)—the cosponsor of Lujan's buyout proposal—suggests that the Hopi distrusted all legislation that would result in continued Diné settlement on protected lands. It also suggests that the Hopi suspected the motives of white politicians who were attempting to secure the partition of sacred lands by manipulating the property interests of the Diné. In figure 4.4, the Diné man is seemingly oblivious to the struggles of his Hopi counterpart. It's important to note the hostile undertones in this cartoon; certainly, the tenor is not friendly toward the Diné. However, the primary architect of the power differential between the Diné and the Hopi in this cartoon is undoubtedly the character representing the United States, not the Diné themselves.

Finally, it's critical to address Sekaquaptewa's commentary on the paternalism that permeated the legislative process in 1974 by noting the size differential between the Hopi and Diné figures and Uncle Sam. While Uncle Sam is depicted as bearded, tall, and adult, the Native American figures are presented as children

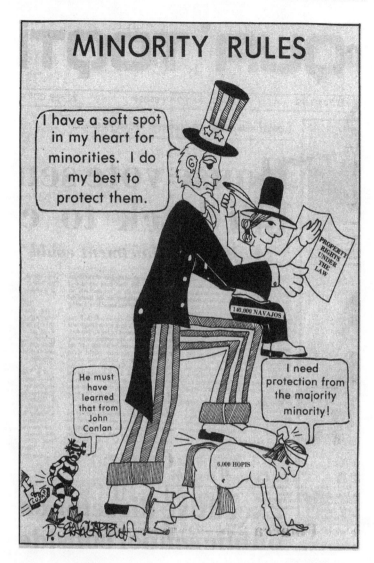

Figure 4.4. Phillip Sekaquaptewa, "Minority Rules," pen-and-ink drawing, *Qua'Töqti*, March 21, 1974, 2. Courtesy of Sequoyah National Research Center, University of Arkansas at Little Rock

(and in the case of the Hopi, abused children). The Hopi and the Diné had decisions made for them by United States representatives; depicting Indigenous adults as children suggested the helplessness they felt. Both groups knew that Uncle Sam and his friends were primarily interested in the material well-being of the

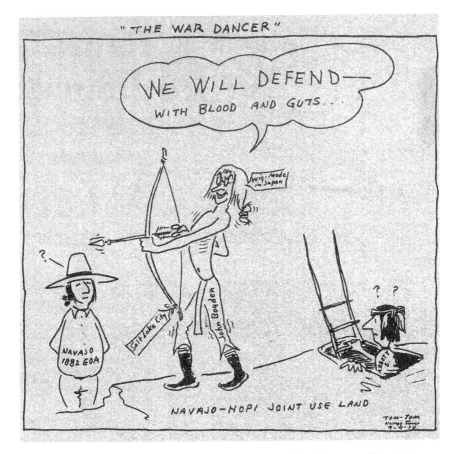

Figure 4.5. Clare Thompson, "The War Dancer," pen-and-ink drawing, *Navajo Times*, April 4, 1974, A2. Courtesy of Sequoyah National Research Center, University of Arkansas at Little Rock

United States at the expense of the well-being of those who made their home on Black Mesa.

Clare Thompson agreed with Sekaquaptewa that representatives of the United States government were far from having Indigenous people's best interests at heart. In "The War Dancer" (figure 4.5), Thompson uses reversal, exaggeration, and geographic commentary to question the motives behind Hopi lawyer John Boyden's work supporting the proposed partition of the Joint-Use Area. By titling the image "The War Dancer," Thompson places Boyden at the heart of what many white men historically classified as a terrible, threatening spectacle. As the *Indian*

Advocate reported in 1904, "In this extraordinary performance [of the war dance], a complete image is given of the terrible reality: the war-whoop is sounded with the most frightful yells; the tomahawk is wildly brandished; and the enemy are surprised, seized, and scalped, or carried off for torture."[13] Thompson makes use of reversal by characterizing Boyden, rather than an Indigenous man, as the war dancer. And if Boyden is the war dancer, it is the Diné who are at risk of being tomahawked, seized, scalped, or tortured.

"The War Dancer" underscores Boyden's violent nature by pointing out that he is anything *but* indigenous to the land. As the labels on the image note, his wig is made in Japan, and his bow hails from Salt Lake City. His whiteness stands in stark contrast to the Diné and Hopi figures on either side of him. His lack of connection to where he stands, labeled "Navajo-Hopi Joint Use Land," suggests that his statement, "We will defend—with blood and guts . . . ," stems from his position as an outsider and invader on recently stolen land.

While presenting Boyden as faux Indigenous is one key reversal in this cartoon, the words "We will defend—with blood and guts" is another reversal, as that sentiment was actually spoken by Abbott Sekaquaptewa, chairman of the Hopi Tribal Council. On March 28, 1974, the *Gallup Independent* reported Sekaquaptewa stating, "I don't propose a war and I don't want that tactic [but] I don't sit here to guarantee that my people will keep the peace. If it takes blood and guts that's what we will do."[14] These words, spoken in support of HR 10337 and partition, revealed the Hopi people's desperation for a resolution to the conflict and reinforced the Diné belief that the Hopi were being manipulated by federal officials.

Indeed, despite intertribal disagreements, the same article in the *Independent* reported that both Diné and Hopi leaders attributed the root cause of the dispute to non-Indigenous individuals hoping to extract value from the land's natural resources. As Sekaquaptewa noted in the article, "We're losing faith in the white man's system of justice. Liberty and justice for all doesn't seem to mean anything for us."[15] Diné tribal chairman MacDonald agreed: "If you let the white man take your land, your water, your mineral resources, you are a good Indian, but if you protect your resources and demand that you get adequate compensation for the same, you are a bad Indian."[16] Both tribal leaders understood the true root cause of the dispute, and they were right to be concerned. In New Mexico alone, 75 percent of the state's revenue in 1972 was derived from mining and extracting "coal, natural gas, natural gas liquids, crude petroleum, and uranium."[17]

Land and resource extraction, as MacDonald and Sekaquaptewa noted, made both Hopi and Diné vulnerable. In "The War Dancer," Thompson depicts this sus-

ceptibility by presenting both Indigenous figures as confused and in disadvanta-
geous positions. Chairman Sekaquaptewa (the figure labeled "Abbott S.") is emerg-
ing from a kiva, an almost accidental witness to Boyden's seemingly imminent
attack. The figure on the left, a Diné man, stands outside the bounds of the Joint-
Use Area, his feet on decidedly lower ground than Boyden's. The white man has
the high ground, which is important in a battle. With the Diné man's hands be-
hind his back and his eyes closed, it is clear that he is at Boyden's mercy.

Though the Diné man is most obviously in danger, both he and the Hopi figure
are in peril. Both are confused regarding the behavior of the white man in their
midst, and both are facing immediate risks: the Diné from Boyden's likely attack
and the Hopi from the dangers associated with mines. The Indigenous figures'
shared confusion, denoted by the question marks over their heads, points to the
absurdity of Boyden being in charge. First, he had no natural ties to the land.
Second, since he was not Indigenous, he had no reason to spill anyone's blood and
guts, although the threat of harm historically attended many colonial legal inter-
ventions across Dinétah and Hopituskwa. Finally, Boyden's decision to use a pro-
noun of association ("we") despite his lack of meaningful connection to the land
reveals his lack of understanding of the social networks and kinship ties that bind
people together across Indigenous landscapes. Both the Hopi and Diné figures
in this cartoon approach the threat of the war dancer with a gentle puzzlement,
allowing Boyden to become a caricature of himself through his poorly conceived
displays of power. Boyden represents the ongoing colonial threat of white men
claiming to own land they have taken by force. White men's power plays, accord-
ing to "The War Dancer," place the Diné in peril. In fact, relentless interventions
into sacred space and continuous material extraction endangered both tribes.

The Four Corners region was at the mercy of multiple proposals for division
during the spring of 1974. In January of that year, Diné and white leaders had met
to discuss partitioning Apache County, which at the time included both Native
American and United States territory.[18] The partition proposal, illustrated a few
months later in "Proposed Apache County Split" (figure 4.6), was to divide the
county in half along the existing reservation line. Publicly, the non-Indigenous
inhabitants of Apache County characterized the division as being in the best in-
terests of the Diné. The *Tucson Daily Citizen* advertised Canyon de Chelly County,
established on April 26, 1974, as "giv[ing] the Indians the full effect of their 81
percent dominance in population."[19]

Diné chairman Peter MacDonald had a different perspective regarding the pro-
posed partition. He characterized it as inherently racist and politically damaging

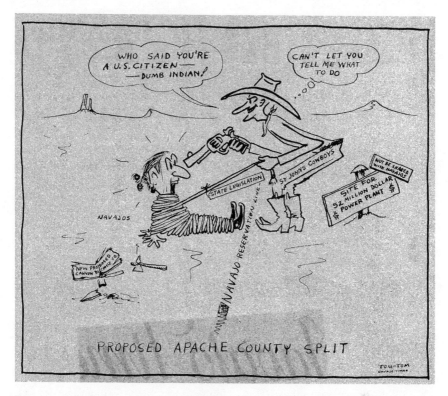

Figure 4.6. Clare Thompson, "Proposed Apache County Split," pen-and-ink drawing, *Navajo Times*, April 11, 1974, A2. Courtesy of Sequoyah National Research Center, University of Arkansas at Little Rock

to Indigenous interests.[20] MacDonald, in a Flagstaff hearing, argued that "the split will not protect the voting rights of the Indian people." Rather, "the bill is discriminatory. It clearly separates Indians and non-Indians in Apache County."[21] He suspected, the *Arizona Republic* reported, that the inhabitants of the southern portion of the county were tired of being outnumbered three-to-one by their Diné neighbors in most elections.[22] MacDonald argued that by creating cleavages in voting districts, the bill would disenfranchise citizen-residents on protected lands and Indigenous people who lived off the reservation, and it would limit the rights of Natives as United States citizens.

"Proposed Apache County Split" emphasizes the deleterious consequences of using race as a metric for dividing land, the problem with deriving power from force, and the question of citizenship. It also addresses issues of resource extrac-

tion, which were foundational to the question of land use and landownership in the Southwest. The predominant visual argument in Thompson's editorial cartoon is that racial and ethnic tensions between the Diné and their non-Indigenous neighbors would not be solved by dividing Apache County. Rather, Thompson's image indicates that the material interests of non-Natives—which could only be realized at the expense of Indigenous land and resources—would have more legal weight after partition.

Perhaps the most striking element of "Proposed Apache County Split" is the antagonistic relationship between the Anglo and Diné figures. The Anglo is depicted as extreme: labeled "St. Johns Cowboys," he is an implied member of an aggressive group targeting Indigenous people. A gun in one hand and a rope labeled "state legislation" in the other, the white cowboy has immobilized the Diné man, is threatening to drag him over the line denoting protected reservation space, and is holding a revolver to his head. The Diné figure, bound and partially gagged by the ties of state legislation, has his eyes wide open in sheer terror. For Thompson, the Anglo support of partitioning the land had nothing to do with the best interests of the Diné and Hopi peoples. Rather, it was about control: of the land, of the legislative process, and of Indigenous bodies.

This cartoon also clearly addresses Indigenous citizenship. The Diné figure— mute in terror—is subjected to the Anglo man's verbal assault: "Who said you're a U.S. Citizen—Dumb Indian!" This statement references the long fight for citizenship that Indigenous people faced in New Mexico after the passage of the Indian Citizenship Act of 1924. Indeed, after 1924, Arizona and New Mexico were the only states with large Indigenous populations that refused to grant Native Americans citizenship. New Mexico cited its state constitution (Article VII, section 1), which prevented Native people who were not taxed from voting.[23] Though many Natives *were* subject to various taxes, they did not challenge the state's move for fear of reprisals against their nation's sovereignty.[24] It wasn't until President Harry Truman's Committee on Civil Rights condemned New Mexico in 1947 that attention was shed on the issue, and Natives finally became citizens in New Mexico in 1948.[25] "Proposed Apache County Split" addresses this fundamental inequity and the racism that ran deep in many white communities of the Southwest. Even in 1974, the real issue for a significant number of the whites supporting the division of Apache County had little to do with borders, boundaries, or citizenship, but everything to do with perceived racial divisions in voting trends.

For many whites, extractive energy enterprises were threatened by Indigenous interests, which tend to privilege the health of the land over financial gains. The

sign on the Anglo side of the border in figure 4.6 reads "Site for 52 Million Dollar Power Plant" and is adorned with dollar signs. The implication is that if it were left up to the Diné, this power plant might be voted down. But with the county partition, the ability of the Diné to vote for the best interests of the land would be overshadowed by white interests. Despite the Diné inability to control the construction of the proposed power plant, the proximity of the plant to Diné sacred spaces guaranteed that they would have to contend with its environmental impact. In this case, the Navajo Reservation line did little to protect Diné from white intervention. Instead, the boundary limited their ability to protect the health of Dinétah from the far-reaching assault of United States–backed extractive enterprises.

In many ways, the Apache County split dispute was a microcosm of the issues at stake in the Navajo-Hopi Land Dispute. In both cases, the press characterized the relationship between Indigenous peoples and non-Natives as internal clashes between inhabitants sharing the land. This is not to say that localized conflict on disputed land was a myth in either the Apache County case or the Navajo-Hopi Land Dispute. Rather, ethnic tensions were overshadowed by a larger fight for the control of land, resources, and political power. For Diné and Hopi communities, as later cartoons emphasized, the relationship between tribal political authority and the state often became subsumed in larger debates over self-determination and tribal recognition.

In "Walking Backward?" (figure 4.7), the tension between self-determination and negotiating bureaucratic hurdles to ensure political success is thrown into stark relief. Here, a Diné man is depicted as biologically twisted: his head, torso, and thighs face one way while his lower legs face another. He employs a magnifying glass, closely examining his own footsteps. An arrow at the bottom of the image and the caption "Walking Backward?" suggest that there is a connection between the land marked "Bureaucracy Red Tapes" and land labeled "Indian Control: Self-Determination." And yet, despite this connection, the Diné are caught in the middle of two mutually exclusive ways of life, unable to move forward or backward.

The depiction of the Diné man in this cartoon suggests that his culture is being risked by the tension between the United States government and tribal attempts at self-determination. The only traditional features of the Diné figure in this image are his long hair, tie, moccasins, and belt buckle. The rest of his attire consists of nontraditional items, a marked difference between this image and other editorial cartoons published in 1974 in both the *Navajo Times* and *Qua'Töqti*. The man's

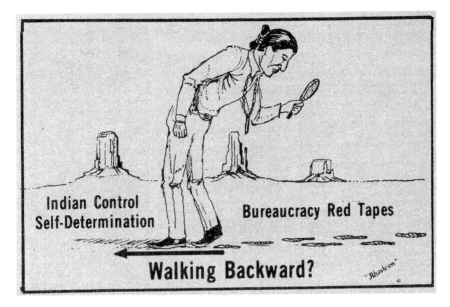

Figure 4.7. Jack Ahasteen, "Walking Backward?," pen-and-ink drawing, *Navajo Times*, May 30, 1974, A3. Courtesy of Sequoyah National Research Center, University of Arkansas at Little Rock

western clothing—his slacks and his button-up shirt—is another symbol of the backwardness being thrust upon Diné; the man's identity is overshadowed by garments that represent bureaucracy, assimilation, intervention, and the United States government as a whole.

In May 1974, regional newspapers, including the *Albuquerque Journal*, the *Arizona Republic*, and the *Gallup Independent*, all reported on the Navajo-Hopi Land Dispute, underscoring the legislative and bureaucratic obstacles that blocked a long-term equitable solution. One hurdle, in the eyes of Lujan, whose written testimony was reprinted in a May 8 article, was the US government. He wrote, "The most shameful aspect of the Navajo-Hopi land dispute is that it has been caused entirely by the United States government itself." He went on: "Having created the problem over the past 100 years, we now order (were the partitioning bill to be passed) the Navajos to take the blame and pay for our mistakes by giving up their homes, their land and very possibly their lives."[26] By 1974 it was not only Diné and Hopi attributing the cause of the dispute to the actions of the US government—it was US government officials themselves.

The *Arizona Republic*, the day after "Walking Backward?" appeared, condemned

the United States government's continued intervention in Diné ways of life. The *Republic* focused on recent contempt charges against the Diné for failing to reduce their herd sizes. Rather than justifying smaller herds, the paper printed Chairman MacDonald's statement, in which he explained that recent legislation "will only renew the government's long-shameful policy toward the Indian people (as well as) renew the Trail of Tears, the Long Walk, Wounded Knee, and other atrocities in the name of civilization against the first Americans."[27] The step backward not only would likely endanger Indigenous ways of life, it also could very well reinforce a dangerous precedent for the United States government: opting for forced removal as opposed to searching for long-term solutions to conflicts over land use and resource management. Figure 4.7 vividly suggests the real threat of a move back toward the termination era, when assimilation was the stated goal of the federal government.

Many Diné and Hopi people believed that long-term solutions to the conflict needed to stem from intertribal cooperation. Diné politician Daniel Peaches, who served in the Arizona legislature from 1975 to 1984, wrote a letter to the editor of the *Navajo Times* in which he called attention to the vulnerability of all Indigenous people at the hands of the United States government: "The Indian people can differ on many issues but because of our minority status we cannot afford to exhaust our total resources to get our way in any dispute or disagreement."[28] Rather than calling attention to tribal differences, Peaches underscored the potential for great political power that rested in tribes' shared experience. His rhetoric was in line with the pan-Indian movement, which was exceptionally strong in the 1960s and 1970s and underscored the importance of unity, power, and the shared experiences of people from different tribes. For the people of Dinétah and Hopituskwa, the violations both tribes had endured at the hands of the federal government justified a collaborative effort to end the conflict.

The long peaceful history between the Diné and the Hopi proved to be an important theme in 1974 Diné and Hopi publications as the leaders for both tribes reframed the conversation regarding the inception of the conflict. The *Navajo Times* published statements that boldly called for "recreat[ing] the harmony which for so long characterized Navajo-Hopi relations."[29] The *Clovis News-Journal* reported Hopi tribal chairman Sekaquaptewa's statement: "It would be 'an abdication of responsibility' for the government to say that it was an Indian dispute . . . because 'the lack of enforcement by the federal government allowed the Navajos to occupy the land.'"[30] Even in cases where intertribal animosity contributed to the tenor of public conversations, the general consensus in regional newspapers

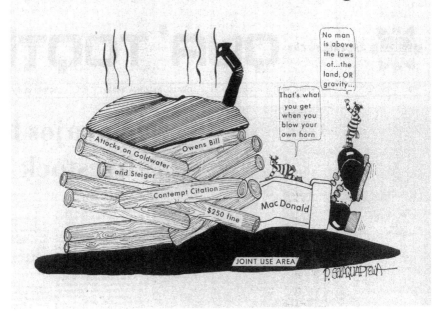

Figure 4.8. Phillip Sekaquaptewa, "And the walls came a tumbling down," pen-and-ink drawing, *Qua'Töqti*, June 6, 1974, 2. Courtesy of Sequoyah National Research Center, University of Arkansas at Little Rock

was that the ultimate responsibility for the Navajo-Hopi Land Dispute rested with the United States government. Yet, despite the many calls for a peaceful resolution, the United States legal system resulted in further social and legal hardships for the peoples of the Four Corners region.

On May 29, 1974, the House of Representatives passed the Owens bill, HR 10337, which called for the partition of the Joint-Use Area.[31] The *Qua'Töqti* cartoon titled "And the walls came a tumbling down" (figure 4.8) depicts the passage of HR 10337 as a significant victory for the Hopi. In this image, Navajo chairman MacDonald is only visible from the knees down: his head and torso are covered by the smoking ruins of a hogan. He is buried by logs labeled "Owens Bill," "Attacks on Goldwater," "and Steiger," "Contempt Citation," and "$250 fine." The *pai'yakyamü* are celebrating, with one crowing, "That's what you get when you blow your own horn," and the other agreeing, "No man is above the laws of . . . the land, OR gravity . . ."

The image of MacDonald crushed under the weight of the Owens bill and his own mistakes suggests that some Hopi leaders considered the legislation to be a righteous solution to the Navajo-Hopi Land Dispute. Regional non-Indigenous papers, despite thinly veiled nonpartisan rhetoric, agreed, often emphasizing the supposedly generous terms of the bill. The *Gallup Independent* reported that the legislation provided $28.5 million for resettlement costs, continued joint ownership of the subsurface minerals on the Joint-Use Area, and allotments for Paiutes living in the Joint-Use Area, and it included the Owens amendment, which provided 250,000 acres of public land in New Mexico and Arizona for the Diné.[32]

Non-Indigenous news services also supported relocation as defined by the Owens bill. Some went further and actively condemned the Diné for fighting to remain on the land. Reporter Martin Waldron presented the conflict in the following way: "The Hopis used about half the land set aside for them to raise sheep and vegetable gardens. Navajos, traditional enemies of the Hopis, moved in and occupied the remainder of the land. . . . The Navajos have refused to acknowledge that the Hopis have a right to any of the disputed land, pointing out the Hopis have never lived there and the Navajos have for generations. The Hopis have accused the Navajos of ruining this land by overgrazing it, a position that agriculture experts of the bureau support."[33]

Waldron's report created an unfavorable juxtaposition of the two tribes. First, he presented the Hopi as nearly assimilated stewards of the land while characterizing the Diné as "traditional" (indicating a lack of modernity) and unaware of their ecological impact on the Joint-Use Area. Second, rather than presenting the Diné claim to the land as stemming from their indigeneity, Waldron characterized them as relatively recent interlopers. Finally, he linked the opinions of the Hopi and white agriculture experts to shore up Hopi claims while insinuating that Diné traditional lifeways jeopardized the health of the contested land. As a whole, Waldron's statement served as a multipronged argument for dispossessing the Diné of joint-use lands.

Waldron was not alone in his perspective. Other *bilagáana* regional newspapers revealed a bias in favor of Hopi ownership of the Joint-Use Area during the summer of 1974.[34] "And the walls came a tumbling down" suggests that MacDonald's "attacks" on Goldwater and Steiger may have been one of the reasons some white politicians favored the Hopi. In fact, a front-page *Qua'Töqti* article accompanying the cartoon suggested as much: "Chairman Peter MacDonald of the Navajo Tribe, who in the final days before the House acted on the Owens bill, openly attacked U.S. Senator Barry Goldwater (R-AZ), and U.S. congressman Sam Steiger (R-AZ),

for their support of the Owens bill, charged the House of Representatives with expediency and 'blind adherence to mistakes of the past' for their overwhelming approval of the Owens bill."[35] As the cartoon makes plain, any legislative favor that the Diné may have been hoping for was significantly hampered by their unstable relationships with unreliable United States politicians.

The Diné were aware that their public image suffered from MacDonald's behavior, unbalanced regional press coverage, and the Hopi's strong relationships with their non-Indigenous representatives. However, some Diné activists were so angry at Goldwater over his pro-Hopi actions that they couldn't help but act out too. Cartoonist Jack Ahasteen remembers one instance in the dispute years when Diné activist Roberta Blackgoat confronted Goldwater as soon as she got physically close enough to him to do so. "When Barry Goldwater showed up in a helicopter she went there and grabbed him by the neck," he says.[36] Still, other Diné wanted to deescalate political tensions. Diné citizen and Arizona state representative Ben Hanley attempted to mediate the situation at the 1974 meeting of the All Indian Pueblo Council (now the All Pueblo Council of Governors) of New Mexico. Hanley's comments at this meeting revealed the extent to which the so-called dispute was crafted by Republican politicians' manipulation of the media:

> Although the newspapers and television and certain congressmen, particularly Sam Steiger, have made a lot out of the unfriendliness and hostility of the two tribes, this is really a smokescreen created to produce an atmosphere for the passage of the Owens-Steiger Bill. . . . No, the land dispute is not a land dispute between tribes. It is the dispute of two tribes with the old friend, the Bureau of Indian affairs [sic]. . . . Now, I would be one of the first to admit that Hopis and Na[va]jos have lived intermingled and intermarried for centuries. It is not very Indian-like for any of us to argue among ourselves about "who owns the land." This is white man's talk—the pride of ownership, the heritage of greed and avarice, the insecurity that causes one Anglo to fight another over material things.[37]

Despite Hanley's plea, the All Indian Pueblo Council voted to support the Hopi in the Navajo-Hopi Land Dispute. Still, Hanley's statement revealed that material ownership, the issue most covered in white media, was not a significant factor in the dispute for Indigenous peoples of the Four Corners region. Rather, the conflict was important to the Diné because the scarcity of space threatened their ability to commune with the land, maintain kinship networks, and graze livestock. Ultimately, this was a battle not between tribes but between European and Native conceptions of landownership.

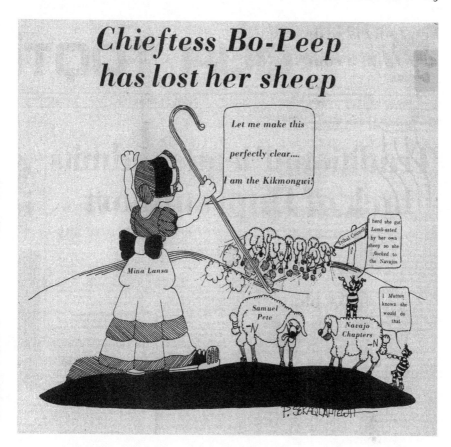

Figure 4.9. Phillip Sekaquaptewa, "Chieftess Bo-Peep has lost her sheep," pen-and-ink drawing, *Qua'Töqti*, June 20, 1974, 2. Courtesy of Sequoyah National Research Center, University of Arkansas at Little Rock

The Hopi also remained apprehensive about their ability to maintain their traditional lifeways during the summer of 1974. Intertribal divisions were especially concerning to the publishers of *Qua'Töqti*, whose editorial cartoons commented on the fractured social landscape across Hopituskwa. In "Chieftess Bo-Peep has lost her sheep" (figure 4.9), Sekaquaptewa uses a white nursery rhyme to question the alertness and abilities of Mina Lansa, the Hopi *kikmongwi* who inherited her position from her brother in 1967.[38]

Despite the fact that her presence—perhaps her very existence—shone a light on persistent intertribal hostility and divisions, which continued to complicate the Navajo-Hopi Land Dispute, Lansa considered herself to be a unifying political

figure. In an August 1, 1974, *Los Angeles Times* article, she was quoted as saying, "I represent all living things. . . . You should not divide men, because all living things go together."[39] She fundamentally believed in the ability of Diné and Hopi to work together to solve their differences: "The traditional Navajo and Hopi people can resolve these issues by themselves. . . . We do not need these bills now, and we will tell the senators and congressmen if we do need them. . . . It is not true that the traditional people of our two tribes are unable to agree on this matter."[40] Lansa's statement was powerful in a number of respects. First, she attributed the root cause of the conflict to outside intervention in Indigenous affairs. Second, she challenged the idea that Native peoples were unable to request United States government assistance when they needed it. Finally, she stated that despite differences in opinion between the traditional people, they could achieve peace without outside intervention and without nontraditional Hopi and Diné, who held less authority in her eyes.

Lansa may have downplayed tribal divisions in interviews with non-Indigenous press outlets, but the picture painted in figure 4.9 and its attending *Qua'Töqti* editorial reveals that her spiritual and political leadership did not reflect the interests of all Hopi tribal citizens. Some of those citizens, in fact, displayed downright hostility toward the Diné and toward Lansa's position. One Hopi man, Dalton Taylor, wrote to the editors of *Qua'Töqti* with what sounded like a threat to her life: "She is supporting the enemy who may someday soon come up and kill one of her family. Will she like this?"[41] Taylor had no evidence to support his claim, but the tone of his statement was clearly ominous.

That personal bias grew from Taylor's objection to women in positions of power. He gave himself away early in his letter: "I respect Mina as a female but I don't respect her as a chieftess because male chiefs are the only ones who can participate in kivas during the sacred religious ceremonies. . . . She is only good for calling unnecessary meetings that don't concern the Hopi people of her village."[42] Taylor's misogyny comes through clearly, but reading between the lines, it is equally clear that Lansa took the time to foster intra- and intertribal communication, valued the opinions of people in her village, and believed in the opportunities that would come with recognition of each tribe's power as an autonomous and sovereign political entity.

The tension surrounding Lansa's position can be seen in "Chieftess Bo-Peep has lost her sheep." Lansa, dressed as Little Bo-Peep, stands in the foreground of the image, calling to her flock, "Let me make this perfectly clear . . . I am the Kikmongwi!" Her Hopi flock is disinterested in her authoritative status and is

rushing away from her toward a sign reading "Tribal Council." Meanwhile, Lansa is attended by two Diné sheep. One is labeled "Samuel Pete." The other is labeled "Navajo Chapters," referencing a cohesive group supporting Lansa's position. The *pai'yakyamü* are in the lower right. One puns, "I herd she got *Lamb-asted* by her own sheep so she *flocked* to the Navajos." The other agrees: "I *Mutton* known she would do that."

The real difference between the sheep running away from Lansa and the Diné sheep grazing next to her rested in their respective opinions on how best to negotiate within the United States political system. Samuel Pete, director of the Navajo-Hopi Land Dispute commission, believed that relocation had to be stopped at all costs due to the hardship it would impose on elderly, illiterate Diné who spoke only Navajo.[43] He argued, "Washington officials feel that these people are just like the people they see in downtown Washington. They think these people can adjust easily to a different environment. This is not the case. They wouldn't understand why they would be required to move when someday the National Guard comes and asks them to leave in two days."[44] For Pete, humanitarian concerns were more important than tribal disagreements. Therefore, allying himself with Lansa allowed for the possibility of productive communication across tribal lines.

The fact that the *pai'yakyamü* says that Lansa was flocking to the Diné underscores the deepening divisions across the Indigenous landscape during the summer of 1974. The opinions and perspectives of the Hopi Tribal Council were so far from those of their spiritual leader that the peaceful solution many Diné and Hopi called for was unlikely. This cartoon argues that despite powerful alliances between Diné and Hopi leaders, nothing had changed: resources on the land were still being sought by corporations like Peabody Energy, personal property in the disputed area remained contested, and factionalism in both tribes threatened to worsen these issues.

Despite the elevated stakes throughout the summer of 1974, political cartoons in *Qua'Töqti* and the *Navajo Times* never lost their humorous perspective. In "Navajo-Hopi dispute" (figure 4.10), the artist presents the conflict through the image of a picnic gone awry: one man throws another into the air by pulling a picnic blanket out from under him. He says, "Its big enough for both of us, but you'r sitting on my blanket!" The image relies on physical comedy to make a point, but also references the fact that the foundation of the Navajo-Hopi Land Dispute was an altercation over ownership. It is not, the artist contends, that there is too little land for both tribes; it is simply that the tribes are unwilling to share the land.

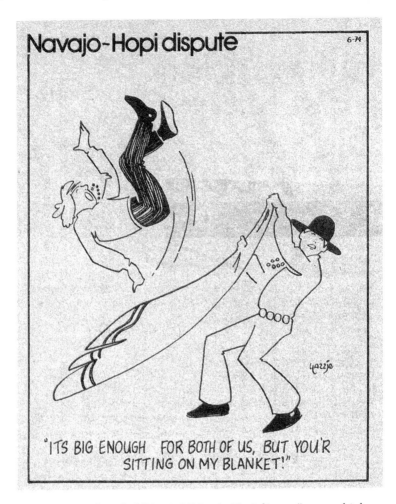

Figure 4.10. Unidentified "Yazzie," "Navajo-Hopi dispute," pen-and-ink drawing, *Navajo Times*, July 11, 1974, A2. Courtesy of Sequoyah National Research Center, University of Arkansas at Little Rock

The use of comedy in this cartoon reflects the resilience and power associated with the Indigenous perspective, reasserts the ability of Diné to live their lives within a contentious political landscape, and provides a counter to the popular culture representation of the stoic, humorless Native. As the historian Vine Deloria Jr. explained, "It has always been a great disappointment to Indian people that the humorous side of Indian life has not been mentioned by professed experts on Indian affairs. Rather, the image of the granite-faced grunting redskin has

been perpetuated by American mythology."[45] Humor has been a weapon of resistance against colonial oppression, a remedy against sorrowful circumstances, and a tool for promoting cross-cultural understanding.

In the twentieth century, comparative humorists such as rhetorician Hélène Cixous argued that humor can powerfully assist in the political and social advancement of subaltern communities.[46] As a tool for empowerment, it can be used both to defuse protracted struggles and as a weapon to highlight injustice or instigate conflict.[47] Humor then becomes a source of cultural survival. It can also, according to literary scholar Ulrike Erichsen, "fulfill a mediating function: indicating differences in cultural practices but also bridging gaps in cultural knowledge."[48] For Indigenous activists and cartoonists, this is certainly true. As the Laguna Pueblo author and activist Paula Gunn Allen eloquently explained, "Humor is the best and sharpest weapon we've always had against the ravages of conquest and assimilation. And while it is a tiny projectile point, it's often sharp, true, and finely crafted."[49] This applies to many Native communities. Humor has the power to create, destroy, and provide social cohesion—an equalizing power regardless of an Indigenous community's material wealth.

The main themes in the Hopi and Diné editorial cartoons of 1974 were often not funny. Rather, many were poignant representations of untenable situations. Yet the *pai'yakyamü* in the *Qua'Töqti* cartoons and the physical humor in the "Navajo-Hopi dispute" cartoon present the often unspoken "other side" of the humorous intervention in the political landscape: the side embodied by United States officials. As sociolinguistics expert Keith Basso noted in 1979, "jokers use jokes to make sense of Whitemen [*sic*]."[50] Sekaquaptewa, Thompson, and others used humor to make sense of the Navajo-Hopi Land Dispute.

For the Diné, lampooning inequity and material privation was not limited to editorial cartoons. In April 1974, for example, many Diné responded to Steiger's Third District mail poll inquiring about fuel scarcity following the 1973 energy crisis and oil embargo with decidedly humorous responses. When asked whether they were experiencing shortages, many Diné answered with a resounding yes. They reported that they were short of raisins, cranberries, love, money, sauerkraut juice, Coors beer, snuff, sense, toilet paper, brains, Twinkies, tempers, and patience, among other things.[51] Of course the real, unwritten answer was *everyone is short of fuel*. Poking fun at the question, though, subverted the power relationship between petitioner and responder and established a model for further social cohesion: Diné experiencing privation were together on the inside, while the unaware pollster was on the outside. These joking responses to Steiger's poll,

like the message in many editorial cartoons, used humor to ridicule long-standing structural inequities that pitted Indigenous peoples against each other at the expense of land, community, resources, and tradition. Humor prevailed where politics failed to provide hope, harmony, and social cohesion.

As journalist Emily Benedek noted in her 1992 text, *The Wind Won't Know Me*, "the power of the energy companies was never too far in the background throughout the [Indigenous] discussions of the land dispute."[52] Indeed, from the perspective of corporate prospectors, the emptier the land the better; after all, large tracts of uninhabited land were best for strip-mining. Emptying the land of Natives was, by 1974, a centuries-old colonial strategy in the United States. As the untitled image in figure 4.11 suggests, many Diné believed that energy companies' preference for the Hopi side of the dispute was based on the probability that the Hopi would grant them access to subsurface minerals. Unlike the Diné, Hopi leaders did not have a history of going on the record to report the environmental consequences of disturbing the land.[53]

The August 1, 1974, *Navajo Times* cartoon (figure 4.11) reflects Diné cartoonist Jack Ahasteen's perspective regarding the competing interests in and uneven paternalism across Dinétah and Hopituskwa. Ahasteen at the time was learning from Clare Thompson. "When I came into being a cartoonist I had a mentor," Ahasteen remembers. "[Thompson] was working for the government . . . [and] he submitted the cartoons [to the *Navajo Times*] as freelance. . . . I'd be the first one to look at the cartoon and ask him all the questions you're asking me: 'What does your boss say to you?' 'What does the tribal government say to you?'" Ahasteen recalls Thompson's fearlessness and support of his young protégé: "I'd ask him these questions: 'How do you come up with this stuff?' 'How do you get the information?' I'd show him cartoons I did and he'd say, 'Just keep on going, just do it.'"[54] That support was instrumental in Ahasteen's ability to persist in a difficult field, particularly after Thompson passed away in a plane crash in December 1974.

From the beginning, Ahasteen's cartoons revealed tensions in the relationships between Indigenous nations and industry. The welcome sign in figure 4.11 suggests a clear connection between Hopi tribal lawyer John S. Boyden and Peabody Coal. Each respective interest has its own slogan painted on the sign: Boyden is presented as the "Great White Father," while Peabody Coal Co. shouts, "Nothing's Quite as Fine as a Hopi-Strip Mine (or as Cheap, Either)." Through this cartoon, Ahasteen asserts that material rather than cultural interests motivated Hopi leaders in the dispute.

Despite the message in figure 4.11, not all Diné were opposed to energy devel-

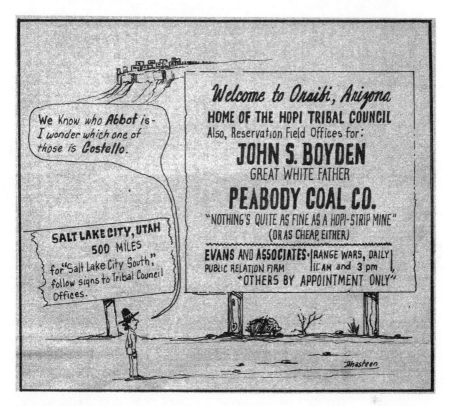

Figure 4.11. Jack Ahasteen, untitled pen-and-ink drawing, *Navajo Times*, August 1, 1974, A3. Courtesy of Sequoyah National Research Center, University of Arkansas at Little Rock

opment. In fact, the tribe negotiated throughout 1974 with the Texas Eastern Transmission Company and Southern California Gas to build multiple coal gasification plants on Dinétah.[55] At the same time, many Diné were concerned about increasing evidence of resource extraction without compensation for the Diné nation or its citizens. As Navajo chairman MacDonald said in 1980, the interest that energy companies had in the generative potential of the Four Corners region rested in their desire not only to "get the resources and the land, as much of it as possible, through partitioning it and taking it away from the Navajos" but also to "punish me and the Navajo Tribe for refusing to let the energy companies steal our resources again."[56]

Energy companies were not the only outsider groups influencing both Diné and Hopi citizens' daily lives. The public relations firm Evans and Associates is

presented in Ahasteen's untitled cartoon as the host for daily range wars ("11: AM and 3 pm")—as a perpetrator of the land dispute. As reported by Mark Panitch of the *Washington Post* and Anita Parlow for the *Multinational Monitor*, Evans and Associates represented the Hopi Tribe at the same time that it represented Western Energy Supply and Transmission Associates, which had an "interest in coal development at the Navajo Burnham plant."[57] This was obviously a conflict of interest and an ethical breach.

Though Evans and Associates ostensibly worked for the Hopi, the public relations company did little to improve the relationship between the two tribes or the public's perception of the conflict. In fact, the PR firm had a history of constructing photos and stories to make the land dispute look worse than it was. As Panitch reported, "During 1970–1972, few papers in the Southwest escaped having a Sunday feature on the 'range war' about to break out between the two tribes. Photos of burned corrals and shot-up stock tanks and wells were printed, although such incidents were not widespread."[58] This deceit was not limited to information presented to the public in print media. Indeed, "by calling Evans and Associates, a TV crew often could arrange a roundup of trespassing Navajo stock. Occasionally when a roundup was in progress, southwestern newsmen would be telephoned by Evans and notified of the event."[59] The result was shocking images of Dinétah and Hopituskwa destroyed by violence, which were projected into thousands of non-Indigenous homes.

Though vilifying the Diné was ostensibly in the interest of a client of Evans and Associates—the Hopi Tribe—the firm's tactics convinced US citizens that intervention needed to take place in the Four Corners region. By staging events for the press that made the Navajo-Hopi Land Dispute appear more violent than it actually was, Evans and Associates contributed to white politicians' false perceptions about intertribal conflict in the Joint-Use Area (and, subsequently, their push to partition the land for the so-called good of its inhabitants). Panitch's reporting shocked United States lawmakers, some of whom referenced his article in a hearing before the Senate's Committee on Interior and Insular Affairs.[60]

In the July 24, 1974, hearing, United States senators and other officials questioned the chairman of the Hopi Tribal Council, Abbott Sekaquaptewa, and attorney John S. Boyden regarding their role in the dispute and their relationship to Evans and Associates. Neither officials nor witnesses were under oath during the investigative hearing, so it is unlikely that the hearing resulted in complete disclosure. Still, the tenor of the questions suggests that at least some United States officials were concerned about the links among energy interests, Evans and Asso-

ciates, and the partition of tribal land. Deep into the proceedings, Senator James Abourezk (D-SD) confronted John Boyden with Panitch's findings: "I just want to read a paragraph out of this 'At the same time, Evans & Associates was representing the Hopi Tribe from 1970 to 1973, they also represented a trade association of 23 utility companies engaged in building power plants and strip mines in the Four Corners Area. The group was called West Associates. The mailing address was the same as Evans & Associates.' Is there any connection between the agency that the Hopi Tribe seems to see or at least representatives of the tribe seem to see in getting the land divided?"[61]

Boyden responded by claiming, "Evans Advertising has nothing to do with Peabody Coal Co. and nothing to do with leasing."[62] Other officials recognized that this general denial did not, in fact, address Abourezk's concerns. Senator Dewey F. Bartlett (R-OK) noted after Boyden's response to Abourezk, "[That] is a rather interesting answer you gave."[63] Both senators clearly doubted that Boyden was presenting all relevant information and continued to question both him and Sekaquaptewa. Abourezk again asked, "So to your knowledge, Mr. Boyden, or Mr. Chairman [Sekaquaptewa], there is no connection between the urgency you see in separating this land and moving the Navajos off and any desire on the part of the utility companies or coal companies to get in there and get out the resources on the joint use area?" Sekaquaptewa gave the pat answer: "No, not as far as I know."[64] Boyden stayed silent. By intentionally muddying the waters regarding the connection between Peabody Energy and Evans and Associates, Boyden and Sekaquaptewa turned the hearing into something similar to an Abbott and Costello comedy sketch, as the Diné character in the foreground of figure 4.11 suggests.

The narrow parameters of the July 1974 investigative hearing prevented the federal government from enacting punitive measures against Evans and Associates or their affiliates, even though both had a vested interest in partitioning the Joint-Use Area. The US government, which had the power to settle both tribes on the Joint-Use Area, now found itself unable to disentangle the corporate and political ties that bound energy interests closely to partition supporters.

This *Navajo Times* cartoon (figure 4.11) is a brilliant example of polysemic representation. The huge sign overpowers the village in the background while the desolate landscape reminds the viewer that many material resources have already been stripped from the land. Finally, the almost complete lack of people in the image suggests that the conflict was, in some ways, out of the hands of those most affected by it. The solitary Diné man stands alone, his fate in the hands of white governmental officials, public relations operatives, and energy extraction interests.

This cartoon shows that Diné and Hopi citizens were aware of the games being played by United States lawyers and politicians, and they knew that United States interventions were unlikely to benefit any residents of Dinétah or Hopituskwa.

Many of the themes first explored in the August 1 issue of the *Navajo Times* returned a week later. In figure 4.12, drawn by Diné cartoonist Clifford Beck Jr., Abbott Sekaquaptewa says, "But, all I want is land for my 'people.'" Rather than depicting his "people" as Hopi, however, the artist references Evans and Associates, Peabody Coal, the Department of the Interior, John S. Boyden, and the Mormon Church. Sekaquaptewa's "people" seem bent on manipulating him to achieve their own goals. Boyden, for example, is depicted as literally pushing the Hopi leader into the spotlight. As a result, the chairman stands on the Joint-Use Area, which the cartoonist labels "Navajo-Hopi Disputed Land." Sekaquaptewa was aware of *Navajo Times* depictions of him as a pawn of white, moneyed interests. On October 17, 1974, he was quoted in the *Gallup Independent*: "Peter MacDonald's charges that I am manipulated by a public relations consultant is further proof that he is willing to talk about anything except Navajos returning Hopi land to Hopis."[65]

For the Diné, Evans and Associates was only one of many concerns about white politicians' continued intervention in the land dispute. In fact, all of the non-Indigenous characters in figure 4.12 are depicted as thinking only of money, implying that they universally value extractive enterprise over the well-being of Indigenous peoples. The dollar signs in their thoughts stand in stark contrast to the information on Sekaquaptewa's political button: "Peaceful Hopi."

The Mormon Church was new to the body of political imaging in the *Navajo Times*. This figure—who is shown pushing Boyden, who in turn pushes Sekaquaptewa—symbolizes Diné distrust of Boyden's religious affiliation with the Church of Jesus Christ of Latter-day Saints. Journalist Jerry Kammer described Boyden as "a former bishop in the Mormon Church, a member of the international Academy of Tribal Lawyers, an unsuccessful candidate for the Utah governorship in 1948 and 1956."[66] In 1974, the Diné were very concerned by Boyden's former powerful post in the Mormon Church and his connection to Mormon interests.

Regional papers reached out to the Mormon Church in 1974 to ask about its relationship to the conflict between the Diné and the Hopi. In an August 5, 1974, article published in the *Daily Herald* of Provo, Utah, one Mormon representative confirmed that attorneys for both tribes were affiliated with the church, but he wished to "reaffirm our position that the LDS Church does not take sides in dis-

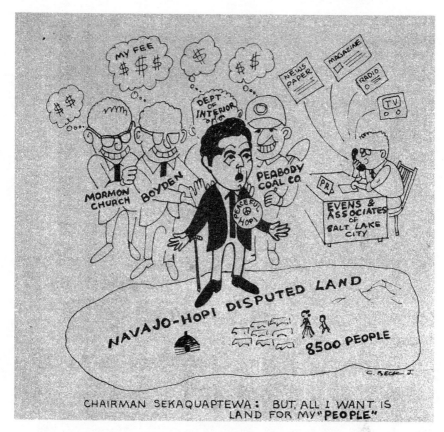

Figure 4.12. Clifford Beck Jr., untitled pen-and-ink drawing, *Navajo Times*, August 8, 1974, A22. Courtesy of Sequoyah National Research Center, University of Arkansas at Little Rock

putes of this kind. We would desire that the issue can be settled amicably between the two Indian tribes involved."[67] As this untitled cartoon suggests, the way in which the church influenced the ideology of leaders behind the dispute remained important in the minds of Diné and Hopi political actors.

The Mormon figure in figure 4.12 was a hidden message for the people who were aware that the owner of *Qua'Töqti*, Wayne Sekaquaptewa, was also president of the local Mormon Church.[68] He was not alone in his faith. As John Dwan, an Evans and Associates representative, stated, "The Mormon religion is the predominant Hopi (Christian) religion."[69] This cartoon indicates that some Diné were concerned that despite the Mormon Church's public denials of involvement

in the dispute, religious connections between Hopis and white politicians might profoundly influence the lives of the more than eight thousand Diné then living on contested land. Specific information regarding what may or may not have taken place in protected religious spaces does not exist in public records, but as figure 4.12 suggests, the Diné were concerned by the possibility of outside religious influence in the conflict.

The figures in this cartoon that characterize the church, Boyden, the Department of the Interior, and Peabody Coal are drawn as a shadow community; indeed, only Sekaquaptewa's character is more than a line drawing. Furthermore, only Sekaquaptewa is drawn standing on the land in question and verbalizes his perspective. Unlike other cartoons, in which Sekaquaptewa is depicted as a villain responsible for the conflict, here he is presented as a victim of others' manipulation. Figure 4.12 reveals that the conflict, in the eyes of at least some of the Diné, was made worse by outside manipulation, the interests of moneyed, non-Indigenous political actors, and the vulnerability of Indigenous representatives at the hands of better politically outfitted public figures.

As a leader, Sekaquaptewa did not represent the majority position within the Hopi Tribe. Benedek wrote, building on anthropologist Richard Clemmer's work, "[When he was] tribal chairman, Sekaquaptewa represented a minority of Hopis—those few who raised cattle, supported economic development including mineral exploitation, and who maintained a burning desire to teach the Navajos a lesson about right and wrong."[70] The cartoonist's choice to place Sekaquaptewa in front of non-Indigenous political actors accomplishes two things: it calls into question his position as a legitimate representative of a large body of Hopi people, and it suggests that his perspective may be colored by white politicians' financial interests in land use and economic policy.

Although there are many layers of information in this cartoon regarding Sekaquaptewa, representations of Diné people take up surprisingly little of the bottom right-hand corner of the image. By limiting the physical presence of the Diné in this editorial cartoon, the artist indicates that despite the 8,500 Diné lives at stake, the voices of Diné and Hopi people are muted by more powerful outside voices. Outsiders could magnify their perspective with money and pure power to be heard through multiple media at both the state and national levels. As the figure sitting at the Evans and Associates desk in this image suggests, the Diné message was limited by PR firms that controlled the story featured in newspapers, magazines, radio, and TV announcements.

Figure 4.12 is ultimately about more than the interests of the individuals be-

hind Sekaquaptewa's platform, the hidden messages behind the Hopi chairman's seemingly peaceful plea for land, and the connections between the Mormon Church, Boyden, and the Hopi people. It is also about the uneven landscape in which information and tribal communications were being filtered and altered prior to publication, likely at the expense of the relationships between important Indigenous political actors.

As the relationship between Hopi and Diné leaders came under increasing pressure, private negotiations became progressively less fruitful. "Negotiations" (figure 4.13) was published in *Qua'Töqti* and depicts the deep concern of Hopi people regarding the public negotiations over land use in District 6. In "Negotiations," one Diné man and one Hopi man sit on contested land within the 1882 reservation. The Diné, wearing a large hat, holds his arms out wide and says, "All this is mine and what[']s left is yours." The Hopi, holding a piece of paper that reads "Law and Order," affirms the Diné statement and evokes the Long Walk and Kit Carson's assault on the Four Corners region by saying, "That[']s what the man in the red shirt said." In this image, the Diné are represented similarly to federal enforcement officers, implying that to some Hopi people, the Diné were far from true allies, despite the fact that the United States government was to blame for the conflict writ large.

Meanwhile, two *pai'yakyamü* reinterpret the conversation, noting, "What's mine is mine . . ." ". . . And what's yours is 'negotiable!'" The cartoon elucidates Hopi concerns over tribal relations with the United States government and the failure of the diplomatic process, which left both Diné and Hopi people dissatisfied.

This cartoon appeared alongside an opinion piece titled "'Negotiation' May Be Delaying Tactic."[71] In this editorial, the *Qua'Töqti* staff member wrote, "The sole point of argument of Peter MacDonald, Navajo Chairman, in his stand on the land dispute seems to be 'negotiation.' . . . MacDonald could obtain more 'delaying time' in Washington this way, to enable his powerful political supporters to 'do their work' on legislation now in process in Congress to solve the dispute."[72] Unfortunately, as the accompanying image indicates, there was little the Hopi could do to avoid negotiation. For the Diné, continued negotiations allowed the conflict to potentially be resolved within the bounds of protected tribal space.

"Negotiations" suggests that tensions between tribal leaders were running high in the fall of 1974. Further, the breakdown in intertribal communications was one reason that the Ninety-Third Congress considered three state bills that each tried to manage the dispute. As the *Arizona Republic* reported on November 14, 1974, the AFL-CIO, the Senate Interior Committee, and senatorial political coa-

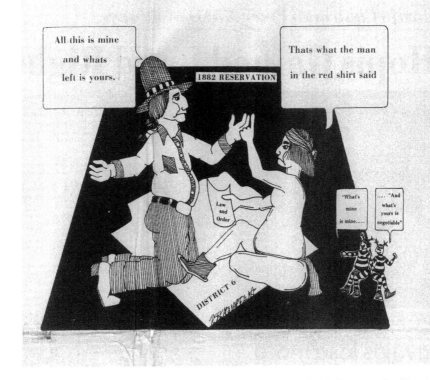

Figure 4.13. Phillip Sekaquaptewa, "Negotiations," pen-and-ink drawing, *Qua'Töqti,*
September 19, 1974, 2. Courtesy of Sequoyah National Research Center, University
of Arkansas at Little Rock

litions were all attempting to forward solutions in case tribal negotiations failed.
While these groups may have been motivated by financial interests in the land,
they were also attempting to avoid the reintroduction of old, unsuccessful legis-
lation during the new Ninety-Fourth Congress.[73]

As tensions in Washington escalated and relationships between tribal officials
continued to deteriorate, the question of protecting the land from ecologically
damaging resource extraction remained unanswered. One site of contention, as

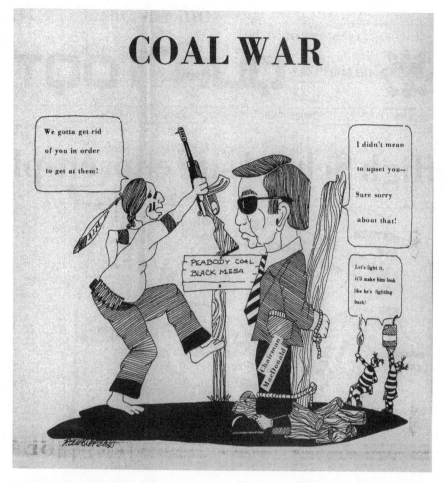

Figure 4.14. Phillip Sekaquaptewa, "Coal War," pen-and-ink drawing, *Qua'Töqti*, October 24, 1974, 2. Courtesy of Sequoyah National Research Center, University of Arkansas at Little Rock

explored in the October 24 *Qua'Töqti* cartoon titled "Coal War" (figure 4.14), was Peabody Coal's $800 million Navajo Power Project initiative.[74]

Regional news coverage focused on the supposed economic benefits that Native peoples could expect from the construction of multiple coal-fired generating stations across reservation spaces. The *Arizona Daily Sun* insisted that the completed power station would "provide about seven and a half million [dollars] annually in state and local taxes."[75] Even better, the plant would employ 300 op-

erators and would require 225 more workers at Peabody Energy's Kayenta Mine in Arizona. The paper noted that these workers would receive, in the aggregate, a total of $9 million per year. Finally, "coal royalties, lease payments and other contributions to the Navajo and Hopi tribes will exceed $1.8 million per year."[76] Should the newspaper's readers wonder about the ecological impact of the generating station or the increased mining on the reservation, they need not worry, for "more than $200 million has been allocated for environmental protection at the generating station, making it one of the cleanest in the world."[77] Clearly, the paper argued, the benefits of the power station far outweighed the costs.

And yet the ugly underside of the Navajo Power Project initiative loomed large for both the Diné and the Hopi. For many Native people, the negative impact of water taken from Lake Powell, increased strip-mining across Black Mesa, and the removal of people from their homes without adequate compensation all far outweighed the positive financial outcomes of corporations' presence on the land. The "coal war," Phillip Sekaquaptewa's editorial cartoon suggests, was not really between the Hopi and the Diné. Rather, it was between Native people and moneyed interests with their eyes on Indigenous land.

As the editor of the *Arizona Republic* reported, Peabody and its corporate affiliates benefited from access to the Joint-Use Area and did not compensate either the Hopi or the Diné for disturbing protected space. The editor of the paper wrote, "The most frequent complaint by local Navajos at present is lack of compensation for land-use area that has been disturbed by Peabody in the course of the strip-mine operation. I believe it is a legitimate complaint for it has been five years since operations began and not one settlement has been made for disturbed land-use area."[78] Had the land been solidly in the hands of one tribe or even in the hands of multiple private owners, such a policy would have been legally indefensible. However, because the ownership of the land remained ambiguous, Peabody was able to extract resources without compensating either the Diné or Hopi people.

While the plight of the land itself concerned the Hopi and Diné, a more immediate problem was the growing number of displaced people across Dinétah and Hopituskwa. Representatives of the American Indian Movement under Diné Larry Anderson, then AIM's national secretary, took action in October 1974. Anderson and five other AIM members stood strategically in front of a ten-story-high dragline in order to prevent continued coal-scraping operations across Dinétah.[79] As Bill Donovan reported for *Qua'Töqti*, "The demonstration at first was being held on behalf of Cecil Yazzie's family, who were forced to move from their hogans last September in order for their land to be strip mined."[80] Though Donovan went

on to report that Navajo chairman MacDonald was "sympathetic with the complaints of the Yazzie family and A.I.M.," he also noted that the Diné were acting as a mediator between the Hopi and Peabody Energy.[81]

As "Coal War" indicates, that Diné mediation drove another wedge between the two tribes. In this cartoon, MacDonald is depicted tied to a stake. He is immobile, passive, and disconnected from the urgency of the Hopi man, who desperately brandishes a weapon. In this image, MacDonald represents a barrier to progress. The Hopi man proclaims, "We gotta get rid of you in order to get at them!" MacDonald apologizes: "I didn't mean to upset you—Sure sorry about that!" MacDonald is presented as an ineffectual politician rather than as an active enemy of the Hopi cause. Still, the sacred clowns' message comes through loud and clear: "Let's light it, it'll make him look like he's fighting back!" In the eyes of Sekaquaptewa, MacDonald's mediation was an obstacle.

"Coal War" can help historians and others to better understand the land dispute. Figure 4.14 reveals that both tribes understood the so-called coal war to be about displacement, land use, and land management. As the forced removal of the Yazzie family shows, Peabody Energy had a vested interest in the Joint-Use Area's ambiguous ownership. Yet many Diné would still face displacement if the land were partitioned by the United States government. In the last months of 1974, editorial cartoons in *Qua'Töqti* and the *Navajo Times* revealed the many downsides to outside intervention in Native sacred spaces. The political artists in both newspapers seemed to have little hope that the struggle between Peabody Energy, the United States government, and the Diné and Hopi peoples would have a favorable outcome for the inhabitants of the Four Corners region. Still, as the armed Hopi man in "Coal War" reveals, the fight continued.

On December 5, 1974, Ken Sekaquaptewa reported for *Qua'Töqti* that the US Senate had passed the Hopi-Navajo bill HR 10337.[82] For cartoonist Phillip Sekaquaptewa, partition meant that representatives of the United States government had gained the upper hand over Indigenous peoples of the Southwest. Sekaquaptewa depicts the Senate's passage of the bill as a paternalistic act prohibiting Indigenous sovereignty and self-determination. In "Dividing the spoils," Uncle Sam towers over a Diné man and gives him more than half of a loaf of bread, which is labeled "Hopi Reservation" (figure 14.15). Uncle Sam condescendingly says, "Here is your share now. Don't eat it all at once!" The portion that he gives the Diné man far exceeds the size of the figure's plate, suggesting that the Diné received a disproportionately large share of the reservation. On the right-hand side of the image, the *pai'yakyamü* hold up a platter, waiting for their turn. "I hope there's some left

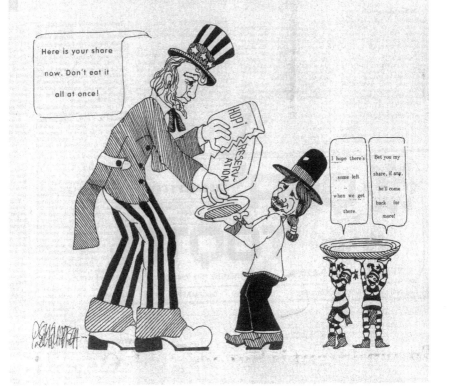

Figure 4.15. Phillip Sekaquaptewa, "Dividing the spoils," pen-and-ink drawing, *Qua'Töqti*, December 5, 1974, 2. Courtesy of Young Research Library, University of California, Los Angeles

when we get there" says one. "Bet you my share, if any, he'll come back for more!" the second responds, suggesting that the conflict will continue.

Though Uncle Sam is undoubtedly the primary antagonist, this editorial cartoon still reflects the author's bias concerning which tribe should have access to the land in question. Uncle Sam's bread does not reflect the ambiguity in the 1882 executive order, and he clearly does not give the land exclusively to the Hopi Tribe. This cartoon depicts the Hopi understanding of their own indigeneity and

stands as an assertion of their right to the entirety of the land as Hopituskwa. Furthermore, the sacred clowns' message reveals the continuing ideological and practical struggles between the Diné and Hopi inhabitants of the land in the face of further intervention into protected space.

Though the *pai'yakyamü* lampoon the Diné's desire for more land, Sekaquaptewa's primary target in "Dividing the spoils" is the federal government's intervention in Indigenous affairs. Sekaquaptewa's image also critiques the ongoing nature of the conflict, despite the passage of HR 10337. In fact, further intervention in the dispute was all but guaranteed by New Mexico Democratic senator Joseph M. Montoya's amendment, which directed the 1.58-square-mile Moenkopi area to undergo immediate litigation.[83] The Democratic senator from Montana, Lee Metcalf, expressed many people's concerns regarding the Montoya amendment: "We must not repeat the mistake of abdicating responsibility to the Court [in] calling for Judicial resolution of the Joint-Use Area dispute."[84] Metcalf, like the Hopi and the Diné, understood that the conflict over the division of land would never truly be over if United States courts remained involved. Only when the Hopi and Diné could control their own land management would intertribal diplomacy have a chance of lasting.

Reporters for regional papers understood the many barriers that stood between congressional action in December 1974 and the final resolution of the Navajo-Hopi Land Dispute. The *Albuquerque Journal* reported, "Congress is closer now than ever to providing an equitable solution to the century-old Navajo-Hopi land dispute. All that remains is resolution of the differences between the Senate and House versions of the bill, the President's signature and a willingness on the part of the two tribes to accept the congressional proposal."[85] However, for at least some Hopi, as Sekaquaptewa's "Dividing the spoils" suggests, the division of the land was unacceptable on every level: it prolonged court battles, dispossessed many Hopi of their homes, and did not solve the problem of the inequitable relationship between tribal leaders and United States officials.

Still, immediately after the bill's passage, Chairman Peter MacDonald publicly supported the legislation. He praised United States senators "for their wisdom and perspicacity in dealing with the long-standing Navajo-Hopi land dispute."[86] Even in the case of the Moenkopi decision, MacDonald applauded the United States government. He viewed extending the legislation as a positive, noting that "the other alternative, taking all the land in dispute from the Navajos, would have been an unfair, unjust and unconstitutional approach."[87] Though MacDonald's public statements sounded resolutely positive, they implied that Diné leaders never

believed that the land could remain untouched by United States politicians. The chairman's words, read in that context, are very nearly a statement of gratitude that the outcome of the senatorial decision was not much worse.

MacDonald's statements, however, did not reflect the position of the Diné as a group. In fact, many Diné refused to recognize the United States as an actor with any authority to partition sacred grounds. One Diné activist, Roberta Blackgoat, said, "They say they can fence me in and divide me from visiting my neighbors. 'Will the fencing cause us to exclude one another?' I said. I have to question their authority. I do this because they are taking things from the culture without asking."[88] In the eyes of many Diné, partitioning the land meant more than just allocating ownership: it was just as much an extractive enterprise as stripping valuable minerals and water from that land.

Despite the Hopi and Diné discontent with the final version of HR 10337, on December 23, 1974, President Gerald Ford took a break from his ski vacation to sign the bill into law. Public Law 93-531 included a provision for more than $52 million to assist Diné relocation, a mandatory six-month period of trial mediation before the courts would divide the land, and final authorization for a suit over the Moenkopi area.[89]

United States officials may have believed that their intervention would provide much-needed closure for the Diné and the Hopi. But despite their intentions, the fight was far from over. Many Diné had no intention of relocating. As Mae Tso remembered, "You see I was born here. The way I walk here. I am from here. I did not just show up here. Some of our leaders are from Europe. Hopis migrated from South America. From the North they brought a Mountain Soil bundle. We are Indigenous. We are still here. And I am not going anywhere."[90] Tso, like Blackgoat and many other Diné, understood that her identity was inextricably entwined with Dinétah. The potential forced removal, fencing, and industrial development were attacks on Diné heritage, history, and identity.

The intertribal discourse seen in 1974 *Navajo Times* and *Qua'Töqti* political cartoons reveals the extent to which both tribes shared interests and concerns regarding non-Indigenous control over tribal land and resources. While the work of Diné and Hopi cartoonists reveals that intertribal conflicts persisted and often loomed large, cartoons published in both the *Navajo Times* and *Qua'Töqti* present non-Native leaders as the primary villains in the conflict. Perhaps most important, Diné and Hopi cartoonists' work reveals that both tribes understood the threat of corporate and industrial enterprises establishing a strong foothold across Dinétah and Hopituskwa in the years following partition. Many Diné and Hopi people

were aware that divisiveness and intertribal enmity only provided additional room for outside interests to prevail. Therefore, the hope for the future security of both tribes rested in their ability to present a united front to outsiders in the years following the passage of PL 93-531. Though the partition bill became law in December 1974, the Diné and Hopi fight for self-determination, sovereignty, and survival would continue long into the future.

Activism in the Aftermath

Protest and Politics, 1974–1998

> The forcible relocation of 10,000 Navajo people is a tragedy of genocide
> and injustice and will be a blot on the conscience of this country for many
> generations. It will hold its place with Wounded Knee, the Long Walk, and
> the Trail of Tears.
>
> —LEON BERGER, DIRECTOR, NAVAJO-HOPI TASK FORCE

The Navajo-Hopi Land Settlement Act (PL 93-531) passed in December 1974. It was supposed to provide a sustainable resolution to the Navajo-Hopi Land Dispute.[1] In the eyes of United States politicians, PL 93-531 equally divided joint-use lands without undue hardship to Diné and Hopi people, and it allowed the Diné to purchase up to 250,000 acres of additional land from Arizona or New Mexico.[2] Still, the legislation could not reconcile the fact that removal itself constituted undue hardship for Indigenous people. Therefore, much as the *Navajo Times* and *Qua'Töqti* cartoons of 1973 and 1974 had foreshadowed, PL 93-531 failed to provide a resolution to a century-old problem. In fact, it spurred further intervention into already contested lands. At the same time, continued activism across the Former Joint-Use Area (FJUA) in the years following the passage of PL 93-531 allowed for the agency, autonomy, and spirit of Diné and Hopi people to remain unbroken. Despite the overwhelming power and reach of the federal government, the Diné and the Hopi preserved their cultures and defended their sovereignty through activism, social cohesion, and political agitation.

Dinétah and Hopituskwa after Partition

The end of 1974 marked the end of important social dynamics across Dinétah and Hopituskwa. First, it ended the visual conversation about the dispute between cartoonists Sekaquaptewa of *Qua'Töqti* and Thompson and Ahasteen of the *Navajo Times*, although both papers continued to publish other editorial cartoons.

The *Navajo Times* did not publish one cartoon related to the dispute in 1975 and very few in 1976, though it did publish some editorial images addressing activism that took place throughout Dinétah and Hopituskwa. Second, the end of 1974 began a significant shift in the relationships among the Hopi, the Diné, and the United States government. Relations may have been unstable prior to the passage of PL 93-531, but they declined immediately after it became clear to the Diné and the Hopi that relocation would be enforced by United States officials.

As journalist Jerry Kammer noted in a 1979 article in the *American Indian Journal*, the impending forced removal of thousands of Diné and scores of Hopis at the hands of the Navajo-Hopi Indian Relocation Commission meant "the largest Indian relocation program since the 1800s."[3] Strong cultural memories of the Long Walk in 1864 meant that many Diné feared for their families and their lives. For the majority of the Hopi, the increased social and economic instability generated by forced relocation was equally undesirable. As the Hopi-Tewa author Albert Yava argued to Kammer, increased grazing land meant little to most Hopis, who tended to be sedentary farmers. Only the cattle-holding Hopi elite could expect to be positively impacted by the federal government's position.[4] Therefore, for many people on both sides of the so-called Navajo-Hopi dispute, approaches of resistance and resilience were the clear path forward, beginning with public activism, cultural preservation, and strong proclamations of the Diné and Hopi peoples' sovereign rights to their traditional homelands.

The Diné spent the first six months of 1975 waiting for the storm. The courts mandated a six-month period of negotiations between the two tribes before federal intervention could take place, but there seemed little hope for resolution. As the *Navajo Times* reported, Hopi chairman Abbott Sekaquaptewa was quite happy with the federal government's plan. He went on record that "the only fair and equitable solution to the land dispute is an actual partition of the land between the two tribes."[5] Without consensus, negotiations stalled. It seemed that despite the option for sovereign Diné and Hopi actions regarding the dispute, Washington would ultimately decide the fates of thousands of Indigenous people across the Southwest.

As it turned out, federal intervention was closer at the start of 1975 than many had realized. On January 30, 1975, the *Navajo Times* reported that the federal Bureau of Land Management (BLM) had declared 1,400 Diné families "'unauthorized occupants' of federal lands" in northwestern New Mexico.[6] Despite the fact that BLM was aware of Diné presence on the land—and had indeed issued grazing permits for Diné herders—BLM leaders were now clearly stating that construct-

ing dwellings or living permanently on the land was illegal. For the Diné, the federal government's scrutiny of their land use across Dinétah was a new threat to their long-standing traditions.[7]

The early months of 1975 were full of contradictions from United States officials. BLM leaders declared residency illegal on lands in the Checkerboard area of northwestern New Mexico, but also stated that "it [is] not our desire to move people from their homes."[8] Furthermore, if the entire Navajo-Hopi Land Dispute was not resolved by the end of June 1975, the courts would be directed to "divide the land 'as near as practicable' 50–50 between Navajo and Hopi [but] also to minimize the disruption of relocation of large numbers of Navajos."[9] With mutually exclusive rhetoric coming at Diné and Hopi people from all sides, the only hope for a positive outcome rested in intertribal discourse and a push for a mutually beneficial settlement.

Activism and Intervention in the Face of Removal

In an act of resistance against partition, dissatisfied Diné and Hopi individuals formed the Navajo-Hopi Unity Committee in February 1975.[10] This committee defied the popular rhetoric pitting the Diné and Hopi against one another as hereditary enemies and instead emphasized the shared political interests of both tribes. Early Unity Committee meetings revealed fissures in official tribal leadership, a distrust of United States officials, and growing cross-cultural cohesion. In an April 17, 1975, meeting, *Qua'Töqti* reported, many Hopis expressed concerns about the Hopi Tribal Council, alleging that council members had "broken many traditional laws" and arguing that they should be exposed.[11] Leaders, including Buck Austin, a traditional Diné medicine man, begged both Diné and Hopi community members to get involved: "plan for your own lives or someone else will plan your lives for you."[12]

Members of the committee found common ground in their concern over the lack of transparency regarding the agendas of the negotiators chosen by the tribal governments, none of whom lived in the disputed area, and hope in their shared vision. As one Diné attendee declared, "we have suffered long enough. We're all brothers and sisters in this room. Let us unite. Let us pray that we may accomplish something for ourselves."[13] The Unity Committee succeeded where the official tribal negotiators failed, bringing together people from different tribal and familial backgrounds to advocate for a sustainable solution and transparency in the political process.

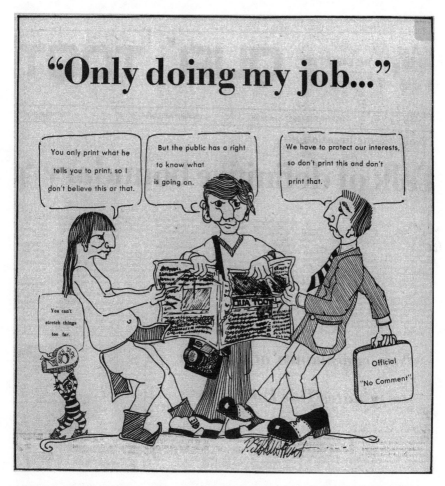

Figure 5.1. Phillip Sekaquaptewa, "Only doing my job . . . ," pen-and-ink drawing, *Qua'Töqti*, May 1, 1975, 2. Courtesy of Young Research Library, University of California, Los Angeles

Despite increased intertribal cooperation, transparency remained a real concern for many Diné and Hopi people, who were uncertain of where to turn or whom to trust in the wake of official United States intervention into traditional tribal lands. As a response to concerns about the many avenues of intervention into Hopi affairs, *Qua'Töqti* published a political cartoon titled "Only doing my job . . ." on May 1, 1975 (figure 5.1). This image deals with issues of responsibility,

identity, negotiation, and misinformation in an era of uncertainty regarding the future. "Only doing my job . . ." sheds light on the hidden influences with which the Native press was forced to negotiate on a daily basis to produce quality news.

Visually, figure 5.1 reveals the broad ideological spectrum that existed across Hopituskwa in 1975. The *pai'yakyamü* on the far left-hand side of the image represents the spiritual and traditional center of Hopi life and embodies much-needed humor and perspective in a fraught struggle for news and knowledge. A traditional Hopi man stands next to the *pai'yakyamü*. He represents the understandably distrustful component of the population, unsure of whether he can trust the news in *Qua'Töqti*, whose editor stands at the center of the image. The traditional man says to the editor, "You only print what he tells you to print, so I don't believe this or that." Meanwhile, the man on the right-hand side of the image typifies white interests. He holds a briefcase emblazoned with the words "Official 'No Comment,'" claws at the already-torn copy of *Qua'Töqti*, and proclaims, "We have to protect our interests so don't print this and don't print that." Hopi council chairman Abbott Sekaquaptewa is literally caught in the middle of these two opposing perspectives. Holding the damaged paper, he looks directly at the reader and says, "But the public has a right to know what is going on." The sacred clown agrees: "You can't stretch things too far." The *pai'yakyamü*—illustrating traditional values as well as hope for the future—holds a roll of tape. The tape is imbued with the potential to restore journalistic justice and hold together the future. Perhaps, despite the frenzied tug-of-war over the press, not all is lost.

Phillip Sekaquaptewa's cartoon reflected the instability of the early negotiations not only between the two tribes but also the instability between Traditionalist and Progressive Hopi perspectives about the press. Regardless of the many varied attempts made by both Indigenous and white actors to control the news, the cartoon in figure 5.1 implored *Qua'Töqti*'s readers to trust the paper. By being transparent about the increasing difficulty of managing outside pressures regarding what to publish and what not to publish, Phillip Sekaquaptewa sets himself apart from the influence feared by the traditional Hopi in the image. Abbott Sekaquaptewa's character both visually and verbally addresses the struggle that the Hopi press faced in the wake of increased outside scrutiny and intervention and takes an activist stance. The *Qua'Töqti* perspective was that regardless of whose interests were at stake, the public had the right to information.

In many ways, the primary goals of the Unity Committee echoed the struggle for independent, sovereign authority represented in this cartoon. In July 1975, just two months after "Only doing my job . . ." appeared, the *Navajo Times* reported

that the committee's goals were "for Navajos and Hopis to live in peace and friendship, each respecting the other's way of life; for all traditional people to control and determine their own lives 'without interference from alien cultures and individuals' and to protect and preserve that culture; and for all people to protect, preserve, and conserve the natural resources of the reservation."[14] The committee emphasized that the fight for sovereignty could only succeed if both the Diné and the Hopi were able to culturally and materially eclipse the influence of outside parties. That did not mean that all interference could be avoided; rather, it meant that Diné and Hopi activism would have to transcend artificial boundaries in order to achieve their goals, boundaries often determined and imposed by non-Indigenous actors.

The creation of the Unity Committee and its subsequent meetings represented a success for the people of the Four Corners region. Despite significant environmental, political, and social hurdles, Diné and Hopi individuals came together and publicly stated that the well-being of all Native peoples across the Southwest depended on the treatment of their neighbors and the land. As the declaration quoted above reveals, citizens of both tribes clearly understood the potential for extractive corporate-colonial enterprise to irreversibly damage traditional tribal homelands. Many Diné and Hopi people also understood the true instigator of the conflict to be the United States government and knew that they had to collaborate with one another to have a chance of realizing their own best interests.

The Unity Committee did not have to wait long before federal intervention across the Joint-Use Area increased dramatically. By August 1, 1975, the Bureau of Indian Affairs took control of all law enforcement and judicial activity across the Joint-Use Area.[15] Lynn Montgomery, the acting deputy project officer for the Joint-Use Area, cited a "conflict of jurisdiction," arguing that because both tribes had at one time obtained legal ordinances applicable to the Joint-Use Area, the federal government should provide police to patrol the area.[16] The real reasons behind BIA intervention, however, seemed to have very little to do with this official justification as neither tribe had requested assistance and no specific safety concerns were immediately cited by BIA officials. Rather, this intervention allowed the federal government to control protected lands prior to the dispute being turned over to the courts.

In the months following the BIA accession of the Joint-Use Area, intertribal diplomatic efforts to settle the dispute began to deteriorate. Despite the positive activism that had emerged from both tribes in the months following the passage of PL 93-531, the official mediating talks soon reached a stalemate. As the *Navajo*

Times reported on September 18, 1975, after the initial deadline for a long-term solution had passed, Diné and Hopi leaders attempted to set up further meetings to extend the negotiations. But by the time Hopi chairman Sekaquaptewa missed the September 14 meeting, it seemed increasingly unlikely that further talks would be fruitful.[17]

Despite the breakdown of intertribal negotiations, both Hopi and Diné activists had continued to protect their own interests. The Unity Committee, which represented ten thousand Diné and three thousand Hopi living in the Joint-Use Area, continued its work through September 1975.[18] The committee strengthened its stance by joining forces with another activist group, the Save the Arizona Strip Committee chaired by William Morall, whose eight thousand members strongly opposed the forced relocation of ranchers on contested lands.[19] Expanding its membership through this alliance allowed the Unity Committee to send a powerful message to political outsiders: the numbers of those opposed to outside intervention and the partition of traditional lands were becoming too great to be ignored.

The Unity Committee also highly valued establishing a strong relationship with traditional Hopi leaders. Many of these traditional elders, like the chief of Old Oraibi, Mina Lansa, the subject of a 1974 *Qua'Töqti* political cartoon, opposed forced relocation. Lansa gave a memorable speech in support of Indigenous self-determination in which she declared, "The Hopi councilmen have determined that you, my children, shall be moved from our midst. You have homes; you were born in them and I know how hard it is to move from one's own home. I will say again as a Hopi chief of one of the oldest villages in the Hopi Nation that I shall not be a party to moving you from our midst."[20] Lansa's statement revealed her hope for the future of the affected Diné and Hopi people but also acknowledged the challenges to come: many chiefs with many different influences and political perspectives retained some power over intertribal negotiations.

Members of the Navajo-Hopi Unity Committee and the Save the Arizona Strip Committee continued to meet in 1976 to contend with many of the issues surrounding the uncertain future for Diné ranchers and residents across the contested lands. While members addressed the practical concerns regarding partition of the land and the potential threat of additional forced stock reduction, they also addressed the ideological threats that impinged on both Diné and Hopi sovereignty. As part of this project, representatives of both committees worked to spread their story to media beyond Hopi and Diné news sources. Their media campaign worked to a degree: television producers as far away as Los Angeles

made statements in support of the Diné and Hopi peoples. One producer, Bill Angelos, went on the record in dismay, saying of forced removal, "How can anyone say that this is Indian self-determination? . . . How can such a thing be tolerated in the United States?"[21] By 1976, outrage over the impending evictions of Joint-Use Area residents was bleeding into populations with no immediate financial interest in the decisions of the United States government in the Four Corners region.

With increasing pressure on all sides to come up with a solution to this growing dissension, the Bureau of Land Management scheduled a meeting in the spring of 1976 to facilitate the purchase of land for the Diné and hopefully settle the dispute for good. But the BLM planned this meeting to be held before the government's first environmental analysis report, which was not due out until the end of March 1976. This report had the potential, like many Collier-era interventions, to change residency patterns on the range.[22] The most generous analysis of this overlapping timeline would suggest that the federal government was badly organized in terms of managing its priorities. A less generous analysis might question the government's intent to follow through with facilitating Diné land purchases.

As Indigenous concerns over land use and acquisition intensified, many Hopi and Diné people continued to advocate for a truly equitable solution. A *Qua'Töqti* cartoon titled "Indian Wars—1976" (figure 5.2) depicts the plight of the Diné and the Hopi as one. In this image, an Indigenous man chases a white man (labeled "White communities") off tribal territory. The white man holds a gun (labeled "Local governments") but is afraid of the Native man, who brandishes a tomahawk labeled "Federal government." The visual message is that while the federal government may be antiquated when juxtaposed with smaller local governments, its might is to be feared nonetheless: the relatively weak tomahawk dominates the white man's gun in the image. The white man cries, "They've come to take our land (communities) away from us!" The Indigenous man and the *pai'yakyamü* have little sympathy. The Indigenous man says, "It was 'fair' when you did it to us, so quit your bellyaching!" The *pai'yakyamü* agree, with some trepidation. "Hope he knows how to use his new weapon!" one clown calls out. "Yeh," replies the other, "and I hope it doesn't backfire!" The author (likely Sekaquaptewa) of this activist image defends the use of federal might when it comes to protecting tribal homelands and Native space, but also rightfully characterizes the federal government as an unstable ally—a weapon that could indeed backfire.

Some success came from surprising places: Arizona state representative Daniel Peaches, for example, publicly endorsed the work of the Navajo-Hopi Unity

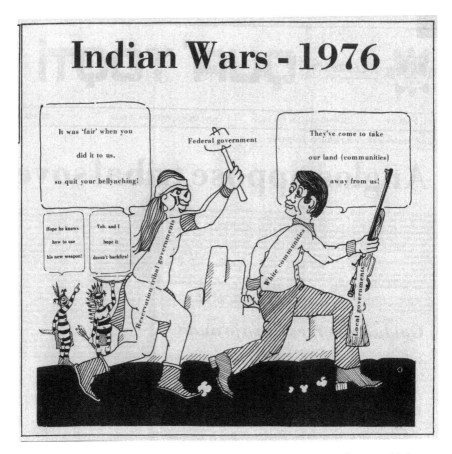

Figure 5.2. Unsigned [Phillip Sekaquaptewa], "Indian Wars—1976," pen-and-ink drawing, *Qua'Töqti*, March 3, 1976, 2. Courtesy of Sequoyah National Research Center, University of Arkansas at Little Rock

Committee just one day after *Qua'Töqti* published "Indian Wars—1976."[23] Still, challenges remained. Court hearings in April and May 1976 left the partition line unresolved, and officials from the Bureau of Indian Affairs succeeded in removing 44,000 of the 120,000 sheep units owned by the Diné in the Joint-Use Area, threatening the livelihoods of their owners and anyone operating within the Diné sheep economy.[24]

Stock remained a central concern for many Diné and Hopi in the Joint-Use Area throughout 1976. Beginning what would later become a larger trend of intertribal solidarity and cooperation, like-minded people formed the Navajo-Hopi

Joint-Use Committee. This six-person group included three Diné and three Hopi individuals. It was formed to address fencing, access to water, applications for new grazing permits, and issues of unclaimed livestock roaming the Joint-Use Area.[25] The committee, understanding that the federal government planned to reduce stock in the Joint-Use Area to sixteen thousand sheep units over the next five years, made recommendations to the BIA regarding which families should be issued new grazing permits.[26] Families that did not have their permit renewed faced significant hardship if they still desired to remain on their land.

While the committee represented the best intentions of both tribes and superficially seemed to be a fair way for the Diné and Hopi communities to retain some authority over stock reduction, it became clear almost immediately that the BIA had put the committee members in an untenable position. The boundaries within which the committee was licensed to act reflected a fundamental misunderstanding of which people were most affected by reduction policies. Each tribe received half of the allocated sheep units; that is, the federal government allowed the Diné and the Hopi to each maintain eight thousand sheep units over five years. Yet because the Hopi were traditionally sedentary and the Diné relied on grazing for their cultural and material preservation, the reduction impacted the Diné to a far greater extent than it did the Hopi.[27] While many Hopi could rely on farming for sustenance, their Diné counterparts had an economy that revolved almost entirely around sheep. Without sheep, they would not be able to survive in their homeland.

The Joint-Use Committee members understood that stock reduction would almost certainly have the unintended consequence of forcing the affected Diné—and some Hopi—to move from their ancestral homelands regardless of the final implementation of the Joint-Use Area partition line. That line, which had been decided by Judge James Walsh early in September, resulted in 3,500 Diné living on lands that would be officially deeded to the Hopi nation.[28] An untold additional number of Diné families would also likely be forced to move to cities if their livestock applications were denied by the Joint-Use Committee and the BIA. Materially, this presented a second set of challenges for the committee, which had no authority to promise funds or guarantee resources for the Diné and Hopi families most impacted by federal stock reduction policies. It also meant that Diné cultural identity would likely be shattered as a result of shrinking, fractured populations on traditional reservation lands.

Any hope for a smooth transition for the families being forced to relocate disappeared with the realization among many Diné and Hopi that the outsiders who

were appointed to the Navajo-Hopi Relocation Commission, an independent agency of the executive branch, were more interested in fighting among themselves than in peaceably solving a century-old conflict or in helping the Diné and Hopi people whose lives would be overturned by relocation.[29] The commission—staffed by former Arizona governor Jack Williams's liaison to the Indigenous tribes of Arizona, John Hawley Atkinson; former governor of the Zuni Pueblo Robert Lewis; and the Reverend Paul Urbano—faced bureaucratic and other difficulties from the start.[30]

By the fall of 1976, interpersonal differences had exploded into a feud between Atkinson and Lewis. Lewis wrote a public letter "charging that the work of the commission under Atkinson [had] been 'a total waste' and that the commission [was] 'totally unacceptable' to the Navajos whose forced relocation from homes in the Joint-Use Area [was] being planned by the commission."[31] He went further, asking Atkinson to resign. Atkinson responded by calling Lewis "an egomaniac as regards publicity" and, in turn, asked Lewis to resign.[32] When asked what the feud was over and why Lewis wrote his letter, Atkinson stated, "I imagine one of the frustrations is to find out the commission can move progressively and successfully without him."[33] It was clear by the end of 1976 that clashing personalities had stopped the commission's progress.

Indeed, such aggressive, public infighting made it clear that the Navajo-Hopi Relocation Commission had become a barrier to ensuring the well-being of Diné and Hopi people. Making matters worse, the group soon stopped addressing its formal duties altogether. After the commission members failed to appear at a public meeting on November 18, 1976, tribal leaders acted. The *Navajo Times* reported that "a petition signed by 400 residents of Hard Rock and Low Mountain in the affected area was sent to Interior Secretary [Thomas S.] Kleppe," asking for the removal and replacement of Atkinson and Urbano from the commission.[34] All told, between complaints lodged by Native American people and by members of the group itself, all three leaders faced requests to resign.

Despite discouraging news from administrators, the Diné and the Hopi continued to protest compulsory removal. Following in the spirit of earlier *Qua'Töqti* editorial images, the *Navajo Times* published an untitled cartoon on December 23, 1976 (figure 5.3), which equated the defunct Relocation Commission with a long history of European imperial conquests of Indigenous peoples in the Southwest. Figure 5.3 reveals the inherent conflict present in the spirits of Urbano and Atkinson and questions the fate of sacred, protected lands if the partition and relocation follow the government guidelines. In this image, the three Relocation

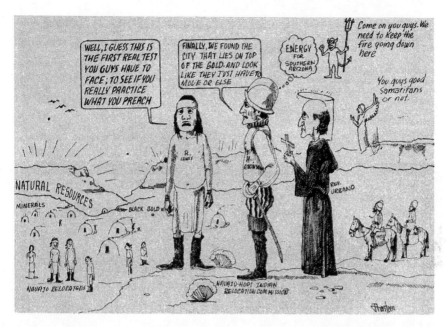

Figure 5.3. Jack Ahasteen, untitled pen-and-ink drawing, *Navajo Times*, December 23, 1976, A4. Courtesy of Sequoyah National Research Center, University of Arkansas at Little Rock

Commission members stand on Dinétah. The land is populated by hogans, gleaming "black gold" (coal), and hills labeled "natural resources." The commission members dwarf the Diné living on the land (labeled "Navajo relocatees"), suggesting a great power differential between those affected by the group's decisions and the commission itself.

The dialogue in this cartoon shows that many Diné had little faith in Atkinson's and Urbano's allegiance to Native people, and this image clearly equates the commission with colonialism. Atkinson is dressed as a Spanish conquistador, complete with boots, a helmet, and a sword, while Reverend Urbano stands ineffectually behind him in the garb of a Catholic missionary. Lewis, depicted as a traditional Indigenous man, declares to Atkinson and Urbano, "Well, I guess this is the first real test you guys have to face; to see if you really practice what you preach." Atkinson responds by referencing Spain's failed sixteenth-century search for the Seven Cities of Gold: "Finally, we found the city that lies on top of the gold. And look[s] like they just have to move or else." His unspoken thought reads, "Energy for southern Arizona," making his loyalties clear.

This editorial cartoon, much like those in *Qua'Töqti*, utilizes spiritual imagery to address the moral heart of the situation. While the *pai'yakyamü* represent the long-standing Hopi spiritual tradition, Diné cartoonist Jack Ahasteen utilizes traditional Christian images of a demon and an angel to represent Reverend Urbano's metaphysical struggle. The demon fans the flames of federal policy, saying, "Come on you guys. We need to keep the fire going down here," while the angel asks, "You guys good Samaritans or not[?]" There are no verbal answers, but the detailed visual landscape in this image suggests that Urbano and Atkinson are in a long line of white colonizers whose interests in extractive enterprise override any ideologies they may have superficially espoused regarding the spiritual or material benefits Native people could gain through the continued presence of non-Indigenous newcomers.

This cartoon is particularly rich because it uses visual discourse to equate United States intervention in the Four Corners region with centuries of Spanish colonial intervention in the same area. The overarching message is centered on the federal government treating Dinétah and Hopituskwa as colonies to be mined for the valuable resources just beneath the surface of sacred land. The colonizing Spaniards from the past are shown to be United States officials in the present. Lewis represents the long-standing activist spirit of Native people but also the specific concerns voiced by detractors of the Relocation Commission itself: would the commission consider the vulnerability of the Diné and Hopi individuals whose material well-being, cultural richness, and religious practices were at stake? Or would they, like Atkinson's thought bubble suggests, succumb to avarice and turn over all of the area's natural resources to ready-and-waiting energy companies?

Figure 5.3 celebrates Indigenous awareness of the challenges facing activists and residents across Dinétah and Hopituskwa. The creation of this cartoon itself was a bold response to individuals in power who had little interest in the concerns of those Diné and Hopi people who would be most affected by forced removal. The message in the image, though, represents an additional, deeper layer of resistance: it reflects a deep distrust of the individuals in power, reveals the abiding memory of the region's long history of colonial occupation and extraction, and declares Native peoples to still be in opposition to white interlopers in sacred spaces.

Collaborative Refusal and the Press

In the face of increasing administrative and bureaucratic challenges, many Diné and Hopi people turned to intertribal organizations for answers. Despite many

varied and sometimes undeclared allegiances within each tribe, groups like the Unity Committee provided insight untainted by federal interests. The group's first important action in 1977, reported in *Qua'Töqti*, was the Unity Committee's public denouncement of a $5 million settlement between the Indian Claims Commission and the Hopi Tribe. The Unity Committee questioned the acreage likely to be lost as a result of this settlement and then went further, asserting in a statement made by Vice Chairman Caleb H. Johnson that "the only possible person who will benefit from this sale of Hopi land will be . . . the Councilmen's Attorney. . . . The only Hopis who probably will benefit from this vast sale of Hopi land would be the dozen Councilmen who have collaborated with Council Attorney. The rest of the poor Hopi People can expect to get nothing."[35] The settlement revealed the fissures and unstable power dynamics between Hopi leadership and the rest of the Hopi people. Further, it showed that many Hopi did not support the actions of the tribal government but had to live with the consequences of their leaders' bargain with the federal government.

Johnson's statement reveals another important, if hidden, issue that permeated Dinétah and Hopituskwa in the aftermath of the passage of PL 93-531: the intertribal class warfare bubbling under the surface of partition negotiations. As a *Qua'Töqti* article of January 6, 1977, noted, not every member of the Hopi Tribe could expect to see the same benefits from deals made with non-Indigenous lawmakers.[36] Similarly, for the Diné, stock reductions impacted large families or families on the edge of survival more than they affected the wealthiest Diné, who had more horses, sheep, goats, and cows than they needed to survive. Johnson's statement was a reminder to his people that the most vulnerable members of society remained at risk in an era of deal-making that excluded the poorest Hopi and Diné. These were the people most likely to experience economic ruin and cultural degradation at the hands of officials ordering stock reduction and relocation.

The February 3, 1977, editorial cartoon created by Diné artist Jack Ahasteen (figure 5.4) underscores the hypocrisy in the actions of United States officials at the expense of Diné and Hopi people. This image features two traditional Diné men standing on the Navajo Reservation, looking over a fenced corral full of sheep (labeled "Stock Reduction in Joint Use Area—Law of This Land"). One man says, "Whatever happened to all those laws and preaching that said 'Justice for all, under God,' and 'Everybody is created equally by God[?]" Ahasteen points out that despite being subject to United States laws, Diné cannot rely on any of the practical or ideological protections that white citizens take for granted. Diné sovereignty was only respected as long as it was convenient for the United States

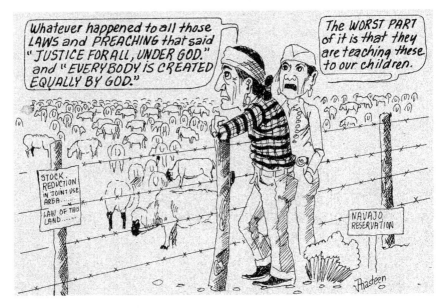

Figure 5.4. Jack Ahasteen, untitled pen-and-ink drawing, *Navajo Times*, February 3, 1977, A4. Courtesy of Sequoyah National Research Center, University of Arkansas at Little Rock

government. Further, Ahasteen questions the claimed moral superiority of the language of the US Constitution—a constitution that, regardless of its rhetoric, accommodated stripping the Diné of their land, wealth, sovereignty, and power.

Ahasteen's cartoon is a searing critique of the chasm between the projected image of the United States as a land of freedom and the reality of the barbed-wire fences installed on protected lands at the behest of federal officials. This cartoon is also a powerful statement of resistance, beseeching viewers to continue their traditional ways despite Washington's interference. As the second Diné man in the image notes, "The worst part of it is that they are teaching these [values] to our children." Ahasteen's editorial cartoon is a call to action: with the future of Dinétah at stake, many Diné felt that they must do *something* to fight against the colonizing power with frighteningly strong, self-affirmed moral authority behind its interventions in the sovereign affairs of Dinétah.

For many Diné, concerns about the United States' continued effort to reduce privately owned Diné herds stemmed from increasing conflict between Hopi and Diné ranchers in the Joint-Use Area. In February 1977, for example, Hopi herders impounded Diné cattle from a dozen different owners ranging on lands that the

Hopi categorized as the "Hopi half" of the Former Joint-Use Area.[37] While the Hopi actions directly impacted the lives and livelihoods of affected Diné individuals, impounding Diné cattle also sent a message to the federal officials in charge of settling and mediating the dispute. While objecting mightily to the impounding of their stock, many Diné agreed with the Hopi that the federal government had "failed miserably to accept [its] responsibility" in ending the dispute.[38] The Diné also saw that ranchers needed immediate protection. Diné patrols were set up across the contested lands in 1977 to police the activity of both Diné and Hopi herders and ranchers. It quickly became clear that while the United States may have had authority in name, Diné and Hopi lawmen were taking control of contested lands even as partition began.

Increased activity and heightened tension across the FJUA throughout 1977 eventually prompted further scrutiny of PL 93-531 by federal courts. On December 22, 1977, the *Navajo Times* reported on federal judge James Walsh's ruling in favor of the Diné who retained some livestock on partitioned lands. In his statement, Walsh noted that "until recently he had overlooked two sections of the 1974 land dispute legislation which indicate that Congress intended to permit Navajos on the Hopi side [of the partition line] to retain stock up until they are relocated."[39] The success was temporary, yet Judge Walsh's new reading of section 14 of PL 93-531 remained important for two reasons. First, it reflected Diné actors' success in obtaining the attention and support of federal officials. Second, it underscored the probability that removal would be delayed and far more complicated than initially anticipated by either lawmakers or the Relocation Commission.

Unfortunately, Walsh's ruling did not prevent partition or the subsequent relocation of Diné families from Hopi partitioned lands to border towns near the Navajo Nation. Shock waves ran through Diné and Hopi communities as information regarding prospective partition put one hundred Hopi and somewhere between fifteen thousand and seventeen thousand Diné on the "wrong" side of recently drawn lines.[40] No one knew exactly how many people would be forced to relocate, but the numbers of those potentially affected were staggering. For many Diné, increased activism and advocacy in the media became especially important after 1977 for the future of the tribe's social cohesion and cultural balance.

In the first month of 1978, a story on the impending partition of the FJUA appeared in the *New York Times* and was reprinted in the *Navajo Times*, reflecting the success of Diné and Hopi activists who had long struggled to get the broader US public to understand their plight. Journalist Molly Ivins wrote an extensive piece on forced removal in which she cited factionalism within the tribes, close

relations between many Hopi and Diné, and the manipulation of the press as rea-
sons for the intensification the land dispute. She also characterized the federal
government as "trying to rectify an old wrong," suggesting that Washington was
at least in part to blame for the current dispute.[41] Even given the strong evidence of
the extent of United States interference in Indigenous affairs in the Four Corners
region, Ivins's article suggested that the 1974 bill was passed due to some Hopis
"exaggerating the state of tension between the tribes, by saying that a 'range war'
was in the offing and that poor little Hopis were being pushed around by the ag-
gressive and more politically powerful Navajos." She went on to argue, "If there
was no tension in the joint use area before, there certainly is now."[42] Ivins's piece
termed the prospective relocation of the Diné as "the largest forced relocation of
Indians since the Indian wars," and she questioned the moral and practical bene-
fits of removing Indigenous people from their traditional homelands.[43]

Continued Protest

Ivins's article and increasing national attention on the dispute suggested some
positive momentum for Diné and Hopi activists, but Washington still showed a
reluctance to engage with the conflict head on. Diné resisters took a powerful
step in the summer of 1978 when thirty-seven Diné, including twenty-five elderly
traditional tribal members, began a trek to Washington, DC, from Window Rock,
Arizona, in protest of removal.[44] The trip included a walk from York, Pennsylva-
nia, to DC and was designed to get the attention of lawmakers and the national
media. One Diné committee member, Danny John, described the decision to take
elders on the protest route: "We needed the participation of the traditional peo-
ple, such as the medicine [men]. . . . They are concerned with tradition [and] the
return of their land and livelihood. It is the elder[s] who are suffering the con-
sequences of the bills introduced. It is necessary that they be recognized."[45] Rec-
ognition, as anthropologist Audra Simpson noted in her seminal work, *Mohawk
Interruptus*, is one way for Indigenous political interventions to be viewed within
a framework of refusal to accommodate colonialist approaches toward Native
American governance.[46] In marching to Washington, Diné elders were physically
commanding the space claimed by the United States in order to assert their sov-
ereignty, their power, and the inhumanity of US government interference in Diné
affairs.

The fight for recognition—and, as Simpson would argue, the struggle for sur-
vival—continued in sister demonstrations across Arizona. In October 1978, with
removal imminent for thousands of Diné, a protest called the March for Sover-

eignty gathered momentum as those impacted by the Long Walk started their two-hundred-mile march from the heart of the Diné reservation to Flagstaff in northern Arizona.[47] The proclaimed purpose of the march was to draw attention to removal and relocation—to garner recognition in the face of decades of being acted upon by the United States government. The march was successful. It grew from eleven to fifty-six protestors and won the attention of tribal officials. Protestors even sent a telegram to President Jimmy Carter, reaffirming their right to sovereign recognition from the United States federal authority.[48] By the late 1970s, it was clear to Native people that the struggle over relocation was a struggle against continued colonialism. It was a fight for recognition, for self-determination, and ultimately for survival.

Despite the emergence of powerful protest movements across Dinétah, many Diné activists remained concerned about the lack of clarity regarding the government's intentions for future removal. Nobody seemed to know exactly how many people were going to be affected, and certainly not every individual residing on the so-called wrong side of the line would be moved. Yet a 1976 estimate in the *Navajo Times*, which had listed 4,000 Diné as being at risk for forced removal, was likely too low.[49] In 1979, journalist Jerry Kammer estimated that as many as 5,000 Diné and 50 Hopi might be affected.[50] And in a 1981 hearing, the Navajo-Hopi Relocation Commission estimated that 9,525 Diné from 2,801 households and 109 Hopi from 31 households would be forced from their homes as a result of recent legislation.[51]

But even when reporting to Congress, the Navajo-Hopi Relocation Commission was not exactly sure of its numbers. Its 1981 report stated, after estimating how many individuals would be subject to removal, "this list is not all-inclusive. Since we have published the names, we have had 143 Navajo people come forward and say that they should be on the list and that they are subject to relocation." This brought the total number to 9,668 Diné and 109 Hopi. More unsettling, the commission reminded Congress, "Enumeration on the list does not mean that they [the affected Diné or Hopi] have applied for relocation benefits."[52] Such benefits, as the report suggested, were not guaranteed to all members of Diné or Hopi families that were subject to removal. Diné and Hopi people, in the midst of their struggle against relocation, were left on their own to negotiate a bureaucracy in flux. United States officials offered no information that would have made it possible for the Diné to act in their own best interests within the parameters for relocation established by the federal government, a chilling echo of the Long Walk.

Instead, US officials proposed a series of intermediary measures meant to appease tribal elders and reduce the grassroots activist response that had been so powerful in media, marches, and intertribal organizing since the passage of the 1974 Navajo-Hopi Land Settlement Act. In the spring of 1980, Congressman Morris Udall of Arizona presented legislation that would grant up to 110 life estates to Diné families "whose heads are at least 50 per cent disabled or who were at least 32 years old on December 22, 1974."[53] Additionally, the Udall Bill provided for 150,000 acres of additional land for relocating affected Diné.[54] While Udall's bill was meant to provide some relief for those most negatively affected by relocation, in reality it did little but shore up the validity of the original 1974 legislation, which deeded much of the Joint-Use Area to the Hopi Tribe. Udall's legislation did not succeed in keeping families together, solve the problem of finding grazing land for thousands of ranchers, nor provide enough financial assistance to ensure that Diné families would not face material privation due to forced relocation. Rather than being a long-term solution, Udall's plan was yet another way the United States government revealed its lack of understanding and interest in the spiritual and familial connections between the Diné and Dinétah.

In the face of the Udall Bill and other off-reservation relocation initiatives, the Diné commissioned a report analyzing the impact of relocation on their people. One section of the report, titled "Implications Life Estates and Off-Reservation Lands: The DeConcini and Udall Amendments," argued that any resettlement outside Arizona and far from Dinétah was unacceptable to the Diné affected by the conflict. After a series of interviews with families likely to be forcibly relocated from the Teesto Chapter in the southern portion of the Navajo Reservation, the report concluded, "*They* [the Diné] *do not want to leave the area within the sacred mountains and which is sacred to their families*."[55] As one respondent said, "They say all elderly people are the ones to stay here [but] we don't agree. We need our families to be with us to feel good. As Navajos we need our family around us in order for us to live."[56] Indeed, the report noted, "living" meant two fundamentally different things for representatives of the federal government and members of the Diné community. Federal representatives were primarily concerned with physical shelter and material resources. But spirituality, family, and tradition were all fundamentally entwined with the land for the Diné.

Washington was aware of the Diné report but failed to acknowledge the validity of its findings. In a December 12, 1979, memo, Dr. Martin D. Topper of the Navajo Area Office of the Indian Health Service wrote only that "the report blames livestock reduction and the threat of relocation for a breakdown of local leader-

ship, the development of severe economic hardship, and the development of depression among both young and old Navajo relocatees."[57] Mention of the report was dropped from the following three monthly memos circulated within the federal government, which instead began emphasizing livestock sales, reduction reports, Relocation Commission benefits, and updated statistics on the process of forced removal in the region.[58]

One subsequent report even characterized the process of removal as benign. The Joint-Use Area memo for December 1979, published January 11, 1980, noted that 166 families had been relocated to date, 128 off reservation lands and 38 on either the Diné or Hopi reservation.[59] The same monthly report concluded that "livestock reduction seems not to be as serious an issue this summer among those Navajos who will not have to relocate as it was in the summer of 1978."[60] The author provided no data to support this bold statement. By characterizing removal as an ongoing process and a success that had progressively fewer rather than progressively more harms associated with it, United States officials attempted to justify the involuntary relocation of Diné and Hopi people.

By February 1980, it was clear that removal placed undue hardship on Diné and Hopi people. In a continuing effort to present the conditions under which forced removals were taking place as humane, the newest Joint-Use Area report discussed the Relocation Commission's suspension of procuring new housing for relocatees as part of a larger project of "provid[ing] additional destination services to Navajo families who have already relocated."[61] This language indicated that removal was continuing despite the increasing material needs of individuals who had already been relocated. In nearly the same breath, the report declared that at the time of appraisal the previous summer, "a total of 25% of the relocated Navajo families were considered . . . to be making inadequate adjustments to their new environments."[62] Topper had front-loaded the report with information regarding the United States' efforts to continue removal and squarely placed the blame for unsuccessful rehabitation on the shoulders of the relocatees in a classic blame-the-victim style.

More ominously, Northern Arizona University anthropology professor John J. Wood's February 21, 1986, report titled "Navajo Relocation from Hopi Partitioned Lands" characterized relocatees from 1977 through 1981 as "typically younger, better educated, more likely to be employed and to have higher household incomes than those certified for relocation but not yet relocated."[63] In other words, the federal government first had relocated those easiest to move, most likely to have off-reservation education or connections to jobs, and more likely to have

significant personal material resources to aid in the transition. Even then, as the Joint-Use Area reports explained, relocation failed. One-quarter of the first wave of relocatees could not adapt to their new environments, and seven years after the partition legislation passed, not all of the families affected had been granted relocation assistance or even provided with information regarding new land on which to settle.[64] In the midst of this confusion and hardship, Diné families lived with the threat of stock impoundment, retaliation sanctioned by the federal government for continuing to live on their traditional homelands, and an uncertain future.

New Institutions, New Work in the Press

The Diné continued to engage in widespread activism in the face of mounting proposals and policy redirects. In 1981, the Navajo tribal chairman's report outlined the immediate way forward for the Diné. Chairman Peter MacDonald, who created the Former Joint-Use Area Task Force, had a mandate of "stopping time-clock relocation, and focusing national attention on one of the greatest injustices by the federal government against Native American people in this country."[65] The task force represented the Navajo Nation's determination to reach United States officials and negotiate with them as equal representatives of sovereign nations. It also demonstrated the Diné government's willingness to invest in a variety of activist efforts in order to achieve the goal of stopping compulsory Diné relocation. Indeed, the Diné presented a unified front against the federal government's efforts to divide and subjugate them by establishing this task force, continuing to engage in grassroots initiatives, and publishing well-researched articles that advocated against removal.

In 1981, the *Navajo Times* published an article titled "Relocators Acknowledge Stress," which cited research by relocation expert and social anthropologist Thayer Scudder that outlined the likely effects of forced removal on populations around the world. This article presented the Diné as one of many sovereign groups forced to negotiate with an occupying power and defend their way of life. Many Diné were aware that relocation was a process that, once started, would become progressively easier for federal officials to complete. They were also aware that forced relocation would likely contribute to worsening relations between the Diné and their neighbors, creating the very conditions cited as the reason behind instigating compulsory removal in the first place. Among other things, a likely outcome of forced relocation was a "tendency for relocatees to become dependent on the agency or agencies responsible for their relocation." Moreover, it was likely to cre-

ate "serious conflicts between the relocatees and those living in the areas to which the relocatees move."[66] This article represented an important activist response: it took widely accepted scholarly research and used it to defend the Diné position on FJUA lands. The Diné were aware that the federal government was creating conditions in which it would be extremely difficult for relocatees to succeed.

Diné leaders believed that a multipronged approach had the best chance of persuading US officials to stop forced relocation. Therefore, in addition to humanitarian arguments against forced removal, the tribal government began to prepare materials for a case that would defend Diné presence on the land in the context of traditional religious practice, which was protected by the American Indian Religious Freedom Act of 1978 and the religious protection clause of PL 93-531. In January 1981, the Diné turned to anthropologist John J. Wood and asked him to write a report that might help preserve traditional Diné homelands as sacred space.[67] By explaining the connection between religious practices and occupancy, the Diné hoped to create a legal case that would stave off removal.

Wood's report, a mix of Diné testimony and anthropological analysis, concluded that relocating the Diné violated the religious protection clause in PL 93-531. Section 21 of the law stated, "The Secretary shall make reasonable provision for the use of and right of access to identified religious shrines for the members of each tribe on the reservation of the other tribe where such use and access are for religious purposes."[68] This clause was written to prevent forced removal from violating the free exercise clause of the First Amendment, which states, in part, "Congress shall make no law respecting an establishment of religion, or *prohibiting the free exercise thereof.*" Problematically, the language in PL 95-341, the Joint Resolution on American Indian Religious Freedom, revealed the federal government's lack of knowledge regarding the establishment and practice of Native religions.[69] By contrast, as Wood correctly argued, "Religion . . . lived at Big Mountain is life itself. . . . Sacred places and practices are part of the definition of occupancy there: to limit people to 'use and access' without occupancy betrays a fundamental misunderstanding of the nature of religion at Big Mountain."[70] For the Diné, religious practices are inextricably and fundamentally entwined with the places of those practices. To remove them from sacred land or prohibit them from accessing traditional places of worship is to intervene in and destroy their spiritual practices. Wood's report challenged the federal government's narrow definition of religious practice and disclosed a tension between removal and the free exercise of religion across Dinétah.

The testimony included in Wood's report bolstered his claims regarding the

importance of the vital connection between Dinétah and Diné religious freedom. An elder named Adzáá Yázhí Bedoni stated, "Us old folks, the grandmas and the grandfathers, from the beginning were taught to live in hogans and to raise sheep and to pray to Mother Earth, the wind, the sun, what gives us life, the air we breath[e], the Mother Earth we walk on and the water we drink. We are told that each of them has gods."[71] Unlike Christianity, Diné cosmology reflects a oneness, a unity, with the land and the spirits of the land. Removal and relocation would unnecessarily and permanently disrupt this harmony.

The tension between human occupancy and the threat of relocation was only one part of Wood's argument against fencing and forced removal. His report also pointed to the shrines and sacred places that permeate Diné cosmology. The religious significance of Diné shrines and sacred places, if recognized by the United States government, would have prevented the disturbance of the land as well as the removal of the people and livestock on it. Wood's report cited an unnamed Diné source who explained, "On Big Mountain there are two shrines; one is for livestock and one is for gambling and magic. You have to go with one or the other. The grandfathers of the people at Big Mountain stayed with livestock."[72] To provide the necessary sustenance and nutrients for this livestock would therefore require the land to be whole and would require stewards of the land. Furthermore, occupancy for the stewards of the land (the Diné) provided a link to their ancestors, a fundamental component of their traditional religious practice.

For the Diné, Big Mountain is a sacred place that requires spiritual protection. As Wood noted in his report, "It is said that the area enclosed by the sacred mountains is a Hogan. The mountains are posts. Within these are a female mountain, Black Mesa, and a male mountain, the Lukachukais. Rivers and springs are veins, and various geographic features are body parts."[73] Wood's report described, if a little clumsily, the life and humanity with which the Diné imbued Dinétah. His report to Congress outlined the necessity of protecting the land, livestock, and people across the Four Corners region. Not to do so would not only place the economic security of the affected Diné at risk but would violate the sanctity of the sacred places and religious shrines of the Diné.

Despite Wood's report, United States officials continued to impound Diné and Hopi livestock in preparation for partition. As the acting area director of the Bureau of Indian Affairs Phoenix office, Curtis Geiogamah, made clear in 1981, the federal officials had no intention of completely ceasing impoundment. Geiogamah defended further intervention by insisting that "we have been willing and continue to be willing to sit down and discuss in a fair and reasonable manner

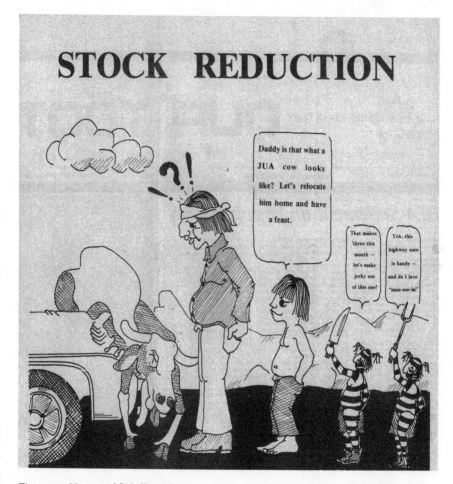

Figure 5.5. Unsigned [Phillip Sekaquaptewa], "Stock Reduction," pen-and-ink drawing, *Qua'Töqti*, April 30, 1981, 2. Courtesy of Sequoyah National Research Center, University of Arkansas at Little Rock

possible—and I stress the word 'possible'—avenues of accomplishing our objectives."[74] (The objectives, of course, were the partition of the Joint-Use Area and the relocation of those Hopi and Diné on the "wrong" side of the partition line.) Geiogamah's statement clearly revealed the gap between the interests of Indigenous peoples and the interests of the Bureau of Indian Affairs.

As the April 30, 1981, *Qua'Töqti* editorial cartoon, "Stock Reduction" (figure 5.5), emphasizes, the damages associated with removal and stock reduction affected the Hopi as well as the Diné. Furthermore, as this cartoon underscores, the

negative effects of the Navajo-Hopi dispute were most threatening to future generations, who had no choice but to contend with the ramifications of both tribal and federal actions across protected spaces. In "Stock Reduction," a cow is dead after being struck by a car. A Hopi man, walking with his young son, expresses shock and confusion upon seeing the dead cow. The son asks, "Daddy is that what a JUA cow looks like? Let's relocate him home and have a feast!" The *pai'yakyamü*, ever-present for a wise word and some humor, chime in: "That makes three this month—let's make jerky out of this one!" and "Yeh, this highway sure is handy—and do I love mon-see-la!"

The highway and car here represent whites interjecting their financial plans and development initiatives into Hopituskwa at the expense of the Hopi community. They also represent the ever-growing threats to Diné and Hopi people. After all, the only reason the Hopi man is not the figure lying across the hood of the car is because the cow was two feet ahead of him on the road. The Hopi man, therefore, directs his shock and outrage not at the dead cow but at the reality that he and his son are in mortal peril due to continued intervention across Hopituskwa.

The young boy and the *pai'yakyamü* represent the resilience, awareness, and resourcefulness of the Hopi in the face of continued colonial aggression. The boy humorously turns the tables on relocation—as a "JUA cow," it was likely a Diné cow—and since it is already dead, the Hopi family may as well benefit from its presence on their land. This comedic relationship between relocation and the reallocation of resources is a comment on the Hopis' will to survive and materially benefit despite further intervention by United States officials.

Like the young boy, the *pai'yakyamü* take the reality of outside intervention and turn it into something positive for the Hopi people. Here, the artist (perhaps Phillip Sekaquaptewa) is a master of double entendre: when the *pai'yakyamü* mentions that this is "three this month," he is referencing both the death of the cow and the threat to Hopi life. By suggesting that the family "make jerky out of this one!" the *pai'yakyamü* references the tribe's refusal to succumb to the pressures and anguish that attend the constant threats to their lives from outsiders. The second clown, who suggests a specific dish, subverts the reality of the highway as a threat and a nuisance and reformulates it as a "handy" intervention for the Hopi people, one from which they will benefit.

"Stock Reduction" reflects the long-standing Native process of taking outside intervention and abuse and reworking them into something of value for the tribe. In the case of the dispute, as published in *Qua'Töqti* during May 1981, concern and apprehension continued to permeate Dinétah and Hopituskwa. *Qua'Töqti* noted

that "events such as the verbal warnings of violence and mayhem to follow the recent transfer of jurisdiction of the Partitioned Lands and the beginning of active impoundment by the Bureau of Indian [A]ffairs personnel of trespass Navajo livestock ha[ve] left many local residents with mixed emotions."[75] As "Stock Reduction" implies, the potential for making something positive out of federal intervention still existed. However, the danger—like the possibility of a lethal car accident—was closer to the lives and families of both Diné and Hopi individuals than many found comfortable.

As the cow represents the slim margin between certain death and bounty (or steak dinner) for the Hopi, the activist initiatives that both Hopi and Diné protestors continued to pursue were some of the few measures that represented hope for future relocatees. Potential relocation for the Hopi seemed especially dangerous because those residing in partition areas faced the likelihood of being resettled in the Bennett Freeze, an area claimed by the Hopi Tribe just west of the Former Joint-Use Area.[76] Residents of the Bennett Freeze area, who were legally prohibited from engaging in construction due to the contested ownership of the land, faced challenges due to outmoded utilities and the lack of necessary improvements to their homes and public buildings. Even more problematically, there were no legal provisions that allowed relocatees to build homes on the Bennett Freeze area, even if they were supposed to reside there due to forced relocation. The potential for families to face prosecution for complying with removal procedures was yet another reason that activism continued across Dinétah and Hopituskwa.[77]

Activists in the early 1980s faced a dual challenge: protecting individuals from being forcibly relocated to less-favorable conditions while also protecting the land from being sold to mining interests, which would irreversibly damage traditional sacred spaces. These tasks were especially difficult given the long-standing chasm between the interests of the United States government and the Navajo Tribal Council and many Diné. As the anthropologist Karen Art noted in 1981, "The explicit goal of the Navajo Tribal Council under the chairmanship of Peter Mac-Donald (who is also chairman of the Council of Energy Resource Tribes) is to promote mining and the economic benefits it brings." This was in direct contradiction to the interests of many Diné. Two local political entities on the reservation issued statements in which they mentioned that they were "totally and unalterably opposed to all development within our boundaries."[78] While these local political organizations, called "chapters," did not have the power or authority wielded by MacDonald's tribal council, they did represent deeply held opposition to outside intervention into Dinétah.

The opposition to mining and land leasing transcended tribal and political boundaries. Many Hopi tribal elders agreed that the land of the Joint-Use Area should be preserved and that the federal government's avarice, rather than Hopi need, was the primary motivating factor for outside intervention. As the *Time* magazine writer James Willwerth reported, "Hopi traditionalist David Monongye, who is blind and past 90, is convinced that the white culture's energy problems are secretly behind the dispute. The land has coal deposits, and Monongye believes that white-owned mining and drilling companies hope to profit from the confusion over its ownership."[79] Monongye represented a population of elders on both sides who—rightfully—never relinquished their distrust of white officials. Willwerth's article revealed that in the midst of many bureaucratic changes and challenges, resource extraction was still at the forefront of a larger corporate-political conversation regarding the future of Hopituskwa and Dinétah.

Many Hopi and Diné traditional elders had little to no formal schooling and no exposure to the inner workings of United States political institutions. Monongye would likely not have been aware that contested ownership was the very complication preventing mineral companies from obtaining leases on contested land between 1946, when the federal government first posited that both tribes may have joint ownership over the land, and 1962, when the court in *Healing v. Jones* ruled in favor of that opinion.[80] Still, elders like Monongye understood that destabilizing political structures across Diné and Hopi lands further disempowered the rightful owners of the land and that the most likely result of removal would be accelerated resource extraction across Dinétah and Hopituskwa.

The Federal Government Attacks Again

In the 1980s, the fight for Indigenous self-determination was complicated by the federal government's attempt to use Indigenous voices to bolster its own agenda of relocation and removal. This trend was in line with the Reagan administration's conservatism and its attempts to appease non-Natives who wanted to, as historian Dean J. Kotlowski stated, "limit the advances of the Native American rights movement, especially with respect to land claims."[81] Much of the data that the federal government gathered during the 1980s, therefore, was used to support the forced removal of Indigenous peoples, including the Diné and Hopi. During the fiscal year 1984–1985, for example, the federal government sponsored a trip to the Wallace Ranch area of Arizona, showed prospective relocatees beautiful tracts of land, and then asked them to fill out a questionnaire regarding their feelings about living on that land.[82]

The questionnaires, which survive in the archives at Northern Arizona University, present a unique body of evidence for examining the interests of federal officials and the needs of the relocatees. The documents are interesting: all fifty-three surviving handwritten questionnaires are unsigned by respondents or administrators. They are thus semi-anonymous. Despite the substantial Diné and Hopi backlash against relocation in public meetings, media, and publications, all but four respondents answered the question "After seeing the new lands, would you like to move there?" with a resounding yes.[83]

Rather than these questionnaires being evidence that many Diné and Hopi people did not object to relocation, the comments reveal that the respondents used this opportunity as a way to negotiate with federal officials for their own best interests and even, in some cases, put the officials on notice that the respondents were well aware of the connection between the Diné tribal council's interests and those of the federal government. One respondent, for example, who checked both yes and no on the questionnaire, wrote, "I would not move here for several reasons: 1) effects of future action by the tribal local presidents and federal gov. in new lands acquired 2) scarceness of jobs available locally 3) putting several families w/ livestock permit in one area is like putting dogs and cats in an enclosed area, it won't take long before something will happen."[84] This participant clearly understood that compulsory removal would not be the end of federal intervention in the affairs of relocatees—in fact, as the first reason above suggests, it would be another beginning. The objection to the lack of jobs in the area reflects the concerns of many relocatees: even if this respondent had assistance for a move, how would they get a job that would cover utilities and property taxes? What would prevent them from becoming homeless yet again when they couldn't keep up with the costs of living in a new area? This response shows that even in documents designed to support the interests of the federal government and expedite forced removal, people found a way to resist and refuse relocation.

Despite the power of the collective Diné and Hopi voices in public protests and documents, the best hope for many Diné, who were battling the interests of their own tribal council, still rested with linking the importance of specific geographic places to traditional Diné religious practices. Part of the reason that this argument against removal was so powerful was that scholars had already been publishing in support of the Diné cultural cause. As anthropologist Karen Art noted in 1981, despite the passage of the American Indian Religious Freedom Act in 1978, "religious concerns have not yet been fully recognized or considered by the federal agencies responsible for making decisions regarding mining on Navajo

land." She went on to argue, "The most fundamental questions for many Navajos are whether mining is consistent with Navajo identity and religion and whether the development-minded Tribal Council is to be accepted as the sole body representing the Navajo people."[85] For many Diné, these were indeed very important questions. Still, the stakes were higher than Art could possibly know.

Just as the people of the Four Corners region faced significant challenges due to federal government inference, so too did the Indigenous press. The weekly Hopi newspaper *Qua'Töqti* encountered financial difficulties that made regular publication increasingly difficult while the *Navajo Times* dealt with political difficulties at the hands of Peter MacDonald.[86] MacDonald was displeased that the *Navajo Times* had officially supported his rival, Peterson Zah, in the 1986 election for tribal chairman. Making matters worse, Zah's platform included the importance of the Diné press and the freedom of that press, and he didn't object to being lampooned by *Navajo Times* reporters and cartoonists. MacDonald did not agree with either of these tenets. After he was inaugurated, he shut down the paper with only two hours' notice. Rather than discuss his reasons for shuttering the *Navajo Times*, he only cited "huge financial losses."[87] Many people, including former publisher Mark Trahant, challenged this claim and believed that the closure was a direct result of the paper's independent political spirit.[88] For both Hopi and Diné activists who relied on a stable, regularly published paper for information, comfort, and humor, the loss of the *Navajo Times* cannot be underestimated. Social cohesion among those opposing continued intervention in Dinétah and Hopituskwa would now have to emanate from a different source.[89]

The Diné found a short-term answer in increasing public protests and the publication of new pamphlets, newsletters, and leaflets. As the fight over compulsory removal showed no signs of resolution in the mid-1980s, Diné activists made a concerted effort to disseminate information about the importance of staying on Dinétah for the spiritual and material survival of the Diné. In one pamphlet published by the activist group In Defense of Sacred Lands, Diné Mae Tso made an impassioned plea against removal:

> All of our sacred songs and prayers are here within our four sacred mountains. The teachings of our ancestors are here in our songs and prayers. These songs and prayers are part of the ceremonies. They are our teaching and our way of life. This is our religion. This is what connects us to the land. Here, we have always made our offerings to the spiritual beings. Here we are known by the spiritual beings. If we are relocated to the new lands, we would not be known,

we could not do our ceremonies. This is our religion, our way of life. If you cut out a person's heart and take it away the person would die. Our creator placed us here on this land, we are part of Mother Earth's heart. If you take us away to another land we will not survive.[90]

Mae Tso's testimony reflected the desperation of many Diné and the need that they felt to continue to resist the dark future of compulsory relocation. Tso's words reveal that sovereignty and survival were connected for many of the Diné. The arguments presented in her statement and reflected in the scholarship of experts like Kammer and Art came to a head in the court case *Jenny Manybeads, et al., v. United States of America* (2000).[91]

Activism in the Courts

The *Manybeads* motion, filed on January 1, 1988, alleged that the forced removal of the Diné violated religious protections already in place for Indigenous peoples in the United States.[92] This motion included first-person testimony from prospective relocatees, expert witness testimony from anthropologists and journalists, and a statement of support from traditional Hopi leaders.[93] It advocated for immediate injunctive relief since removal would violate the religious freedom of the Diné. This motion's goals were two-pronged: to show the religious and social harms that relocation would cause the Diné and to show what non-Indigenous actors stood to gain from intervening in the Four Corners region.

Manybeads testimony from Diné elders, such as Violet Ashkie, presented the court with evidence of the ways in which religion is integrated into daily life for traditional Diné. Ashkie told the court: "The Dineh were placed between the four sacred mountains. Our religious teachings instruct us to always live within the four sacred mountains. . . . Each clan originated in certain areas within our sacred homeland as caretaker of our ancestral land. But each family was placed in a certain area within our sacred homeland as caretakers of that land. We must stay on our land and keep the balance according to the Creator's plan."[94] Ashkie went on to explain the religious significance of geographically specific offerings that the Diné make on the land, the necessity of balance in the Four Corners region, and the connection to ancestors that stems from Diné occupancy. Her powerful testimony showed her deeply held belief in the necessity of remaining on the land but also a willingness to sacrifice personal information and sacred information to outsiders in an effort to protect sacred spaces.

Another Diné advocate, Roger Attakai, agreed with Ashkie regarding the im-

portance of sacred spaces and traditional practices, and he also argued that BIA intervention had already caused significant harm to traditional Diné communities. Attakai specifically pointed to BIA fencing as one of the ways in which the federal government was already violating the rights of the Diné on their traditional homelands. Attakai said, "The BIA says we should just walk around or over the fences to make our prayers and offering[s]. They do not understand the Navajo. They do not know our ceremonies and our prayers. Once the path to our Creator is destroyed the offerings or prayers won't be effective."[95] Attakai, like Ashkie, took pains to underscore the importance of continued Diné traditions on the land and the permanent consequences of the destruction of that land.

Attakai also revealed that the Diné were aware of the chasm between the facts of the dispute and the ways in which the conflict had been presented in the media for the benefit of non-Indigenous actors. Attakai went so far as to accuse the BIA of knowingly engaging in illegal activity in order to create a larger conflict that would then justify further federal intervention on protected Diné and Hopi lands. Attakai said, "They [the BIA] just keep building fences and trying to provoke us into a confrontation. They like to create the confrontations so that they can tell the press that the Navajos are violent and that we are breaking the law. In their hearts they know the truth, they know they are breaking the law."[96] Attakai's statement referred back to the same argument against federal intervention seen in the July 19, 1973, *Qua'Töqti* editorial cartoon "Riding Fence" (see figure 3.9) and in later editorial images of the "range wars" created by the press in order to justify government intervention on protected lands. Federal officials may have presented the government's policies as if the United States were a modernizing paternal benefactor intervening in a land dispute, but Attakai disclosed that many Diné were well aware that this was far from the truth.

As the journalist Jerry Kammer argued in his testimony for the case, the likely motivation behind the federal government's paternalistic attitudes rested in the vast mineral wealth beneath Black Mesa. Kammer emphasized the close connections among commercial energy interests, tribal councils, and protected spaces. He pointed to land leases and bids for oil exploration that took place as early as 1962 on Diné and Hopi lands, the refusal of the Hopi to allow a Diné buyout of contested space, and the continued support of the Diné by traditional Hopi tribal elders. He testified that traditional Hopi elders had long believed that "the land dispute and relocation are simply ploys to remove the Navajos from occupancy of the JUA in order to allow the energy companies to begin devastating development."[97] Kammer and later researchers presented no smoking gun directly tying

energy companies to removal. Yet the interests and activities of energy companies, PR firms like Evans and Associates, and federal officials painted a clear picture of the financial incentives for forcing the Diné off their traditional homelands in order to clear places like Black Mesa for energy exploration and extraction.

For many Diné, removal created danger, and as the anthropologist Thayer Scudder noted in his eighty-point testimony, "the compulsory relocation of the Navajos, with strong ties to their land and homes, is an extremely traumatic experience and one which violates their religious freedom."[98] Forced removal also put the entire Diné cosmos in danger. For thousands of people, compulsory removal meant nowhere to call home, no kinship networks to rely on, no communing with the land, no religious offerings to be made, no prayers to be answered. The *Manybeads* motion represented perhaps the Navajo Nation's best-organized advocacy against compulsory removal. It was not enough.

In a move far too little and late, the US Congress passed the Navajo and Hopi Indian Relocation Amendments of 1988 (PL 100-666). Congress constructed these amendments to provide some relief by infusing $50.3 million into the removal process, taking control of relocation out of the hands of the Relocation Commission, and putting the authority for relocating the Diné in the hands of the newly minted commissioner for the Office of Navajo and Hopi Relocation under the assistant secretary for Indian affairs.[99] Additionally, PL 100-666 created a $10 million Navajo Rehabilitation Trust Fund meant to provide material relief for Diné who were subject to relocation. No provisions were made to protect the religious practice of the Diné facing removal.

In the face of continuing legislation meant to expedite removal, it was clear to many Diné resisting removal that the tide was turning further against them. They had no intention, however, of discontinuing their efforts while the courts were deliberating the *Manybeads* motion. Instead, they made a stand against relocation in an April 12, 1989, hearing before the House Interior Appropriations Subcommittee. After more than fifteen years of activism and outrage, the Diné once again attempted to communicate to US representatives just what relocation meant for their spiritual and physical well-being. Representatives of the Navajo Nation carefully explained,

> Relocation has no place in the traditional Navajo world. Suppose, you who are Christians, that there were only certain places where Jesus could hear your prayers or help you, and that anywhere else, you were at the mercy of Satan. Suppose that, for no fault of your own, someone were to expel you from the

lands where you were safe and tell you [that] you could never go back to the place where your prayers could be heard. Suppose they also made you leave behind your Bibles and all the other things you use in your worship. And suppose you were left in a terrible place where Jesus and God could never hear you again or save your soul. If you can imagine these things, you can imagine what relocation means to traditional Navajos.[100]

The Navajo Nation went on to insist that that while relocating Diné with religious ties to Dinétah was inhumane, it also irreparably damaged the lives and relationships of Diné who were less traditional: "We are [also] opposed to relocation because it doesn't work. It doesn't work because it precipitates divorce, child and spouse abuse, alcoholism, drug abuse, family breakup, loss of relocation homes, indigence, welfare dependence, and even sometimes suicide among those who relocate."[101] By stating these grim facts directly to representatives of the United States government, the Diné were undercutting any denial by the United States about the deleterious consequences of removal for Indigenous people.

Though the Navajo Nation's public statement underscored the harmful impacts of removal, the Diné were not arguing for partition to immediately cease. Rather, they were asking to be able to access the $10 million appropriation set aside for the Navajo Rehabilitation Trust Fund. The argument, ultimately, was that while relocation was damaging both spiritually and physically to Diné, relocation without financial support would be even worse. The unspoken subtext of this statement was that the Relocation Commission, which had not asked for any of the funds set aside by Congress for the removal and relocation of the Diné, cared little for the well-being of its charges. By appealing directly to the Congress of the United States, the Navajo Nation drew attention to both the issues surrounding the concept of removal and their concerns with the administrative side of forced relocation.

The April 12 hearing included testimony from Hopi tribal chairman Ivan L. Sidney, whose statement revealed mounting antagonism between the Hopi and the Diné. Sidney referred to the Diné as the Hopis' "adversary," cited their "refusal to pay fair rental value" on contested lands, and minimized Diné hardship during relocation by referring to their suffering as "growing pains."[102] Yet despite these partisan elements of his testimony, Sidney's words reflected, in a way, another moment of Native unity against the federal government. In his testimony, Sidney agreed with the Diné that limiting their access to the Navajo Rehabilitation Trust Fund was guaranteed to further damage the long process of resettlement. He

argued, "The Hopi people believe *it is imperative that no alteration or funding re-straints be imposed on current relocation priorities.* . . . This method of relocation, worked out painfully over fourteen years, must move forward and not backward. This is especially true now that an end to this agonizing process is in sight."[103] For the Hopi, preventing the necessary funds from reaching the Relocation Commission was tantamount to prolonging the dispute.

Like earlier attempts, the 1989 hearing did not end the conflict. On October 18, 1989, federal district judge Earl H. Carroll dismissed the *Manybeads* motion.[104] The Diné had presented multiple voices in favor of their cause, provided compelling evidence linking the interests of the federal government with the interests of powerful energy corporations, and enlisted experts in the fields of journalism and anthropology to provide corroborating evidence and testimony. They had approached the Hopi Tribe, commanded the respect of many Diné and Hopi tribal elders, and even reached out to the broader American public through a widely disseminated and carefully constructed campaign in the press. Still, it was not enough to prevent relocation.

Manybeads might have survived if it had not been for a Supreme Court case, *Lyng v. Northwest Indian Cemetery Protective Association* (1988), which was being heard nearly simultaneously.[105] In *Lyng*, the Northwest Indian Cemetery Protective Association took action against Secretary of Agriculture Richard Lyng after the US Forest Service aimed to construct a paved road through land in Chimney Rock in southwestern Colorado, where many Indigenous people of Hoopa Valley traditionally held their religious ceremonies. In a 5–3 decision, the Supreme Court found that the free exercise clause of the First Amendment did not provide equal protections against lumbering or road construction in the contested area.[106] In the notes to an article, legal scholar Stephen McAndrew argued that, despite other factors, "*Manybeads v. the United States* was dismissed . . . largely because of the high court ruling in *Lyng*."[107] For the Diné and the Hopi of the Four Corners region, it was clear that the conservatism of the 1980s extended far past the economy. The United States government was simply not interested in protecting Native people's religious freedom to the same extent as non-Natives' religious freedom.

By 1989, the situation across Dinétah and Hopituskwa was dire. One hundred members of the Hopi Tribe and six thousand Diné had been forcibly removed from Former Joint-Use Area lands. Grazing permits on the land had, as early as 1986, resulted in a 90 percent stock reduction rate across the disputed area. Tribal elders characterized removal, as experts like Scudder and Kammer had long understood, as tantamount to death.[108] With so much at stake, the Diné made an important

decision. If federal courts and the US Congress could not or would not prevent forced removal, it was time to appeal to the international community. And unlike leaders from the United States, those from the international community listened.

International Activism

In 1989, the Economic and Social Council of the United Nations published a report under the oversight of the Commission on Human Rights' Subcommission on Prevention of Discrimination and Protection of Minorities. This report concluded that US agencies and workers had disrespected the human rights of many Diné and Hopi people in the Four Corners region.[109] It noted that the relocation was threatening "the cultural survival of the Hopi and Navajo people" and that "both people—Hopis and Navajos—are peaceful and very religious people. In particular, the traditional Elders and the traditional Navajo People expressly stated that they have very friendly relations and wish to live in peace together."[110] The United Nations saw, through Diné and Hopi testimony and advocacy, what the United States refused to see: this was not primarily an intertribal dispute. This was largely a dispute between two tribes and the federal government.

Throughout the 1990s, the Diné continued to appeal to the United Nations for support against relocation. Many had a long historical memory and likened their twentieth-century resistance to the way the Diné had resisted the Long Walk of the nineteenth century. As Jon Norstog, the assistant director of the Navajo-Hopi Land Commission, explained in 1993: "This is exactly what Kit Carson and his troops did. . . . They destroyed the livestock and food supplies to force the Navajo people into submission. It's the same old federal strategy."[111] For the resisters, public appearances by Hopi and Diné people fighting together for one cause showed strength against an old oppressor and underscored the fact that the interests shared by the Hopi and the Diné far outweighed long-standing tribal differences.

Together, the Diné and Hopi resisters who approached the United Nations in the early 1990s cited many factors contributing to the suffering that attended partition: the impossibility for the Diné to practice their religion, the fact that Diné and Hopi individuals remained impacted by the ongoing construction ban in the Bennett Freeze area, and the low morale in both tribes due to the continued United States interference in protected lands.[112] The intertribal coalition that approached the United Nations in 1993 reflected the long-standing belief, echoed in Diné and Hopi editorial cartoons, that federal officials systematically exacerbated and manipulated the conflict between the Diné and the Hopi.

Though Diné and traditional Hopi leaders had succeeded in convincing many

influential international figures of the validity of their objections to forced relocation, the US Congress continued to pursue compulsory removal by passing the Navajo-Hopi Land Dispute Settlement Act of 1996. Federal policy makers continued to portray the land dispute as an intertribal conflict, stating in the bill that "it is in the public interest for the Tribe, Navajos residing on the Hopi Partitioned Lands, and the United States to reach a peaceful resolution of the longstanding disagreements between the parties."[113] Despite a renegotiation of the financial benefits and the timeline for the complete removal of the Diné from the Hopi partitioned area, the 1996 act did not ameliorate the basic harm, which was removal in the first place. Therefore, in March 1997, the Diné issued a public statement against removal. A press release by Gloria Begay Duus stated that despite recent legislation, "over 300 Navajo families continue to resist relocation mandated by the 1974 Congressional Act because their families have been the sole occupants of the high desert plateau prior to European contact, nearly 500 years ago."[114] Sovereignty based on their continued occupancy, which stretched back centuries before the United States became a country, was the basis on which some Diné continued to oppose forced relocation. No political or hard currency could be traded for the value of their ancestral homeland.

For many Diné activists, the refusal to relocate in the 1990s stemmed from their ongoing desire to protect Dinétah from resource extraction. These activists risked their property and their freedom to fight Peabody Coal. A 1998 account of conditions across Dinétah by the special rapporteur on religious intolerance of the United Nations Commission on Human Rights, Abdelfattah Amor, discussed multiple cases of Peabody's retribution against Indigenous activism as evidence that energy interests continued to interfere on tribal land. In one example, on May 30, 1997, Navajo tribal police had arrested Diné matriarch Mabel Benally, her husband, and their two children, who were all protesting Peabody clearing land next to their home. According to the report, the tribal police "waited until 6:00PM and arrested the Benally family for trespassing on their own land. Peabody was allowed to continue their activities. The reason the Benally's [sic] were told they were arrested was because they were interfering with Peabody's mining activities."[115] Peabody not only was willing to interfere with a family's right to their own land, it used members of the tribal police to threaten anyone who might slow down its mining operations.

The Benally family's experience was not unique. It was one in a series of events in which Peabody employees directly threatened Diné activists who were attempting to prevent further extractive enterprise from gaining a foothold across

Dinétah. Just four and a half months after the Benally family was arrested on Peabody's orders, other Diné elders, including matriarch Ataid Y. Lake, approached the operators of Peabody bulldozers, "telling the vehicle operators of the sacred shrines and burial sites there."[116] Lake and her fellow activists were threatened and told not to interfere with Peabody's operations. For many Diné and Hopi activists of the 1990s, staying on the land provided further opportunities to protest resource extraction, while relocating meant giving up any opportunity to protect Dinétah from the ever-expanding mining operations.

In a continued effort to avoid relocating, activists turned for support to multiple nongovernmental organizations that worked with the United Nations. The Decade Committee of the World's Indigenous Peoples, the Women's Environment and Development Organization, and the Committee on the Status of Women endorsed Indigenous activists and speakers, providing an expanded political platform for resistance.[117] Diné and Hopi activists also continued to occupy the physical spaces under contention on the reservation: reporter Wendy Young for the *Navajo-Hopi Observer* (established 1981) noted that activists completed a four-day vigil in Window Rock, Arizona, in support of the Diné living on Hopi partitioned lands.[118]

More than twenty years after partition, resisters were still living on the partitioned lands, and the fight for sovereign control of Dinétah and Hopituskwa continued. Though hardship persisted, decades of intertribal support, multipronged resistance efforts, and appeals to the international community did not go unnoticed. Instead, the slow accumulation of Indigenous activism led to an incredible victory. In 1998, the United Nations opened an investigation of the United States for violating the religious freedom of its citizens by forcibly removing them from their traditional homeland. As reporter Jacqueline Keeler noted, this was "the first time an international agency ha[d] ever made such a move."[119]

But the year 1998 did not mark the end of the so-called Navajo-Hopi Land Dispute. In fact, conflicts over occupancy, resources, and sovereignty continue today. The UN investigation did, though, mark an important turning point in the conflict. It revealed the success that the Diné had in claiming their rights and the power they wielded through activism and the press. Most important, it verified the claims that artists and activists like cartoonists Clare Thompson, Jack Ahasteen, and Phillip Sekaquaptewa had been making for decades, squarely placing the responsibility for the Navajo-Hopi Land Dispute on the US government and its policy makers.

Though the UN condemnation of the United States was a rhetorical victory, it

was also incredibly powerful. Free of United States politics, which had long failed the interests of Indigenous people, it reflected a broader truth. It revealed a widespread understanding of the inequity taking place across Dinétah and Hopituskwa and recorded forever that Indigenous activism in practice—in the media, in protests and marches, and in front of judges—had a real, lasting, positive result.

Continued Diné and Hopi resistance against outside intervention demonstrated activists' will to persevere, insistence on peaceful protest, and use of further political agitation in the face of economic predation on the part of the United States government and various corporations. As the spokesperson for the Sovereign Dineh Nation–Dineh Alliance, Louise Benally, proclaimed, "We are the Diné from the land, affected and forever impacted by the awful relocation legislation. We do not give anyone the right to advocate violence . . . on our behalf, for only we can represent, speak, and decide for ourselves. Our prayers are for Peace and Healing to return to the land. In beauty, all was created and in beauty it will be finished."[120]

The fact that partition is not "over," that the conflict still persists, is a testament to Diné and Hopi resilience, success, and refusal to be reduced to the value of the natural resources on their land.

Conclusion

Editorial cartoons published in *Qua'Töqti* and the *Navajo Times* in 1973 and 1974 revealed the Navajo-Hopi Land Dispute to be a locus of continued colonialism in the United States rather than a conflict that stemmed from intertribal disagreements. These satirical images presented a larger truth, with United States officials, corporations, and public relations firms as the true instigators of the conflict. Throughout the land dispute, Diné and Hopi editorial cartoons proved to be an important mode of public activism along with political marches, appeals to the press, and engagement with international governing bodies. Editorial images constituted important examples of Diné and Hopi resistance to colonialism, reflected the strength of continued intertribal cohesion, and established new modes of artistic discourse for both the Diné and the Hopi. Ultimately, however, this book is about more than editorial cartoons. It is about the importance of holding up Indigenous voices and reframing the conflict—and the subsequent forced removal of Indigenous people—as a process created and perpetuated by non-Natives but consistently and successfully resisted by both Hopi and Diné people.

Indeed, as the cartoons of *Qua'Töqti* and the *Navajo Times* showed, the shared bonds of indigeneity transcended manipulative interventions by agents of Peabody Coal, Evans and Associates, and the United States government. The indictment of the federal government in these cartoons reveals the extent to which political art was able to galvanize various communities and encourage activism beyond the borders of the United States. Indigeneity became not only a motivator for social cohesion but also the basis upon which Diné and Hopi elders were able to defend their sovereignty both domestically and on the international stage. This is not to say that any of the cartoonists purported to speak for the entirety of their tribe nor to deny the fact that many political fissures existed in each tribe. Rather,

this important art shows that both Diné and Hopi activists and artists were determined to highlight the financial interests of US politicians and corporations in furthering the conflict between the two tribes. This discourse showed that rather than discord, the unity present before and after partition supported the members of the Hopi and Diné communities who were most vulnerable.

The *Qua'Töqti* and *Navajo Times* cartoons discussed in this book underscored the continuing United States colonialism on Dinétah and Hopituskwa. These cartoons examined the impact of corporate enterprise aided by federal policy makers focused on extracting and exploiting the subsurface material wealth in the region. They were acts of resistance in the face of continued threats to Diné and Hopi sovereignty and Indigenous lives. Although the jointly owned lands were officially partitioned by the federal government, activism continued. Diné and Hopi resisters ultimately proved successful in their fight for recognition: their activist efforts resulted in the United Nations officially condemning the United States for its role in orchestrating the Navajo-Hopi Land Dispute. The international community acknowledged the sovereign rights of the Diné and Hopi nations, rights that the United States has continually denied.

Despite this success, however, the negative ramifications of the conflict have persisted: thousands of people were dispossessed of their traditional homelands and their property, and they were relocated to areas where it was nearly impossible for them to thrive. Issues around forced removal on contested lands continue today. Despite the ongoing nature of the conflict, it is clear that the true instigators of this tragedy were non-Indigenous interlopers into Native space. It is also clear that thousands of people lost their lands, livelihoods, and connection to their culture and heritage. Those lifelines were forfeited by industrial greed. Knowing what has happened, discussions about reparations and restitution should begin.

More research is needed on the generational outcomes of the dispute, the effects of the continued violence enacted by the United States government on Indigenous peoples, and the effects of forced removal on second-generation relocatees. Much more can be understood about the long history of United States intervention in the Four Corners region by examining the intersection of art and activism and the promise of continued intertribal alliances between the Diné and the Hopi in the twenty-first century.

Still, conflict over partition is ongoing across Dinétah and Hopituskwa. Diné and Hopi activists, through organizations like the Forgotten People and Black Mesa Indigenous Support, continue to advocate for social and environmental justice. The spirit of resistance is alive and well in the face of continued land leases legal-

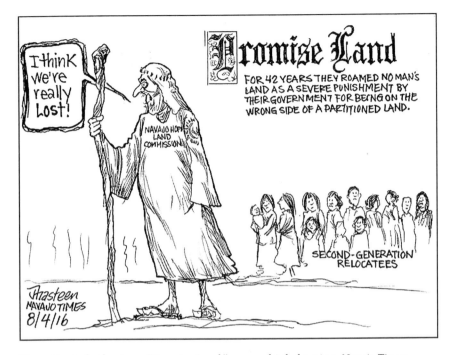

Figure C.1. Jack Ahasteen, "Promise Land," pen-and-ink drawing, *Navajo Times*, August 4, 2016, n.p. Courtesy of Jack Ahasteen

ized by the 1996 passage of PL 104-301, the constant threat of resource extraction, and many Indigenous people's deteriorating financial security.

Researchers from Black Mesa Indigenous Support estimate that fourteen thousand Diné were forcibly removed from their homes in the years following partition. Representatives of the activist organization clearly state on their website that the federal government's motive for compulsory removal was the billions of tons of oil, coal, and uranium under protected lands.[1]

While some activists work in the media, create powerful art, protest publicly, and engage in community organizing, others simply refuse to move from their ancestral homelands. That is also an important statement, a demand for recognition and sovereignty amid continued colonialism enacted by the United States government.

Editorial cartooning has also continued as an important form of activism across Dinétah. In the 2016 cartoon titled "Promise Land," Jack Ahasteen references the long impact of cultural violence inflicted by the federal government (figure C.1).

Ahasteen depicts the Navajo-Hopi Land Commission as a lost prophet, while second-generation relocatees are left homeless in the background. Ahasteen's image uses relative size, biblical imagery, and a stark landscape to tell a bleak truth: the project of forced relocation and cultural elimination that was started in the nineteenth century by United States policy makers continues in the twenty-first century. The ripples of the 1974 act now affect a new generation of relocatees.

Today, Ahasteen hopes to find a protégé, someone to continue the tradition of Indigenous cartooning. "I'm trying to find one," he says. "It's really hard to find. . . . Today's kids, they have other concerns, other issues that go with them. I try to talk to them . . . but a lot of things have just left. There's no jobs here. There's no housing, no economic development."[2] With few prospects for economic success on the reservations, many talented young Diné and Hopi artists do not remain in their ancestral homelands.

The path toward economic recovery is made harder by the reality that many people who were removed have nothing left to go back to. And for many people who want to return, the historical trauma makes it difficult to seriously consider the prospect. "It's hard [to go back]," Ahasteen says. "It hurts, you know?"[3] The memories of removal, of the range wars, of the struggle to survive are wounds that are still open. They are wounds that Ahasteen continues to address through the narratives and humor in his cartoons. Hopefully, in the fullness of time, the next generation of Diné and Hopi artists will be there to take up the mantle.

Appendix

Drawing Humor: A Conversation with Jack Ahasteen

The author interviewed Ahasteen on April 28, 2021. The resulting article appeared on the front page of the Navajo Times *on May 6, 2021, and has been lightly edited here.*

Cartoonist Jack Ahasteen of the *Navajo Times* is not a fan of notoriety. In fact, during the most contentious days of the Navajo-Hopi Land Dispute, he often didn't sign his own cartoons. "I didn't want to be in the limelight," he says. "I don't want to be in the public, but somehow the word got out." Despite Ahasteen's best efforts, a measure of fame has found him. Sometimes strangers will even approach his grown daughters in Phoenix, inquiring about Ahasteen. He says, "They say, 'You know, whenever we introduce ourselves to somebody, they recognize our last name. And they want to know if this is your dad that's doing [all these] cartoons[s]."

Ahasteen's work stands out for its unflinching representations of life in the Four Corners region and, specifically, the reality of the injustice of Diné forced removal beginning in the mid-1970s. It's an issue that hits close to home. Ahasteen's own family faced forced removal from their ancestral home at the hands of United States officials. "Right where that land was divided up, it was where I was born. I wasn't born in the hospital," he says.

Facing relocation was traumatic, Ahasteen says, especially for elders who didn't speak English and therefore couldn't understand what United States officials were telling them. "They didn't understand what the laws are, or what was going on," Ahasteen remembers, noting that he was getting most of the information about relocation and the range wars from the *Navajo Times*, which he read each week while studying at Arizona State University. "So really, I used to always tell my parents in a humorous way what was going on, and they would just laugh about it. And that's where I got the ideas, how to draw cartoons and stuff like that. . . . I had to draw these cartoons in a way they could understand it."

Soon, Ahasteen's work became known to the *Navajo Times*. Even before he had an official job with the paper, his work was being showcased on the front page. "[Back then,] they didn't have computers to do the layout and stuff like that. They had an old-fashioned way of doing it, using wax and pasting it onto a sheet. And sometimes they would have a space that I started [drawing in]. [They'd just] tell me to scribble something on there, a graphic illustration. Then, pretty soon, people wanted me to do some cartoons. [They'd say,] 'Can you draw a cartoon?'"

Of course, Ahasteen wasn't the only cartoonist drawing editorial cartoons related to the Navajo-Hopi Land Dispute. He followed Clare Thompson, who passed away in

December 1974, and he was producing work at the same time as Phillip Sekaquaptewa, the Hopi cartoonist with *Qua'Töqti*. Soon, a conversation between the two developed, taking place entirely in images. "I could read the Hopi newspaper," Ahasteen remembers. "And I would create something [in response to their cartoons,] kind of like copying something that they said or something that they [did], and put[ting] it back in there."

The cartoons that were created as a result gave voice to the trauma of forced removal. As Ahasteen remarked in a 2019 *Navajo Times* front-page article written by Rima Krisst, "There's no word for relocation in Navajo. It was like a death sentence to them."* The breakdown in communication between officials enacting removal and the Diné who experienced it was worse than most people knew. As Ahasteen says, in Diné cosmology, death is explained as your spirit going away, over the hill, and not coming back. "That's a process of a funeral, when they have somebody that leave[s] this world. That's what they usually say. Just go over the hill, don't come back. Wherever the spirit goes, they tell them and encourage them to don't look back at the school or the hill, and don't come back."

When it came to relocation, officials who spoke zero Navajo and often failed to bring translators with them to conversations with Diné people managed to transmit the expectation to traditional elders that relocation meant moving away, over the hill, and not coming back. "Actually [they were] told to die and don't come back," Ahasteen says.

For many people, including second-generation relocatees, any government offers regarding relocation assistance, housing assistance, or other funding paled in comparison to the reality of leaving. For Ahasteen's family, relocation from Window Rock, Arizona, was accompanied by empty promises. As he originally told Krisst of the *Navajo Times*: "The federal government promised us, 'You're going to have a better life.'" That "better life" might come with a house boasting new amenities, but it meant leaving behind land, livestock, and traditional lifeways.

Ahasteen, seeing the sorrow of his parents and his community, knew that there had to be a better way to survive. He reflects on the reality of the value of people's lives being rejected by officials tasked with relocating thousands of people. "What is it going to do [to you] when you're told to leave this world?" he asks. There are no answers, only loose ends. Still, Ahasteen believes, "There has to be some kind of humor for them to understand that you can still be happy. You can still smile." Editorial cartoons, during and after the dispute, proved to be a balm to the open wounds.

Still, the historical trauma of relocation persists to this day. In the cartoons that Ahasteen published with the *Navajo Times* in the years following partition, the emotional scars are drawn as physical wounds. In "After the dust settle . . . ," originally published on February 16, 2005, Ahasteen presents two battered and beleaguered men, representing the Hopi and Diné nations (figure A.1). The dust includes all of the harms of the past hundred years: drought, relocation, job loss, religious desecration, loss of revenue, and livestock reduction. The fence between the Hopi and Diné

*Rima Krisst, " 'Now You Know Why I Draw': Relocation Spawned Cartoonist's Career," *Navajo Times*, March 31, 2019, 1

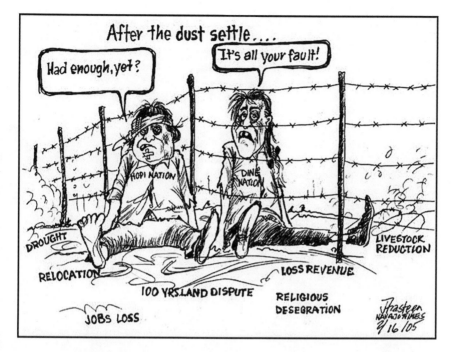

Figure A.1. Jack Ahasteen, "After the dust settle . . . ," pen-and-ink drawing, *Navajo Times*, February 16, 2005, n.p. Courtesy of Jack Ahasteen

stands, its sharp barbed wire a reminder of the thorns in the relationship that still exist.

For Ahasteen, it isn't over. The past isn't the past. As he notes, "One of my daughters who is always tuned into people, she has health issues, and she's always saying that I've been traumatized by this. What do you do? . . . Their grandparents, what they had to go through. How to cope with all of this stuff? It goes back to that, but for me it's like . . ." He trails off, but it's clear exactly what he means. Ahasteen clears his throat and notes, "I wish these reporters, some of these reporters, [that I'd] told them about it. What does historical trauma do?"

For many people in the region, Ahasteen's cartoons themselves have become a guide for how to survive. In fact, Ahasteen found out through a reporter that there was a hogan literally wallpapered with his art in what was then known as the Joint-Use Area. Now, Ahasteen continues serving as a guide for his community. "I just focus on the cartoons," he says. He even brings cartooning to his other endeavors. Sometimes, for example, he helps out one of his daughters at her bakery, illustrating cakes so that they transform into edible works of art. And sometimes he holds public conversations about his role as a cartoonist, about forced relocation, and about the range wars. He's a photographer too, and often takes photos that, like his cartoons, build important linguistic and cultural bridges.

Ahasteen believes that continuing the conversation is important. The second generation, as he knows firsthand, is often only exposed to the reality of the dispute through his work. "They [second-generation relocatees] come up to me and say, 'We didn't know nothing about all this stuff that happened until we saw that cartoon,'" Ahasteen says. "And they get emotional about it, and they want to be a part of it." Thinking of ways to heal, and the people who have experienced relocation and passed on, Ahasteen says, "We can create a memorial for them, or something. We keep telling them, 'You had great-grandparents that fought all of this. They were talking about all this relocation. You still need to talk about that because they left. But they prayed for you. That's why you're here. They prayed that one day [their] grandkids are going to live in this world, and they can continue their legacies.'"

The fight goes on. But Ahasteen would rather laugh than succumb to weariness. After all, the joy, the humor, and the community that define his cartoons can't ever be taken away from Diné people who are protecting their traditions and fighting injustice. That, at least, is theirs to keep.

Notes

Introduction

Epigraph. Jack Ahasteen (*Navajo Times* cartoonist), in discussion with the author, May 5, 2021.

1. Quoted in Benally, *Bitter Water*, 30.
2. In this book, each Indigenous group will be referred to as its members refer to themselves: Diné (which translates to "the people") and Hopi (which translates to "peaceful person" or "well-mannered person"). Denetdale, *Long Walk*, 7; Geertz, *Invention of Prophecy*, 251.
3. Benedek, *Wind Won't Know Me*, 135; Denetdale, *Long Walk*, 7; Geertz, *Invention of Prophecy*, 250–251; Redhouse, *Geopolitics of the Navajo-Hopi Land Dispute*, 13–30.
4. Coulthard, *Red Skin, White Masks*. Native American studies scholar Robert Allen Warrior's work regarding group sovereignty and recognition is also key to understanding the ideas Coulthard presented in *Red Skin, White Masks*. See Warrior, "Intellectual Sovereignty."
5. Simpson, *Mohawk Interruptus*.
6. Johnson, "Special Message to the Congress on the Problems of the American Indian."
7. Banks and Erdoes, *Ojibwa Warrior*; Castile, *To Show Heart*; Clarkin, *Federal Indian Policy*; Josephy, *Red Power*; Stern, *Loud Hawk*.
8. Rosenthal, "Beyond the New Indian History."
9. Bachman, *Death and Violence on the Reservation*; Blackhawk, *Violence over the Land*; Carpenter, *Seeing Red*; Meyer, *Native Americans*; Silva, *Aloha Betrayed*; Taylor and Pease, *Violence, Resistance, and Survival*.
10. Rosenthal, "Beyond the New Indian History," 962–974.
11. Horsman, "Well-Trodden Paths and Fresh Byways," 242.
12. Richter, "Whose Indian History?," 380.
13. The 1970s, 1980s, and early 1990s saw a spate of historically specific groundbreaking works that foregrounded Native voices and Native political experiences. Examples include Nash, *Red, White, and Black*; Usner, *Indians, Settlers, and Slaves*; White, *Middle Ground*; White, *Roots of Dependency*. See also Deloria, *Playing Indian*. Richter himself contributed to the field in 1992 with his *Ordeal of the Longhouse*, which resituated and recontextualized the relationship between colonizer and colonized in the American Northeast. The late 1990s and early 2000s saw the publication of even more carefully considered Indigenous histories, which broadened the field for up-and-coming ethnographers and historians.

14. Brooks, *Captives and Cousins*; Merrell, *Into the American Woods*; Ostler, *Plains Sioux*.

15. Hosmer, *American Indians in the Marketplace*; Meyer, *White Earth Tragedy*; O'Neill, *Working the Navajo Way*.

16. Blackhawk, "Currents in North American Indian Historiography," 320.

17. Deloria, *Indians in Unexpected Places*. Also see Hämäläinen, *Comanche Empire*; Jacoby, *Shadows at Dawn*.

18. Some studies of the Indian Claims Commission were the first to place Native voices in positions of power and authority. See Berkhofer, "Political Context of a New Indian History"; Lurie, "Indian Claims Commission Act"; Pierce, "Work of the Indian Claims Commission." Donald Fixico's 1997 edited volume shows how far the project of focusing on Native voices has come. Fixico, *Rethinking American Indian History*.

19. Quoted in Pearce, *Women and Ledger Art*, 3. Issues of representation in the New Indian history are also addressed in Gidley, "Pictorialist Elements"; Meek, "And the Injun Goes 'How!' "; Murray, *Forked Tongues*.

20. Scholars including professor of ethics and institutions Barbara Perry, First Nations studies scholar Lisa Poupart, sociologist Ronet Bachman, and public health experts Jonathan R. Sugarman and David C. Grossman have studied the intersection between conditions in Native communities and violence, connecting the realm of the political and social to that of the private in twentieth-century Native histories. Bachman, *Death and Violence on the Reservation*; Perry, "American Indian Victims"; Poupart, "Crime and Justice"; Sugarman and Grossman, "Trauma among American Indians." The violence inherent in removal has become so important to discussions of the New Indian history that it is even a focal point in textbooks: historian John M. Dunn's *Relocation of the North American Indian* is a textbook that uses the phenomenon of removal as an axis around which to explore Indigenous experiences in the twentieth-century United States. Historians Ned Blackhawk and Nicolas Rosenthal and public health expert Alan Sorkin have all, in different ways, discussed the specificities of removal as they pertain to financial concerns of the twentieth century. Blackhawk, "I Can Carry On from Here"; Rosenthal, *Reimagining Indian Country*; Sorkin, *Urban American Indian*.

21. Activists and authors have been challenging the myth of the vanishing Native since Cherokee activist Elias Boudinot delivered his 1826 address to the First Presbyterian Church in Philadelphia. He famously asked, "Shall red men live, or shall they be swept from the earth? With you and this public at large, the decision chiefly rests." Boudinot, *Address to the Whites*, 7. Iverson's text is the most-cited historical monograph to take up the issue—and ultimately put it to rest. Iverson, *"We Are Still Here."*

22. Fixico, *Urban Indian Experience in America*, 3.

23. Rosenthal, *Reimagining Indian Country*, 3.

24. Benedek, *Wind Won't Know Me*, 167–241; Florio and Mudd, *Broken Rainbow*; Brugge, *Navajo-Hopi Land Dispute*; Kammer, *Second Long Walk*; Pasternak, *Yellow Dirt*; Redhouse, *Geopolitics of the Navajo-Hopi Land Dispute*, 1–38; Voyles, *Wastelanding*, 151–184; Weisiger, *Dreaming of Sheep*, 17–202; Wilkins, *Navajo Political Experience*, 173–279. The Navajo-Hopi Land Dispute also makes an appearance in journalist and independent historian Judith Nies's *Unreal City*, which focuses on water rights.

25. Dunbar-Ortiz, *Indigenous Peoples' History*, 193.

26. Banks and Erdoes, *Ojibwa Warrior*; Cobb, *Native Activism*; Cornell, *Return of the Native*; Deloria, *Behind the Trail of Broken Treaties*; Deloria, *Custer Died for Your Sins*; Kemnitzer, "Personal Memories of Alcatraz, 1969"; Means and Wolf, *Where White Men Fear*; Smith and Warrior, *Like a Hurricane*.

27. Cobb, *Native Activism*, 198.

28. National Indian Education Association, www.niea.org; Smith and Warrior, *Like a Hurricane*, 60–87.

29. Cobb, *Native Activism*, 2; "Native Americans Walk."

30. Fixico, *Invasion of Indian Country*, ix; Iverson, *"We Are Still Here"*; Rosenthal, *Reimagining Indian Country*, 13; Voyles, *Wastelanding*, 1–26.

31. Hoffman, *Caricature*, 16.

32. Hess and Kaplan, *Ungentlemanly Art*, 15.

33. Dewey, *Art of Ill Will*, 1–2.

34. Johnson, "Cartoons," 21.

35. Although there were four colonies in New England, Franklin drew them as one segment of the snake, labeled "N.E.," ostensibly to underscore the importance of their unity. Dewey, *Art of Ill Will*, 2.

36. Despite their rarity, influential political cartoonists like Thomas Nast were often so powerful that their work impacted election outcomes. Historian Richard Samuel West noted, "Nast was a dogmatist. . . . The harshness of his heavy black line and the severity of his crosshatching mirrored his angry politics." West, *Satire on Stone*, 128.

37. Nevins and Weitenkampf, *Century of Political Cartoons*, 134.

38. Dewey, *Art of Ill Will*, 6.

39. Clark, "Dr. Montezuma, Apache," 56.

40. Montezuma, untitled article, *Wassaja*, April 1916, 1.

41. The earliest issues of *Talking Leaf* (1935) are nonextant, but later issues are well known for containing cartoons. Murphy and Murphy, *Let My People Know*, 92, 107, 115. See figure 3.9 for a specific example.

42. For more on Indigenous press outlets in the Southwest, see Murphy and Murphy, *Let My People Know*, 16.

43. Their research covered 1828–1978. Murphy and Murphy, *Let My People Know*, 91, 177–187.

44. Murphy and Murphy, *Let My People Know*, 92–94.

45. Murphy and Murphy, *Let My People Know*, 91.

46. Editors quoted in Murphy and Murphy, *Let My People Know*, 92.

47. "Hopi Weekly Is in Second Year," *Gallup Independent*, July 23, 1974, 6; "Hopi Paper's Dance Lists Will Appeal to White Eyes," *Arizona Republic*, August 2, 1973, D1.

CHAPTER 1: **The Beginning**

Epigraph. Malcolm D. Benally, ed., *Bitter Water: Diné Oral Histories of the Navajo-Hopi Land Dispute* (Tucson: University of Arizona Press, 2011), 75.

1. Benally, *Bitter Water*, 17.

2. Levy, *In the Beginning*, 40.

3. Levy, *In the Beginning*, 40.

4. O'Bryan, *Diné*, 1.

5. O'Bryan, *Diné*, 13.

6. Levy, *In the Beginning*, 51. Historian Peter Iverson, who described many of the intricacies of the emergence of the Diné from the underworlds, relied heavily on scholar and activist Ethelou Yazzie's edited *Navajo History*, but also cited Levy's work and humanities scholar Paul Zolbrod's translated *Diné Bahané: The Navajo Creation Story*. In Iverson's account, the Fourth World, the dazzling world, is the one in which the Diné currently live. Iverson, *Diné*, 8.

7. Iverson, *Diné*, 11, 12.

8. Anthropologist Charlotte Johnson Frisbie's definition of *hózhó* is "continual good health, harmony, peace, beauty, good fortune, balance, and positive events in the lives of self and relatives." Cited in Iverson, *Diné*, 12; Levy, *In the Beginning*, 51–67.

9. Iverson, *Diné*, 12.

10. Iverson, *Diné*, 14.

11. Benally, "Han'é Béé'ééhanííh," 41–46.

12. Waters and Fredericks, *Book of the Hopi*, ix.

13. Waters and Fredericks, *Book of the Hopi*, 1–198.

14. Waters and Fredericks, *Book of the Hopi*, 1.

15. Leeming, *Creation Myths of the World*, 113.

16. Geertz, "Structural Elements in Uto-Aztecan Mythology," 54.

17. Levy, *In the Beginning*, 31.

18. Brugge, *Navajo-Hopi Land Dispute*, 3; Sundberg, *Dinétah*, 8.

19. Sundberg, *Dinétah*, 8. The first time that the word "Navajo" comes up in the historical record is in Franciscan friar Gerónimo de Zárate Salmerón's writings. In 1626, he noted that some Apache were farmers, called Apaches de Návaju. The word "Navajo," Carmean noted, is a "Tewa Pueblo word for 'great cultivated fields,' reflecting the Tewa's understanding of the distinctions between these two groups." Carmean, *Spider Woman Walks This Land*, 11–12. Though there was a clear Diné presence in the Four Corners region by the early seventeenth century, debates regarding the tenure of Diné presence in the Southwest often hinge on linguistic studies. These studies show striking similarities between the Diné language and Athabaskan languages spoken by Native peoples in western Canada, the Pacific Northwest, and Alaska, suggesting that the Diné migrated relatively recently to the Four Corners region. Still, as AnCita Benally and Peter Iverson insisted, justifying land claims based on glottochronology and lexicostatistics misses the point. Regardless of earlier habitations, the Four Corners is a key component of modern Diné and Hopi identities. The land defines how Hopi and Diné relate to their heritages, their ancestors, and their continued spiritual relationships, including to the land itself. Iverson, *Diné*, 6.

20. Brugge, "Comments on Athabaskans and Sumas," 286–287.

21. Sundberg, *Dinétah*, 18.

22. Because the Spaniards originally resided in the Rio Grande Valley, which was far to the east of the traditional Diné homeland, the impact of their arrival was not immediately felt. Iverson, *Diné*, 21–23.

23. Iverson, *Diné*, 21.

24. As historian Lynn R. Bailey noted, prior to the introduction of domesticated livestock by the Spanish, the Diné could be described as "hunters who farm[ed]." However, "livestock was an integral part of the Hispanic tide as it swept northward over the great central plateau of Mexico during the mid-1500s." Bailey, *If You Take My Sheep*, 39, 46–47.

25. Sweet and Larson, "Horse, Santiago, and a Ritual Game," 69.

26. Worcester, "Early History," 56.

27. Bailey, *If You Take My Sheep*, 47.

28. Blackmar, *Spanish Colonization*; Brooks, *Captives and Cousins*; Carter, *Indian Alliances and the Spanish*; Cruz, *Let There Be Towns*; Roberts, *Pueblo Revolt*; Weber, *Spanish Frontier*.

29. For more on the concept of intellectual sovereignty, see Warrior, *Tribal Secrets*.

30. During and after the revolt, Puebloan peoples sought refuge with the Diné, who took them in. As Carmean noted, "Even today there remains a large amount of intermarriage between Navajo and various Pueblo groups." Carmean, *Spider Woman Walks This Land*, 11. Indigenous communities of the Southwest were far from hermetically sealed ethnographic groups. For archaeological documentation of intertribal exchange and proximity following the Pueblo Revolt, see Kelley and Whitely, *Navajoland*; Keur, "Chapter in Navajo-Pueblo Relations"; Powers and Johnson, *Defensive Sites of Dinétah*.

31. Wilcox, *Pueblo Revolt*, 37–38.

32. See Bandelier's writings on the Southwest, especially Bandelier, Morgan, and White, *Pioneers in American Anthropology*; see also Bolton and Marshall, *Colonization of North America*; Lummis, *Spanish Pioneers*.

33. Udall, *To the Inland Empire*, 204.

34. The Hopi, Keres, Towa, and Zuni peoples are descended from Ancestral Pueblo peoples. Reff, *Disease, Depopulation, and Culture Change*, 22–30.

35. Carmean, *Spider Woman Walks This Land*, 11.

36. Knaut, *Pueblo Revolt of 1680*, 107.

37. Carmean, *Spider Woman Walks This Land*, 12.

38. Knaut, *Pueblo Revolt of 1680*, 72–88.

39. Fray Juan Bernal to the Tribunal, April 1, 1669, from the Convent of Santo Domingo, in Hackett, *Revolt of the Pueblo Indians*, 272.

40. Carmean, *Spider Woman Walks This Land*, 10.

41. Reff, *Disease, Depopulation, and Culture Change*, 22–30.

42. Hackett, *Revolt of the Pueblo Indians*, 234–235.

43. Wilcox, *Pueblo Revolt*, 153.

44. Hackett, *Revolt of the Pueblo Indians*, 246.

45. Carmean, *Spider Woman Walks This Land*, 11.

46. Quoted in Preucel, *Archaeologies of the Pueblo Revolt*, 213.

47. Preucel, *Archaeologies of the Pueblo Revolt*, 213.

48. Wilcox, *Pueblo Revolt*, 152.

49. Wilcox, *Pueblo Revolt*, 158.

50. Wilcox, *Pueblo Revolt*, 152.

51. Wilcox, *Pueblo Revolt*, 152.

52. Spanish accounts of Diné activity are especially prevalent between 1753 and 1772, as many Spanish colonists were successful in their request for land grants on traditional tribal homelands. Jenkins, Minge, and Reeve, *Navajo Activities*, 4–7.

53. Bailey and Bailey, *History of the Navajos*, 16.

54. Bailey, *If You Take My Sheep*, 124.

55. Dyk and Left Handed, *Son of Old Man Hat*, 32.

56. Tapahonso, *Sáanii Dahataał*, 7–11.

57. Quoted in Benally, *Bitter Water*, 30.

58. Bailey and Bailey, *History of the Navajos*, 17.

59. Wilson, *Military Campaigns in the Navajo Country*, 7–8.

60. Bailey and Bailey, *History of the Navajos*, 18.

61. For the Hopi, interactions were indeed often laced with conflict, particularly with Utes, whom many Hopi consider to be their hereditary enemies. Iverson, *Diné*, 32.

62. Iverson, *Diné*, 32.

63. Bailey and Bailey, *History of the Navajos*, 17–18.

64. Bailey and Bailey, *History of the Navajos*, 18.

65. McNitt, *Navajo Wars*, 59–91.

66. Wrobel, *Global West, American Frontier*, 136–181. Also see Carlisle and Golson, *Manifest Destiny*; Hausdoerffer, *Catlin's Lament*; Miller, *Native America, Discovered and Conquered*; Ruiz, *Mexican War*.

67. Underhill, *Navajos*, 91–92.

68. Bailey and Bailey, *History of the Navajos*, 18.

69. As the treaty was never ratified by the US Senate, federal officials were also not bound by the agreement. Lyon, "Navajos in the Anglo-American Historical Imagination," 488.

70. Van Valkenburgh, "Short History of the Navajo People."

71. Bailey, "Navajo Wars," 6.

72. Bailey, "Navajo Wars," 6; McNitt, *Navajo Wars*, 325–384.

73. Bailey, "Navajo Wars," 6.

74. Bailey, "Navajo Wars," 7.

75. Bailey, "Navajo Wars," 7. Dodge certainly had an allegiance to the United States government, but his actions showed that he was also interested in the well-being of the Diné, with whom he lived in close proximity. He established a community center for the Diné near his own residence and provided lessons in ironsmithing and silversmithing, both of which were to serve the economic well-being and independence of the Diné.

76. Bailey, "Navajo Wars," 7.

77. Bailey, "Navajo Wars," 7.

78. Bailey and Bailey, *History of the Navajos*, 18.

79. Letter from Rencher to unnamed captain, May 1, 1860, reprinted in Correll, *Through White Men's Eyes*, 21.

80. Bailey, *Long Walk*; Faulk, *Crimson Desert*; McNitt, *Navajo Wars*, 59–91.

81. Colonel Thomas Fauntleroy to General Winfield Scott, November 6, 1859, in *Executive Documents Printed by Order of the House of Representatives*, 9:11.

82. Iverson, *Diné*, 48.

83. Iverson, *Diné*, 48.

84. Iverson, *Diné*, 49.

85. Danziger, "Steck-Carleton Controversy," 189.

86. Danziger, "Steck-Carleton Controversy," 191.

87. Danziger, "Steck-Carleton Controversy," 191.

88. Sundberg, *Dinétah*, 63.

89. United States Office of Indian Affairs, *Annual Report of the Commissioner*, 136.

90. Tohe, "Hwéeldi Bééhániih," 79.

91. Dunlay argued that "Kit Carson . . . had little to do with the Long Walk, except to warn General Carleton that he had probably underestimated the number of Indians to be transported and provided for, and to insist that they must be adequately fed and kindly treated." Dunlay, *Kit Carson and the Indians*, 317. The fact that Carson manipulated Indigenous people who trusted him in order to gather intelligence that was ultimately used to force them to surrender their land, their property, and sometimes their life, makes Dunlay's statement questionable at best. For an excellent argument that situates Carson in the center rather than on the periphery of Carleton's military maneuvers, see Bailey, *Bosque Redondo*, 89–90.

92. Not all Pueblo peoples helped Carson. Some, including some Hopi, continued to advise the Diné to avoid or fight United States military officers. Bailey, *Bosque Redondo*, 89–90.

93. Bailey, *Bosque Redondo*, 91.

94. Thompson, *Army and the Navajo*, 27.

95. Thompson, *Army and the Navajo*, 26.

96. In January 1864, for example, a reprisal against Diné raiders resulted in the deaths of nine Diné. Thompson, *Army and the Navajo*, 26.

97. Letter from Commanding Brigadier General James H. Carleton to Brigadier General Lorenzo Thomas, September 6, 1863, in Dolittle, *Condition of the Indian Tribe*, 134.

98. Trafzer, *Kit Carson Campaign*, 138.

99. Tohe, "Hwéeldi Bééhániih," 78.

100. Diné of the Eastern Region of the Navajo Reservation, *Oral History Stories*, 29.

101. John Beyale Sr., undated interview, in Diné of the Eastern Region of the Navajo Reservation, *Oral History Stories*, 41.

102. Diné of the Eastern Region of the Navajo Reservation, *Oral History Stories*, 11.

103. Bailey, *Bosque Redondo*, 57.

104. Iverson, *Diné*, 52.

105. Bailey, *Bosque Redondo*, 103.

106. Correll, *Through White Men's Eyes*, 27.

107. Bailey, *Bosque Redondo*, 103.

108. Thompson, *Army and the Navajo*, 27.

109. Thompson, "To the People of New Mexico," 347.

110. Bailey, *Bosque Redondo*, 104.

111. Bailey, *Bosque Redondo*, 188.

112. Bailey, *Bosque Redondo*, 187.
113. Letter from General William T. Sherman to Ulysses S. Grant, June 7, 1868, in Simon, *Papers of Ulysses S. Grant*, 18:258.
114. Barboncito and the Navajo Tribe of Arizona, New Mexico, and Utah, *Treaty*, 1–2.
115. Trafzer, *Kit Carson Campaign*, 243–244.

CHAPTER 2: **Divide and Conquer**

Epigraph. Peterson Zah and Peter Iverson, *We Will Secure Our Future: Empowering the Navajo Nation* (Tucson: University of Arizona Press, 2012), 110.

1. Bailey and Bailey, *History of the Navajos*, 39.
2. Bailey and Bailey, *History of the Navajos*, 17–18.
3. McClure to Kobbe, February 15, 1870.
4. Bailey and Bailey, *History of the Navajos*, 41.
5. Kappler, *Indian Affairs*, 805.
6. Welsh to Vilas, September 26, 1888, quoted in Stephens, "Origin and History," 82.
7. McPherson, *Northern Navajo Frontier*, 62.
8. Kammer, *Second Long Walk*, 29–30.
9. Kammer, *Second Long Walk*, 30. Of course, white conceptions of land use were markedly different than those of Indigenous people. For the Hopi, sacred land was considered to be in use even if settlements and crops were not directly on it. This was just one way in which US officials fundamentally misunderstood the Indigenous relationship to the land in question.
10. Burton in *Annual Report of the Department of the Interior*, 476.
11. Kammer, *Second Long Walk*, 31.
12. Kammer, *Second Long Walk*, 31.
13. Kappler, *Indian Affairs*, 877.
14. Bailey and Bailey, *History of the Navajos*, 108–109.
15. Redhouse, *Geopolitics of the Navajo-Hopi Land Dispute*, 8.
16. "Coal Prices Rise."
17. Kammer noted in his seminal text on the Navajo-Hopi Land Dispute that Commissioner Charles Burke argued that the Hopi were in fact *confined* to that six hundred square miles due to Diné encroachment on Hopi traditional lands. Kammer, *Second Long Walk*, 31; United States Congress, Senate, Committee on Indian Affairs, *Partition of the Surface Rights*, 353–356.
18. United States Congress, Senate, Committee on Indian Affairs, *Partition of the Surface Rights*, 357–360.
19. Art, "Natural and Supernatural Resources," 21.
20. Iverson, *Diné*, 133–134; Art, "Natural and Supernatural Resources," 4; Navajo Nation, "Hopi, Navajo, and Christian Leaders."
21. Iverson, *Diné*, 134.
22. The Hopi established their tribal council in 1936. From 1921 to 1936 the traditional leaders (*kikmongwi*) remained in control. Once the council was established, however, divisions between traditional leaders and the council created significant tension within the Hopi Tribe. See Clemmer, *Continuities*. Also see Hopi leader Emory

Sekaquaptewa's searing 1982 review of Clemmer's work, which further outlines the strain in Hopi communities between traditional and council leaders.

23. Bailey and Bailey, *History of the Navajos*, 193.

24. Crane, "Report Made to Indian Office, March 12, 1918, concerning Hopi-Navajo Range Question," in *Indians of the United States*, 3:793.

25. United States Congress, Senate, Committee on Indian Affairs, *Partition of the Surface Rights*, 361.

26. Brugge, *Navajo-Hopi Land Dispute*, 31.

27. Study cited in Aberle, *Peyote Religion*, 187.

28. Quoted in Wilkins, *Navajo Political Experience*, 20.

29. Wilkins, *Navajo Political Experience*, 21.

30. Wilkins, *Navajo Political Experience*, 32–33.

31. Iverson, *Diné*, 144.

32. A "sheep unit" is the amount of plant life one sheep can consume. As Kammer noted, based on the estimates done on Dinétah in the 1930s, a cow equaled four sheep units while a horse equaled five. Kammer, *Second Long Walk*, 33.

33. Kelly, *Navajo Indians and Federal Indian Policy*, 157.

34. United States Department of the Interior, *Annual Report*, 108–109.

35. Kelly, *Navajo Indians and Federal Indian Policy*, 157.

36. Kelly, *Navajo Indians and Federal Indian Policy*, 157.

37. Iverson, *Diné*, 148–149.

38. Bailey and Bailey, *History of the Navajos*, 187–188.

39. Quoted in Deloria, *Indian Reorganization Act*, 171.

40. Aberle, *Peyote Religion*, 70.

41. Bailey and Bailey, *History of the Navajos*, 193–195. Also in 1934, the Navajo Reservation was officially and legally defined (48 Stat. 984). The defined area reflected existing Diné settlement patterns, which surrounded the 1882 Hopi area. See Jones, "Issue Brief."

42. Edward H. Spicer and John Collier, "Sheepmen and Technicians: A Program for Soil Conservation on the Navajo Indian Reservation," in Spicer, *Human Problems in Technological Change*, 187.

43. Kammer, *Second Long Walk*, 40.

44. As Kammer showed in his research, "The Hopis objected strongly to being limited to one-fifth of the 1882 reservation." Kammer, *Second Long Walk*, 40.

45. Bailey and Bailey, *History of the Navajos*, 191.

46. Bailey and Bailey, *History of the Navajos*, 192.

47. Quoted in Pollock, *Navajo Confrontation*, 96–97.

48. Pollock, *Navajo Confrontation*, 96.

49. Ricketts and McPhee, *Navajo Indians in a Changing World*, 13.

50. United States Congress, Senate, Committee on Indian Affairs, *Partition of the Surface Rights*, 361–362.

51. Benedek, *Wind Won't Know Me*, 134; Voyles, *Wastelanding*, xiii.

52. Cohen, *Ownership of Mineral Estate*.

53. Benedek, *Wind Won't Know Me*, 135.

54. Benedek, *Wind Won't Know Me*, 135.

55. Kelly, *Navajo Indians and Federal Indian Policy*, 190.

56. O'Neill, *Working the Navajo Way*, 85.

57. O'Neill, *Working the Navajo Way*, 85.

58. O'Neill, *Working the Navajo Way*, 85.

59. Bailey and Bailey, *History of the Navajos*, 239.

60. Rosenthal, *Reimagining Indian Country*, 1.

61. O'Neill, *Working the Navajo Way*, 87.

62. Redhouse, *Geopolitics of the Navajo-Hopi Land Dispute*, 8.

63. Zah and Iverson, *We Will Secure Our Future*, 118.

64. Zah and Iverson, *We Will Secure Our Future*, 110.

65. Kammer, *Second Long Walk*, 46.

66. Brugge, *Navajo-Hopi Land Dispute*, 96.

67. *Healing v. Jones*, 210 F. Supp. 125 (D. Ariz. 1962).

68. Kammer, *Second Long Walk*, 169.

69. Some Diné further believed that the Hopi were awarded District 6 based on its proximity to natural resources and their comparatively positive relationship with the United States government, which would, the Diné thought, facilitate resource extraction. Kammer, *Second Long Walk*, 133.

70. Quoted in Kammer, *Second Long Walk*, 50.

71. Wilkinson, *Fire on the Plateau*, 212–213.

72. Quoted in Allison, *Sovereignty for Survival*, 47.

73. Indian Law Resource Center, "Report to the Hopi Kikmongwis," 125.

CHAPTER 3: **Fourth World Activism**

Epigraph. "Liberty & Justice for All?," *Qua'Töqti*, July 19, 1973, 2.

1. *Healing v. Jones*, 210 F. Supp. 125 (D. Ariz. 1962).

2. Iverson, *Diné*, 214–215.

3. James E. Cook, "New Voice for Dineh, Loud and Clear," *Arizona Republic*, April 18, 1963, 14.

4. Iverson, *Diné*, 230.

5. Nakai, "Inaugural Address of Raymond Nakai."

6. Nakai, "Inaugural Address of Raymond Nakai," 2.

7. Quoted in Brugge, *Navajo-Hopi Land Dispute*, 93.

8. Hamley, Yankwich, and Walsh, *In the United States District Court*, 105–106.

9. Other artists on occasion also published editorial cartoons related to the land dispute in the *Navajo Times*. Brugge, *Navajo-Hopi Land Dispute*, 181, 232.

10. Cox, "What Is Hopi Gossip About?," 89.

11. Cox, "What Is Hopi Gossip About?," 90.

12. Richland, "Hopi Sovereignty," 91.

13. Iverson, *Diné*, 228–231.

14. Associated Press, "'Won't Quit Post,' Asserts Council for Navajo Tribe," *Salt Lake Tribune*, January 2, 1964, A7.

15. Associated Press, "Won't Quit Post," A7.

16. Iverson, *Diné*, 231.

17. William Steif, "Indian Battle over Oil near Eruption: Udall Fails in Fight to Block Navajo Lawyer," *Pittsburgh Press*, November 11, 1964, 41.

18. Kelley and Francis, *Navajo Sacred Places*, 150.

19. Steif, "Indian Battle over Oil near Eruption," 41.

20. Kelly, *Navajo Indians and Federal Indian Policy*, 112.

21. McPherson, *Navajo Land, Navajo Culture*, 196.

22. McPherson, *Navajo Land, Navajo Culture*, 197.

23. Republic Washington Bureau, "Eviction of 35 Navajos from Hopi Lands Ordered: Squatters Stay Past Deadline," *Arizona Republic*, April 5, 1966, 25.

24. Benally, *Bitter Water*, 23.

25. Perdue and Greene, *Cherokee Nation*, xiv; Parins and Blackburn, "Full Scope of the Trail of Tears," 8.

26. Thornton, "Cherokee Population Losses," 289.

27. Jackson, "On Indian Removal."

28. Voyles, *Wastelanding*, 9.

29. Voyles, *Wastelanding*, 10.

30. Redhouse, *Geopolitics of the Navajo-Hopi Land Dispute*, 8.

31. Gordon, *Black Mesa*, 12.

32. Ali, *Mining, the Environment, and Indigenous Development Conflicts*, 83; Benedek, *Wind Won't Know Me*, 13.

33. Voyles, *Wastelanding*, 10.

34. Brugge, *Navajo-Hopi Land Dispute*, 116–118.

35. Johnson, "Special Message to the Congress on the Problems of the American Indian."

36. "Rainbow Prophecy."

37. "Rainbow Prophecy."

38. Black, "Warriors of the Rainbow Prophecy."

39. "The Indian: The Forgotten American," 1819–1820.

40. Brugge, *Navajo-Hopi Land Dispute*, 197.

41. Brugge, *Navajo-Hopi Land Dispute*, 198.

42. Kennedy, "Tribal Elections," 497.

43. Pevar, *Rights of Indians and Tribes*, 240.

44. For more on DNA and its legal controversies, see Iverson, *Diné*, 240–242; Iverson, "Legal Council and the Navajo Nation," 1–15.

45. Iverson, *Diné*, 243.

46. Center for Biological Diversity, "Lawsuit Seeks Release of Public Records."

47. *Hamilton v. Nakai*, 453 F.2d 152 (1971).

48. Kappler, *Indian Affairs*, 805.

49. Quoted in *Executive Documents of the Senate of the United States*, 210.

50. Kappler, *Indian Affairs*, 802.

51. Eads, "Prospecting Permits," 117.

52. Brugge, *Navajo-Hopi Land Dispute*, 95–100.
53. 373 US 758 (1963). For a discussion, see Dutton, *American Indians*, 87.
54. *United States Congressional Serial Set, Serial Number 14947*, 3.
55. Hansen, "Survey of Civil Jurisdiction," 325.
56. Hansen, "Survey of Civil Jurisdiction," 325.
57. Kalt and Singer, "Myths and Realities of Tribal Sovereignty," 1.
58. Folger, "Thirsty Nation," 25.
59. Bailey and Bailey, *History of the Navajos*, 37.
60. Quoted in Warrior, *Tribal Secrets*, 123.
61. See Brugge, Benally, and Yazzie-Lewis, *Navajo People and Uranium Mining*; Eichstaedt, *If You Poison Us*; Pasternak, *Yellow Dirt*.
62. Dunbar-Ortiz, *Indigenous Peoples' History*, 235.
63. In a 2001 interview, in response to a question regarding his stance on the Surface Mining Control and Reclamation Act, Steiger said, "I thought that the strip mining ought to be regulated, but that the regulations weren't realistic." Ferdon, "Oral History Interview with Sam Steiger," 6; Kammer, *Second Long Walk*, 93–94.
64. Kammer, *Second Long Walk*, 95.
65. Redhouse, *Geopolitics of the Navajo-Hopi Land Dispute*, 1–38.
66. "Sam Steiger Collection, 1923–1996: Biographical Note," September 6, 2016, Arizona Archives Online, http://www.azarchivesonline.org/xtf/view?docId=ead/nau /steiger_sam.xml.
67. Quoted in Kammer, *Second Long Walk*, 95.
68. *Hearing before the Committee on Indian Affairs*, 6.
69. Redhouse, "Geopolitics of the Navajo-Hopi Land Dispute."
70. Bruce to Hamilton, November 24, 1972.
71. Kammer, *Second Long Walk*, 98.
72. Quoted in Kammer, *Second Long Walk*, 99.
73. Wright, *Clowns of the Hopi*, 3–8.
74. Janik, *Fools and Jesters*, 252.
75. Wright, *Clowns of the Hopi*, 7.
76. Parsons and Beals, "Sacred Clowns," 492.
77. Janik, *Fools and Jesters*, 252.
78. Page, "Spider Coming Down," 115.
79. Fixico, *Indian Resilience and Rebuilding*, 57.
80. "Navajos Deny Contempt: Hopis Affirm Charges," *Qua'Töqti*, July 26, 1973, 1.
81. "Navajos Deny Contempt," 1.
82. "Boyden Expresses Hopi View of the Land Dispute," *Qua'Töqti*, August 2, 1973, 2.
83. Kappler, *Indian Affairs*, 805; "Boyden Expresses Hopi View of the Land Dispute," 2.
84. Kappler, *Indian Affairs*, 805; "Boyden Expresses Hopi View of the Land Dispute," 2.
85. Correspondence also showed Boyden as employed by Boyden, Tibbals & Staten (1967) and Boyden, Kennedy, Romney & Howard (1978). Indian Law Resource Center, "Report to the Hopi Kikmongwis," 151.
86. In 1967 the Hopi were listed as clients of Boyden, Tibbals & Staten. Indian Law Resource Center, "Report to the Hopi Kikmongwis," 151.

87. Indian Law Resource Center, "Report to the Hopi Kikmongwis," 150.
88. Quoted in Wilkinson, *Fire on the Plateau*, 298.
89. Indian Law Resource Center, "Report to the Hopi Kikmongwis," 152–154.
90. "Conlan Admits Anti-Steiger Motive in Decision to Sponsor Navajo Bill," *Qua'Töqti*, August 23, 1973, 1.
91. "Conlan Admits Anti-Steiger Motive," 1.
92. "Conlan Admits Anti-Steiger Motive," 1.
93. "Conlan Playing Games with Hopis," *Qua'Töqti*, August 23, 1973, 2.
94. "Conlan Playing Games with Hopis," 2.
95. "MacDonald Faces New Ruling in Contempt of Court Charge," *Qua'Töqti*, August 30 1973, 1.
96. "MacDonald Faces New Ruling," 1.
97. "Can Hopis Find Way Back to Nature?," *Qua'Töqti*, September 20, 1973, 2.
98. Quoted in Benally, *Bitter Water*, 47.

CHAPTER 4: **Discourse and Discord**

Epigraph. Harrison Lapahie Jr., "Navajo-Hopi Land Dispute." May 20, 2010. http://www.lapahie.com/navajo_hopi_land_dispute.cfm.

1. Voyles, *Wastelanding*, 157.
2. Pasternak, *Yellow Dirt*, 1.
3. Parsons, *Social Organization of the Tewa*, 148.
4. Quoted in Beck, Walters, and Francisco, *The Sacred*, 315.
5. MacDonald quoted in "McDonald [sic] Says Land Solution Not Any Closer," *Qua'Töqti*, February 28, 1974, 1.
6. Bennett, "New Era for American Indians," 14–17.
7. Gallup American Coal Company, Labor Compilation Record, January 1945, reprinted in O'Neill, *Working the Navajo Way*, 115.
8. O'Neill, *Working the Navajo Way*, 115.
9. O'Neill, *Working the Navajo Way*, 132.
10. Kammer, *Second Long Walk*, 108; *Navajo-Hopi Land Dispute: Hearing before the Committee*, 616.
11. Quoted in "No Settlement to Land Dispute Appears Near," *Navajo Times*, April 4, 1974, D2.
12. Kammer, *Second Long Walk*, 109–112.
13. "Indian Dances," *Indian Advocate*, June 1, 1904, 169.
14. "Hopi Peace Isn't Sure," *Gallup Independent*, March 28, 1974, 1.
15. "Hopi Peace Isn't Sure," 1.
16. "Hopi Peace Isn't Sure," 1.
17. "Gallup's Old King Coal Could Make Comeback," *Gallup Independent*, March 28, 1974, 1.
18. "Navajos to Discuss 2-County Proposal," *Arizona Republic*, January 16, 1974, C3.
19. "Panel Okays Bill Splitting County; Filibuster Expected," *Tucson Daily Citizen*, April 27, 1974, 3.
20. "Panel Okays Bill Splitting County," 3.

21. "Leaders State Navajo Positions on Two Issues: 'Frisco Peaks Development, Division of Apache County," *Gallup Independent*, April 3, 1974, 2.

22. "Navajos to Discuss 2-County Proposal," C3.

23. Sánchez, Spude, and Gómez, *New Mexico*, 307.

24. Sánchez, Spude, and Gómez, *New Mexico*, 307.

25. Sánchez, Spude, and Gómez, *New Mexico*, 308.

26. Scott Beaven, "Montoya, Lujan Attacked by Leader of Hopi Tribe," *Albuquerque Journal*, May 8, 1974, A3.

27. Bill Donovan, "Navajos Held in Contempt on Land Dispute," *Arizona Republic*, May 31, 1974, 1.

28. Daniel Peaches, "Letter to Editor," *Navajo Times*, May 30, 1974, A3.

29. Peaches, "Letter to Editor," A3.

30. "Indians Ask U.S. Arbitration," *Clovis News-Journal*, May 9, 1974, 18.

31. "Navajos Fined until Livestock Is Reduced," *Qua'Töqti*, June 6, 1974, 1.

32. "Discussion Follows Hopi-Navajo Land Dispute Bill," *Gallup Independent*, June 10, 1974, 2.

33. Martin Waldron, "Navajos and Hopis Feud over Land," *Morning News*, June 17, 1974, 36.

34. For Diné opinions, see "Navajos Plan Alternatives in Hopi Rift," *Albuquerque Journal*, June 11, 1974, B7. For white politicians' opinions, see "Navajos to Appeal Citation for Contempt in Land Suit," *Arizona Republic*, June 6, 1974, B2.

35. "Navajos Fined until Livestock Is Reduced," 1.

36. Jack Ahasteen (*Navajo Times* cartoonist) in discussion with author, May 5, 2021.

37. "Indian Bureau Has Set Navajo against Hopi, Pueblos Are Told," *Gallup Independent*, June 12, 1974, 2.

38. "She's an Indian Chief," *Philadelphia Inquirer*, February 19, 1967, 38.

39. Marlene Cimons, "Clash of Cultures in Potomac Council," *Los Angeles Times*, August 1, 1974, 121.

40. Cimons, "Clash of Cultures in Potomac Council," 121.

41. Dalton Taylor, "Letter to the Editor," *Qua'Töqti*, June 20, 1974, 2.

42. Taylor, "Letter to the Editor," 2.

43. "Utah Candidate Opposes Forced Solution to Land Dispute," *Navajo Times*, April 25, 1974, A1.

44. Associated Press, "Navajos Begin New March," *Las Vegas Optic*, July 16, 1974, 1.

45. Deloria, *Custer Died for Your Sins*, 146.

46. Cited in Virginia Richter, "Laughter and Aggression: Desire and Derision in a Postcolonial Context," in Reichl and Stein, *Cheeky Fictions*, 65.

47. Ulrike Erichsen, "Smiling in the Face of Adversity: How to Use Humour to Defuse Cultural Conflict," in Reichl and Stein, *Cheeky Fictions*, 39.

48. Erichsen, "Smiling in the Face of Adversity," 40.

49. Quoted in Lincoln, *Indi'n Humor*, 7.

50. Basso, *Portraits of "the Whiteman,"* 18.

51. "Humor Not One of Arizona Shortages per Steiger Poll," *Navajo Times*, April 4, 1974, A23.

52. Benedek, *Wind Won't Know Me*, 139.

53. Benedek, *Wind Won't Know Me*, 138.

54. Ahasteen discussion with author, May 5, 2021.

55. Benedek, *Wind Won't Know Me*, 139.

56. Kammer, *Second Long Walk*, 136.

57. Parlow, "Politics of Plunder," n.p.; Mark Panitch, "Whose Home on the Range?," *Washington Post*, July 21, 1974, C3.

58. Panitch, "Whose Home on the Range?," C3.

59. Panitch, "Whose Home on the Range?," C3.

60. *Navajo-Hopi Land Dispute: Hearing before the Committee.*

61. *Navajo-Hopi Land Dispute: Hearing before the Committee*, 230.

62. *Navajo-Hopi Land Dispute: Hearing before the Committee*, 230.

63. *Navajo-Hopi Land Dispute: Hearing before the Committee*, 230.

64. *Navajo-Hopi Land Dispute: Hearing before the Committee*, 232.

65. "Sekaquaptewa Answers MacDonald," *Gallup Independent*, October 17, 1974, 1.

66. Kammer, *Second Long Walk*, 122.

67. "Church Not Involved in Navajo-Hopi Dispute," *Daily Herald*, August 5, 1974, 10.

68. Kammer, *Second Long Walk*, 62–63.

69. Mark Panitch, "American Indians at War again but Carry Skirmish into Courtrooms," *Lansing State Journal*, July 21, 1974, 61.

70. Benedek, *Wind Won't Know Me*, 145; Clemmer, *Continuities*, 8.

71. "'Negotiation' May Be Delaying Tactic," *Qua'Töqti*, September 19, 1974, 2.

72. "'Negotiation' May Be Delaying Tactic," 2.

73. Washington Bureau, "3 State Bills Await Returning Congress," *Arizona Republic*, November 14, 1974, B12.

74. "The Navajo Plant . . . A New Source," *Arizona Daily Sun*, April 20, 1974, A5.

75. "The Navajo Plant . . . A New Source," 1.

76. "The Navajo Plant . . . A New Source," 1.

77. "The Navajo Plant . . . A New Source," 1.

78. Editor, "All Is Not 'Black' and 'White' in Black Mesa Dispute," *Arizona Republic*, November 23, 1974, A7.

79. "Tribe Plans Meeting on Coal Protest," *Arizona Republic*, October 16, 1974, A9.

80. Bill Donovan, "Peabody Kayenta Mine Resumes Operation after AIM Shutdown," *Qua'Töqti*, October 24, 1974, 1.

81. Donovan, "Peabody Kayenta Mine Resumes Operation," 1.

82. Ken Sekaquaptewa, "Partition Bill Passes," *Qua'Töqti*, December 5, 1974, 1.

83. Sekaquaptewa, "Partition Bill Passes," 1.

84. Sekaquaptewa, "Partition Bill Passes," 1.

85. "End Navajo-Hopi Dispute?," *Albuquerque Journal*, December 4, 1974, A4.

86. "Navajo Leader Hails Land Bill," *Tucson Daily Citizen*, December 4, 1974, 46.

87. "Navajo Leader Hails Land Bill," 46.

88. Quoted in Benally, *Bitter Water*, 33.

89. Ben Cole, "Ford Signs Mineral Strip Bill and Indian Land-Issue Measure," *Arizona Republic*, December 24, 1974, B1.

90. Quoted in Benally, *Bitter Water*, 23.

CHAPTER 5: **Activism in the Aftermath**

Epigraph. Quoted in "Navajo Religion: A Sacred Way of Life," n.p. Cline Library, Northern Arizona University, Flagstaff, n.d.

1. Jones, "Issue Brief."

2. Public Law 93-531, 88 Stat. 1712 (1974).

3. Kammer, "Navajo and Hopi Dispute," 2. Removal ended up impacting far more than 5,050 individuals, the amount Kammer originally estimated would be subject to removal.

4. Kammer, "Navajo and Hopi Dispute," 7.

5. "Hopi Tribe Is Pleased," *Navajo Times*, January 3, 1975, A3.

6. Jerry Kammer, "Tribe Faces Second Land Dispute," *Navajo Times*, January 30, 1975, 1.

7. Kammer, "Tribe Faces Second Land Dispute," 1.

8. Quoted in Kammer, "Tribe Faces Second Land Dispute," 1.

9. "Land Dispute Top Story—1974," *Navajo Times*, January 3, 1975, A6.

10. "Navajo-Hopi Unity Committee Challenges Public Law 93-531," *Navajo Times*, July 3, 1975, A16.

11. "Dissatisfied Hopis, Navajos United to Solve Land Dispute Problem," *Qua'Töqti*, April 24 1975, 1.

12. Quoted in "Dissatisfied Hopis," 1.

13. Quoted in "Dissatisfied Hopis," 1.

14. "Navajo-Hopi Unity Committee Challenges," A16.

15. Ross Becker, "BIA Polices Joint Use Area," *Navajo Times*, August 21, 1975, 1.

16. Becker, "BIA Polices Joint Use Area," 1.

17. Ross Becker, "Land Dispute Talks End," *Navajo Times*, September 18, 1975, 1.

18. *Environmental Analysis Record*, 147.

19. "Alliance Is Opposed to Houserock Resettlement," *Navajo Times*, July 24, 1975, 1; Becker, "Land Dispute Talks End," 1.

20. "Navajo-Hopi Unity Committee Meets," *Navajo Times*, October 30, 1975, A15.

21. Quoted in "Committees Consider Navajo Relocation," *Navajo Times*, January 29, 1976, A12.

22. "BLM Sets Navajo Land Purchase Request Meetings," *Navajo Times*, March 18, 1976, 1.

23. "Peaches Opposes P.L. 93-531," *Qua'Töqti*, March 4, 1976, 1.

24. Bill Donovan, "Tribes Testify in Court on JUA Partition Proposal," *Qua'Töqti*, April 15, 1976, 1; "Hopis Give Testimony in Partition Hearing," *Qua'Töqti*, May 6, 1976, 1; Jerry Kammer, "Navajo Livestock Reduction Down 1/3," *Qua'Töqti*, September 23, 1976, 1.

25. L. Joy Bossert, "Problems with Stock Reduction Concern Navajo JUA Residents," *Navajo Times*, September 23, 1976, A2.

26. Bossert, "Problems with Stock Reduction," A2.

27. Bossert, "Problems with Stock Reduction," A2.

28. L. Joy Bossert, "Proposed JUA Partition Line Decided," *Navajo Times*, September 16, 1976, 1.

29. "Interior Department Has No Authority over Relocation Commission, Says Members," *Navajo Times*, February 3, 1977, A2.

30. L. Joy Bossert, "Two Chapters Will Accept Relocatees; Replacement of Two Commissioners Asked," *Navajo Times*, January 27, 1977, 1.

31. "Atkinson Calls for Lewis Resignation," *Navajo Times*, December 2, 1976, 1.

32. "Atkinson Calls for Lewis Resignation," 1.

33. "Atkinson Calls for Lewis Resignation," 1.

34. Wendy Feder, "Relocation Commission Lacks Concern," *Navajo Times*, November 25, 1976, A5; "Relocation Commission Is Investigated," *Navajo Times*, December 2, 1976, 1.

35. "Unity Committee Denounces $5 Million Settlement," *Navajo Times*, January 6, 1977, 1.

36. "Unity Committee Denounces."

37. L. Joy Bossert, "Navajo Cattle Yet to Be Released," *Navajo Times*, March 3, 1977, 1.

38. Navajo chief of police Phillip Meek quoted in Bossert, "Navajo Cattle Yet to Be Released," 1.

39. "Judge Walsh Indicates Navajos May Keep Stock until Moved," *Navajo Times*, December 22, 1977, A14.

40. Cheyfitz, "Theory and Practice," 628.

41. Molly Ivins, "Navajo Relocation Program like a Nightmare of Events Long Past," reprinted in *Navajo Times*, January 5, 1978, B15.

42. Ivins, "Navajo Relocation Program," B15.

43. Ivins, "Navajo Relocation Program," B15.

44. "37 Navajos Leave for the Longest Walk," *Navajo Times*, July 6, 1978, A19.

45. Quoted in "37 Navajos Leave for the Longest Walk," A19.

46. Of course, given the financial concerns surrounding corporate and governmental land leases, the situation is far from simple. See Simpson's discussion of "sovereignty within an imposed sovereignty." Simpson, *Mohawk Interruptus*, 162.

47. Casey Watchman, "The 'March for Sovereignty' Reaches Flagstaff," *Navajo Times*, October 26, 1978, A3.

48. Watchman, "'March for Sovereignty' Reaches Flagstaff," A3.

49. "Committees Consider Navajo Relocation," *Navajo Times*, January 29, 1976, A12.

50. Kammer, "Navajo and Hopi Dispute," 2.

51. *Hearing before the Select Committee on Indian Affairs.*

52. *Hearing before the Select Committee on Indian Affairs*, 2.

53. "New Legislation Proposed for JUA [Joint-Use Area] Life Estates," *Navajo Times*, March 13, 1980, 1.

54. "New Legislation Proposed for JUA Life Estates," 1.

55. Schoepfle et al., "Human Impact," 25 (emphasis in original).

56. Quoted in Schoepfle et al., "Human Impact," 25.

57. Topper, "JUA Report for November 1979," 2.
58. See Topper, "JUA Report for December 1979," "JUA Report for January 1980," "JUA Report for February 1980."
59. Topper, "JUA Report for December 1979."
60. Topper, "JUA Report for December 1979," 2.
61. Topper, "JUA Report for February 1980."
62. Topper, "JUA Report for February 1980," 2.
63. Wood, "Navajo Relocation," 3.
64. Topper, "JUA Report for February 1980"; Topper, "JUA Report for November 1979."
65. "Navajo Tribal Chairman's Report, 1981."
66. "Relocators Acknowledge Stress," *Navajo Times*, January 15, 1981, 11.
67. Wood and Stemmler, "Land and Religion at Big Mountain," 2.
68. Public Law 93-531, 88 Stat. 1712 (1974).
69. Wood and Stemmler, "Land and Religion at Big Mountain," 5.
70. Wood and Stemmler, "Land and Religion at Big Mountain," 6.
71. Quoted in Wood and Stemmler, "Land and Religion at Big Mountain," 3.
72. Quoted in Wood and Stemmler, "Land and Religion at Big Mountain," 11.
73. Wood and Stemmler, "Land and Religion at Big Mountain," 6–7.
74. "BIA Statement on Impoundment," *Qua'Töqti*, April 4, 1981, 1.
75. "Apprehension Still Exists on Hopi Reservation," *Qua'Töqti*, May 28, 1981, 1.
76. "House-Senate Compromise on Relocation Bill," *Qua'Töqti*, June 12, 1980, 1.
77. The eighteen-year construction freeze in the area had "left the former JUA with the oldest schools, the wors[t] utility service, and the poorest roads and housing on the reservation." "JUA Area May Receive Funds," *Navajo Times*, March 6, 1980, 3.
78. Quoted in Art, "Natural and Supernatural Resources," 5.
79. Quoted in Jerry Kammer, "*Time* Magazine's Land Dispute Story 'Comes Up Short,'" *Navajo Times*, June 26, 1980, 17.
80. See Clemmer, "Review," 227.
81. Kotlowski, "From Backlash to Bingo," 618.
82. "Relocation Questionnaires, 1984–1985."
83. "Relocation Questionnaires, 1984–1985," 1.
84. Anonymous respondent, October 29, 1985, in "Relocation Questionnaires, 1984–1985," n.p.
85. Art, "Natural and Supernatural Resources," 20.
86. "Hopi Paper 'Still Alive,'" *Arizona Republic*, September 7, 1984, 18.
87. Tim Giago, "*Navajo Times* Today All Wet," *Great Falls Tribune*, June 22, 1987, 7A.
88. Giago, "*Navajo Times* Today All Wet," 7A.
89. The *Navajo Times* was later revivified and today is a major media outlet in Dinétah and online. See Susan Landon, "Committee to Explore Navajos' Newspaper Needs," *Albuquerque Journal*, March 7, 1987, 21; Mark Shaffer, "Silenced Voice: Newspaper's Demise Highlights Problems of Tribal Media," *Arizona Republic*, March 8, 1987, C2; Iverson, *Diné*, 287–289.
90. Quoted in "Navajo Religion: A Sacred Way of Life," n.p.

91. *Jenny Manybeads, et al., v. United States of America*, 209 F.3d 1164 (9th Cir. 2000).

92. "Navajo-Hopi Land Dispute: Chronology."

93. Affidavits of Violet Ashkie, Jerry Kammer, Roger Attakai, and Thayer Scudder, and "Statement of the Traditional Leaders of the Villages of Smungopavi [*sic*] and Mishongnovi Sovereign Hopi Nation," in *Manybeads v. United States*.

94. "Affidavit of Violet Ashkie," *Manybeads v. United States*, 2.

95. "Affidavit of Roger Attakai," *Manybeads v. United States*, 2.

96. "Affidavit of Roger Attakai," *Manybeads v. United States*, 2–3.

97. "Affidavit of Jerry Kammer," *Manybeads v. United States*, 6.

98. "Affidavit of Thayer Scudder," *Manybeads v. United States*, 7.

99. Public Law 100-666, 102 Stat. 3929 (1988).

100. "Statement of the Navajo Nation," 1.

101. "Statement of the Navajo Nation," 1.

102. "Testimony of Chairman Ivan L. Sidney," 5, 6, 8.

103. "Testimony of Chairman Ivan L. Sidney," 4 (emphasis in original).

104. "Navajo-Hopi Land Dispute: Chronology."

105. *Lyng v. Northwest Indian Cemetery Protective Association*, 485 US 439 (1988). https://www.oyez.org/cases/1987/86-1013.

106. Miller, "Navajo-Hopi Relocation Act," 36.

107. McAndrew, "*Lyng v. Northwest*," 376.

108. Parlow, "Politics of Plunder," n.p.

109. "Discrimination against Indigenous Peoples," 15.

110. "Discrimination against Indigenous Peoples," 15.

111. Quoted in Valerie Taliman, "Navajos, Hopis, Approach U.N.," *Navajo Times*, December 2, 1993, 2.

112. Taliman, "Navajos, Hopis, Approach U.N.," 2.

113. Navajo-Hopi Land Dispute Settlement Act of 1996, 1.

114. Duus, "International-Wide Gathering of Friends," 2.

115. "NGOs Meet with Traditional Diné and Hopi Leaders," 6.

116. "NGOs Meet with Traditional Diné and Hopi Leaders," 6.

117. Wendy Young, "Living Conditions on HPL Receive National and International Attention," *Navajo-Hopi Observer*, 1997, n.p.

118. Wendy Young, "Hopi Partition Land Resistors Speak Out in Window Rock," *Navajo-Hopi Observer*, April 9, 1997, 5.

119. Jacqueline Keeler, "A Woman Warrior Puts Faith in Words: UN Investigates Navajo Removal," *Pacific News Service*, February 27, 1998, n.p.

120. Benally, "Message for the Diné 'Resistance,'" 2.

Conclusion

1. "Background," Black Mesa Indigenous Support.

2. Ahasteen in discussion with author, May 5, 2021.

3. Ahasteen in discussion with author, May 5, 2021.

Bibliography

Archival Sources

Benally, Louise. "A Message for the Diné 'Resistance' of the Hopi Partitioned Land (HPL)." April 11, 1997. Cline Library, Northern Arizona University, Flagstaff.

Bruce, Louis R., to Clarence Hamilton. November 24, 1972. Cline Library, Northern Arizona University, Flagstaff.

"Discrimination against Indigenous Peoples: The Relocation of Hopi and Navajo Families." Report Submitted to the United Nations Commission on Human Rights, Subcommission on Prevention of Discrimination and Protection of Minorities, by Mr. John Carey Pursuant to Subcommission Decision, October 5, 1988. 1989. Cline Library, Northern Arizona University, Flagstaff.

Duus, Gloria Begay. "International-Wide Gathering of Friends to Help Some Navajos Begin a Third Long Walk and Protest Evictions of Others." 1997. Cline Library, Northern Arizona University, Flagstaff.

Ferdon, Julie. "An Oral History Interview with Sam Steiger." June 8, 2001. Sharlot Hall Museum Research Center, Prescott, Arizona.

Jackson, Andrew. "On Indian Removal." Presidential address to Congress, Washington, DC, December 6, 1830. Record Group 46, Records of the US Senate, 1789–1990. National Archives, Washington, DC.

Jones, Richard S. "Issue Brief: Navajo Hopi Relocation: Updated 03/25/86." Cline Library, Northern Arizona University, Flagstaff.

Kappler, Charles J. "Indian Affairs: Laws and Treaties." N.d. Oklahoma State University, Stillwater.

Marwitt, J. P., and Gary F. Fry. "Radiocarbon Dates from Utah." 1970. Unpublished manuscript, University of Utah, Salt Lake City.

McClure, Charles, to William Kobbe. February 15, 1870. Letters Received, Records of the New Mexico Superintendency, Records of the Bureau of Indian Affairs, Record Group 75, roll 11, National Archives, Washington, DC.

Nakai, Raymond. "Inaugural Address of Raymond Nakai, Chairman of the Navajo Tribal Council, 1963." Cline Library, Northern Arizona University, Flagstaff.

"Navajo-Hopi Land Dispute: Chronology of Events in the 1882 Executive Order Area." N.d. Cline Library, Northern Arizona University, Flagstaff.

Navajo Nation. "Hopi, Navajo, and Christian Leaders to Speak Out for 2,000 Dineh (Navajo) Indians Who May Lose Religious Freedom, Traditional Way of Life." 1997. Cline Library, Northern Arizona University, Flagstaff.

"Navajo Religion: A Sacred Way of Life." N.d. Cline Library, Northern Arizona University, Flagstaff.

"Navajo Tribal Chairman's Report, 1981." Cline Library, Northern Arizona University, Flagstaff.

"NGOs Meet with Traditional Diné and Hopi Elders." 1998. Cline Library, Northern Arizona University, Flagstaff.

"Relocation Questionnaires, 1984–1985." Cline Library, Northern Arizona University, Flagstaff.

Schoepfle, Mark, et al. "The Human Impact of the Navajo-Hopi Land Dispute: The Navajo View." Unpublished report. Shiprock, AZ: Navajo Community College, 1979. Cline Library, Northern Arizona University, Flagstaff.

"Statement of the Navajo Nation before the House Interior Appropriations Subcommittee, April 12, 1989." Cline Library, Northern Arizona University, Flagstaff.

"Testimony of Chairman Ivan L. Sidney for the Subcommittee on Interior and Related Agencies of the Committee on Appropriations." 1989. Navajo-Hopi Indian Relocation Program collection, Cline Library, Northern Arizona University, Flagstaff.

Topper, Martin D. "JUA Report for December 1979." Cline Library, Northern Arizona University, Flagstaff.

———. "JUA Report for February 1980." Cline Library, Northern Arizona University, Flagstaff.

———. "JUA Report for January 1980." Cline Library, Northern Arizona University, Flagstaff.

———. "JUA Report for November 1979." Cline Library, Northern Arizona University, Flagstaff.

Wood, John J. "Navajo Relocation from Hopi Partitioned Lands." 1986. Cline Library, Northern Arizona University, Flagstaff.

Wood, John J., and Kathy Mullin Stemmler. "Land and Religion at Big Mountain: The Effects of the Navajo-Hopi Land Dispute on Navajo Wellbeing: A Report to the Congress of the United States of America. Prepared on Behalf of the Big Mountain Community." 1981. Cline Library, Northern Arizona University, Flagstaff.

US Government Documents

Annual Report of the Department of the Interior, Fiscal Year Ending June 30, 1900. Washington, DC: US Government Printing Office, 1900.

Cohen, Felix S. *Ownership of Mineral Estate in Hopi Executive Order Reservation.* Washington, DC: US Department of the Interior, Bureau of Indian Affairs, 1946.

Congressional Record Containing the Proceedings and Debates of the Forty-Third Congress, First Session, in Six Parts, with an Index, vol. 2. Washington, DC: US Government Printing Office, 1874.

Dolittle, J. R. *Condition of the Indian Tribes: Report of the Joint Special Committee Appointed under the Resolution of March 3, 1865 with an Appendix.* Washington, DC: US Government Printing Office, 1867.

Environmental Analysis Record: Navajo Tribe Application to Purchase National Resource

Lands in the House Valley–Paria Plateau Area, Coconino County, Arizona. Arizona: US Bureau of Land Management, 1976.

Executive Documents Printed by Order of the House of Representatives during the First Session of the Thirty-Sixth Congress, 1859–'60, in Fifteen Volumes, vol. 9. Washington, DC: Thomas H. Ford, Printer, 1860.

Executive Documents of the Senate of the United States for the Second Session of the Forty-Eighth Congress and the Special Session of the Senate Convened March 4, 1885. Washington, DC: US Government Printing Office, 1888.

Hamley, Frederick G., Leon R. Yankwich, and James A. Walsh. *In the United States District Court for the District of Arizona, No. Civil 579 Prescott, Opinion of the Court, Appendix to Opinion—Chronological Account of Hopi-Navajo Controversy, Findings of Fact, and Conclusions of Law, Judgement.* San Francisco, CA: Pernau-Walsh, 1962.

Hayden, F. V. *Bulletin on the United States Geological and Geographical Survey of the Territories,* vol. 3. Washington, DC: US Government Printing Office, 1877.

Hearing before the Committee on Indian Affairs of the Committee on Interior and Insular Affairs, United States Senate, Ninety-Third Congress, First Session on H.R. 1193. Washington, DC: US Government Printing Office, 1973.

Hearing before the Select Committee on Indian Affairs, United States Senate, Ninety-Sixth Congress, Second Session on P.L. 93-531, Report and Plan of the Navajo-Hopi Relocation Commission, May 20, 1981. Washington, DC: US Government Printing Office, 1981.

Indians of the United States: Investigation of the Field Service: Hearings by a Subcommittee of the Committee on Indian Affairs, House of Representatives, vol. 3. Washington, DC: US Government Printing Office, 1920.

Kappler, Charles J., ed. *Indian Affairs, Laws, and Treaties,* vol. 1. Washington, DC: US Government Printing Office, 1904.

Navajo-Hopi Land Dispute: Hearing before the Committee on Interior and Insular Affairs, United States Senate, Ninety-Third Congress, Second Session on H.R. 10337 and S. 3230. Washington, DC: US Government Printing Office, 1974.

Navajo-Hopi Land Dispute Settlement Act of 1996. S.1973 (104th), February 17, 2017. https://www.govtrack.us/congress/bills/104/s1973/text.

Powers, Margaret, and Byron Johnson. *Defensive Sites of Dinétah.* Cultural Resources Series, No. 2. Albuquerque, NM: US Department of the Interior, Bureau of Land Management, 1987.

"Public Law 100-666, Nov. 16, 1988." Washington, DC: US Government Publishing Office, February 1, 2017. https://www.gpo.gov/fdsys/pkg/STATUTE-102/pdf/STATUTE-102-Pg3929.pdf.

Reports of the Committee of the Senate of the United States for the Second Session, Thirty-Ninth Congress. Washington, DC: US Government Printing Office, 1867.

Ricketts, Orval, and John McPhee. *The Navajo Indians in a Changing World.* Window Rock, AZ: Navajo Service and the United States Department of the Interior, 1941.

Sheridan, P. H. *Record of Engagements with Hostile Indians within the Military Division of the Missouri from 1868–1882.* Washington, DC: US Government Printing Office, 1883.

United States Congress, Senate, Committee on Indian Affairs. *Partition of the Surface Rights of Navajo-Hopi Indian Land: Hearing before the [Subcommittee on Indian Affairs of the Committee on Interior and Insular Affairs], United States Senate, 93rd Congress, 1st Session on H.R. 1193*. Washington, DC: US Government Printing Office, 1973.

United States Congressional Serial Set, Serial Number 14947, Senate Reports, Nos. 142–212. Washington, DC: US Government Printing Office, 2006.

United States Department of the Interior. *Annual Report of the Commissioner of Indian Affairs to the Secretary of the Interior for the Fiscal Year Ended June 30, 1929*. Washington, DC: US Government Printing Office, 1929.

United States Office of Indian Affairs. *Annual Report of the Commissioner of Indian Affairs for the Year 1863*. Washington, DC: US Government Printing Office, 1863.

Other Primary Sources

Barboncito and the Navajo Tribe of Arizona, New Mexico, and Utah. *Treaty between the United States of America and the Navajo Tribe of Indians, with a Record of the Discussions That Led to Its Signing*. Flagstaff, AZ: K. C. Publications, 1968.

Benally, Malcolm D. *Bitter Water: Diné Oral Histories of the Navajo-Hopi Land Dispute*. Tucson: University of Arizona Press, 2011.

Boudinot, Elias. *An Address to the Whites Delivered in the First Presbyterian Church on the 26 of May, 1826*. Philadelphia, PA: William F. Geddes, 1826.

Butler, William. *Sir William Butler: An Autobiography*. New York: Scribner's, 1911.

Center for Biological Diversity. "Lawsuit Seeks Release of Public Records for Peabody Coal Operations on Tribal Lands in Arizona." October 5, 2010. http://www.biological diversity.org/news/press_releases/2010/peabody-coal-10-05-2010.html.

Diné of the Eastern Region of the Navajo Reservation. *Oral History Stories of the Long Walk: Hwéeldi Baa Hané*. Crownpoint, NM: Lake Valley Navajo School, 1990.

Dyk, Walter, and Left Handed. *Son of Old Man Hat: A Navaho Autobiography*. 1938. Reprint, Lincoln: University of Nebraska Press, 1967.

Florio, Maria, and Victoria Mudd, dirs. *Broken Rainbow*. Earthworks Films, 1985.

Indian Law Resource Center. "Report to the Hopi Kikmongwis and Other Traditional Hopi Leaders on Docket 196 and the Continuing Threat to Hopi Land and Sovereignty." March 1979. http://indianlaw.org/hopi_report.

Johnson, Lyndon B. "Special Message to the Congress on the Problems of the American Indian: The Forgotten American." Washington, DC, March 6, 1968. American Presidency Project. http://www.presidency.ucsb.edu/ws/?pid=28709.

Kemnitzer, Luis S. "Personal Memories of Alcatraz, 1969." In *American Indian Activism: Alcatraz to the Longest Walk*, ed. Troy R. Johnson, Joane Nagel, and Duane Champagne, 113–119. Urbana: University of Illinois Press, 1997.

Lapahie, Harrison, Jr. "Navajo-Hopi Land Dispute." May 20, 2010. http://www.lapahie .com/navajo_hopi_land_dispute.cfm.

Means, Russell, and Marvin J. Wolf. *Where White Men Fear to Tread: The Autobiography of Russell Means*. New York: St. Martin's Griffin, 1995.

Simon, John Y., ed. *The Papers of Ulysses S. Grant*, vol. 18: *October 1, 1867–June 30, 1868*. Carbondale: Southern Illinois University Press, 1991.

Tapahonso, Luci. *Sáanii Dahataał/The Women Are Singing: Poems and Stories*. Tucson: University of Arizona Press, 1993.

Van Valkenburgh, Richard F. "A Short History of the Navajo People." KTGM radio, 1938. https://archive.org/stream/ERIC_ED050862/ERIC_ED050862_djvu.txt.

Secondary Sources

Aberle, David F. *The Peyote Religion among the Navajo*. New York: Wenner-Gren Foundation for Anthropological Research, 1966.

Aikens, C. Melvin. "Fremont Culture: Restatement of Some Problems." *American Antiquity* 37:1 (1972): 61–66.

Ali, Saleem H. *Mining, the Environment, and Indigenous Development Conflicts*. Tucson: University of Arizona Press, 2003.

Allison, James Robert, III. *Sovereignty for Survival: American Energy Development and Indian Self-Determination*. New Haven, CT: Yale University Press, 2015.

Art, Karen Majcher. "Natural and Supernatural Resources: Mining on Navajo Land and the American Indian Religious Freedom Act." *Chicago Anthropology Exchange* 14 (1981): 4–26.

Axtell, James. *Beyond 1492: Encounters in Colonial North America*. New York: Oxford University Press, 1992.

Bachman, Ronet. *Death and Violence on the Reservation: Homicide, Family Violence, and Suicide in American Indian Populations*. New York: Auburn House, 1992.

"Background." Black Mesa Indigenous Support. N.d. https://supportblackmesa.org /background/.

Bailey, Garrick Alan, and Roberta Glenn Bailey. *A History of the Navajos: The Reservation Years*. Santa Fe, NM: SAR Press, 1986.

Bailey, Lynn R. *Bosque Redondo: The Navajo Internment at Fort Sumner, New Mexico, 1863–1868*. Tucson, AZ: Westernlore, 1998.

———. *If You Take My Sheep: The Evolution and Conflicts of Navajo Pastoralism, 1630–1868*. Pasadena, CA: Westernlore, 1980.

———. *The Long Walk: A History of the Navajo Wars, 1846–68*. Los Angeles, CA: Westernlore, 1964.

Bailey, Paul D. "The Navajo Wars." *Arizoniana* 2:2 (1961): 3–12.

Bandelier, A. F. A., H. Morgan, and L. A. White. *Pioneers in American Anthropology: The Bandelier-Morgan Letters, 1873–1883*. New York: AMS Press, 1978.

Banks, Dennis, and Richard Erdoes. *Ojibwa Warrior: Dennis Banks and the Rise of the American Indian Movement*. Norman: University of Oklahoma Press, 2004.

Bansett, Kent. *A Journey to Freedom: Richard Oakes, Alcatraz, and the Red Power Movement*. New Haven, CT: Yale University Press, 2018.

Basso, Keith. *Portraits of "the Whiteman": Linguistic Play and Cultural Symbols among the Western Apache*. Cambridge: Cambridge University Press, 1979.

Beck, Peggy V., Anna Lee Walters, and Nia Francisco. *The Sacred: Ways of Knowledge, Sources of Life*. Tsaile, AZ: Navajo Community College Press, 1992.

Benally, AnCita. "Han'é Béé'ééhanííh: With Stories It Is Remembered." Master's thesis, Arizona State University, Tempe, 1993.

Benedek, Emily. *The Wind Won't Know Me: A History of the Navajo-Hopi Land Dispute.* New York: Knopf, 1992.

Bennett, Robert. "A New Era for American Indians." *AFL-CIO American Federationist* 73 (December 1996): 14–17.

Berkhofer, Robert F., Jr. "The Political Context of a New Indian History." *Pacific Historical Review* 40:3 (1971): 357–382.

Bighorse, Tiana, Gus Bighorse, and Noël Bennett. *Bighorse the Warrior.* Tucson: University of Arizona Press, 1990.

Black, John. "Warriors of the Rainbow Prophecy." April 22, 2014. Ancient Origins. http://www.ancient-origins.net/myths-legends/warriors-rainbow-prophecy-001577.

Blackhawk, Ned. "Currents in North American Indian Historiography." *Western Historical Quarterly* 42:3 (2011): 319–324.

———. "I Can Carry On from Here: The Relocation of American Indians to Los Angeles," *Wicazo Sa Review* 11:2 (1995): 16–30.

———. *Violence over the Land: Indians and Empires in the Early American West.* Cambridge, MA: Harvard University Press, 2006.

Blackmar, Frank W. *Spanish Colonization in the Southwest.* Baltimore, MD: Johns Hopkins University Press, 1890.

Bolton, H. E., and T. M. Marshall. *The Colonization of North America, 1492–1783.* New York: Macmillan, 1919.

Bottomley-O'looney, Jennifer. "The Art of Storytelling: Plains Indian Perspectives." *Montana: The Magazine of Western History* 62 (Autumn 2012): 42–55.

Boyd, Caroline E. *Rock Art of the Lower Pecos.* College Station: Texas A&M University Press, 2003.

Braun, Eric. *The American Indian Rights Movement.* Minneapolis, MN: Lerner, 2019.

Brooks, James. *Captives and Cousins: Slavery, Kinship, and Community in the Southwest Borderlands.* Chapel Hill: University of North Carolina Press, 2002.

Brown, Dee. *Bury My Heart at Wounded Knee: An Indian History of the American West.* New York: Holt, Rinehart, and Winston, 1970.

Brugge, David M. "Comments on Athabaskans and Sumas." In *The Protohistoric Period in the North American Southwest, AD 1450–1700,* ed. David R. Wilcox and W. Bruce Masse, 291–320. Tempe: Arizona State University Press, 1981.

———. *The Navajo-Hopi Land Dispute: An American Tragedy.* Albuquerque: University of New Mexico Press, 1994.

Brugge, Doug, Timothy Benally, and Esther Yazzie-Lewis, eds. *The Navajo People and Uranium Mining.* Albuquerque: University of New Mexico Press, 2006.

Calloway, Colin. *One Vast Winter Count: The Native American West before Lewis and Clark.* Lincoln: University of Nebraska Press, 2003.

Campbell, Alec C. *African Rock Art: Paintings and Engravings on Stone.* New York: Abrams, 2001.

Campbell, Stanley. "The Cheyenne Tipi." *American Anthropologist* 17:4 (October–December 1915): 685–694.

Carlisle, Rodney P., and J. Geoffrey Golson. *Manifest Destiny and the Expansion of America.* Santa Barbara, CA: ABC-CLIO, 2007.

Carmean, Kelli. *Spider Woman Walks This Land: Traditional Cultural Properties and the Navajo Nation*. Walnut Creek, CA: AltaMira, 2002.

Carpenter, Cari M. *Seeing Red: Anger, Sentimentality, and American Indians*. Columbus: Ohio State University Press, 2008.

Carroll, N., ed. *Theories of Art Today*. Madison: University of Wisconsin Press, 2000.

Carter, William B. *Indian Alliances and the Spanish in the Southwest, 750–1750*. Norman: University of Oklahoma Press, 2009.

Castile, George Pierre. *To Show Heart: Native American Self-Determination and Federal Indian Policy, 1960–1975*. Tucson: University of Arizona Press, 1998.

Cheyfitz, Eric. "Theory and Practice: The Case of the Navajo-Hopi Land Dispute." *Journal of Gender, Society, Politics and the Law* 10:3 (2002): 619–632.

Churchill, Ward. *Struggle for the Land: Indigenous Resistance to Genocide, Ecocide, and Expropriation in Contemporary North America*. Monroe, ME: Common Courage, 1993.

Clark, Neil M. "Dr. Montezuma, Apache: Warrior in Two Worlds." *Montana: The Magazine of Western History* 23:2 (1973): 56–65.

Clarkin, Thomas. *Federal Indian Policy in the Kennedy and Johnson Administrations, 1961–1969*. Albuquerque: University of New Mexico Press, 2001.

Clemmer, Richard O. *Continuities of Hopi Culture Change*. Ramona, CA: Acoma, 1978.

———. "Review: Crying for Children of Sacred Ground: A Review Article on the Hopi-Navajo Land Dispute." *American Indian Quarterly* 15:2 (Spring 1991): 225–230.

"Coal Prices Rise: The Price of Heat in 1909." History Nebraska. N.d. https://history.nebraska.gov/publications_section/coal-prices-rise-the-price-of-heat-in-1909/.

Cobb, Daniel M. *Native Activism in Cold War America: The Struggle for Sovereignty*. Lawrence: University Press of Kansas, 2008.

Cornell, Stephen. *The Return of the Native: American Indian Political Resurgence*. New York: Oxford University Press, 1988.

Correll, J. Lee. *Through White Men's Eyes, a Contribution to Navajo History: A Chronological Record of the Navajo People from Earliest Times to the Treaty of June 1, 1868*, vol. 3. Window Rock, AZ: Navajo Heritage Center, 1979.

Coulthard, Glen Sean. *Red Skin, White Masks: Rejecting the Colonial Politics of Recognition*. Minneapolis: University of Minnesota Press, 2014.

Cox, Bruce A. "What Is Hopi Gossip About? Information Management and Hopi Factions." *Man* 5:1 (March 1970): 88–98.

Cruz, Gilberto Rafael. *Let There Be Towns: Spanish Municipal Origins in the American Southwest, 1610–1810*. College Station: Texas A&M University Press, 1988.

Danziger, Edmund J. "The Steck-Carleton Controversy in Civil War New Mexico." *Southwestern Historical Quarterly* 74:2 (1970): 189–203.

Dean, Jeffrey S. "The View from the North: An Anasazi Perspective on the Mogollon." *Kiva* 53:2 (1988): 197–199.

Deloria, Philip Joseph. *Indians in Unexpected Places*. Lawrence: University Press of Kansas, 2004.

———. *Playing Indian*. New Haven, CT: Yale University Press, 1998.

Deloria, Vine, Jr. *Behind the Trail of Broken Treaties: An Indian Declaration of Independence*. Austin: University of Texas Press, 1988.

———. *Custer Died for Your Sins: An Indian Manifesto.* 1969. Reprint, Norman: University of Oklahoma Press, 1988.

———, ed. *The Indian Reorganization Act: Congresses and Bills.* Norman: University of Oklahoma Press, 2002.

Denetdale, Jennifer. *The Long Walk: The Forced Navajo Exile.* New York: Chelsea House, 2008.

Dewey, Donald. *The Art of Ill Will: The Story of American Political Cartoons.* New York: New York University Press, 2007.

Dorn, Ronald I., et al. "New Approach to the Radiocarbon Dating of Rock Varnish, with Examples from Drylands." *Annals of the Association of American Geographers* 82:1 (1992): 136–151.

Drinnon, Richard. *Facing West: The Metaphysics of Indian-Hating and Empire Building.* Minneapolis: University of Minnesota Press, 1980.

Dunbar-Ortiz, Roxanne. *An Indigenous Peoples' History of the United States.* Boston: Beacon, 2014.

Dunlay, Tom. *Kit Carson and the Indians.* Lincoln: University of Nebraska Press, 2000.

Dunn, Dorothy. *American Indian Painting of the Southwest and Plains Areas.* Santa Fe: University of New Mexico Press, 1968.

Dunn, John M. *The Relocation of the North American Indian.* Detroit: Lucent, 2006.

Dutton, Bertha Pauline. *American Indians of the Southwest.* Albuquerque: University of New Mexico Press, 1975.

Eads, Sharon. "Prospecting Permits on Indian Lands: Who Benefits?" *American Indian Law Review* 2:2 (Winter 1974): 117–124.

Eichstaedt, Peter H. *If You Poison Us: Uranium and Native Americans.* Santa Fe, NM: Red Crane, 1994.

Estergreen, M. Morgan. *Kit Carson: A Portrait in Courage.* Norman: University of Oklahoma Press, 1962.

Faulk, Odie B. *Crimson Desert: Indian Wars of the American Southwest.* New York: Oxford University Press, 1974.

Fixico, Donald. *Indian Resilience and Rebuilding: Indigenous Nations in the Modern American West.* Tucson: University of Arizona Press, 2013.

———. *The Invasion of Indian Country in the Twentieth Century: American Capitalism and Tribal Natural Resources.* Boulder: University Press of Colorado, 2012.

———, ed. *Rethinking American Indian History.* Albuquerque: University of New Mexico Press, 1997.

———. *The Urban Indian Experience in America.* Albuquerque: University of New Mexico Press, 2000.

Folger, Tim. "A Thirsty Nation." *One Earth* (Fall 2014): 14–26.

Geertz, Armin W. *The Invention of Prophecy: Continuity and Meaning in Hopi Indian Religion.* Berkeley: University of California Press, 1994.

———. "Structural Elements in Uto-Aztecan Mythology: Hopi Gender and Cosmology." *Method and Theory in the Study of Religion* 8:1 (1996): 51–64.

Gidley, Mick. "Pictorialist Elements in Edward S. Curtis' Representation of American Indians." *Yearbook of English Studies* 24:1 (1994): 180–192.

Gordon, Susan. *Black Mesa: The Angel of Death*. New York: John Day, 1973.

Guild, Thelma S., and Harvey L. Carter. *Kit Carson: A Pattern for Heroes*. Lincoln: University of Nebraska Press, 1984.

Hackett, George, ed. *Revolt of the Pueblo Indians*. Translated by Charmion Clair Shelby. Albuquerque: University of New Mexico Press, 1942.

Hämäläinen, Pekka. *The Comanche Empire*. New Haven, CT: Yale University Press, 2008.

Hansen, Sandra. "Survey of Civil Jurisdiction in Indian Country, 1990." *American Indian Law Review* 16:2 (1991): 319–375.

Hausdoerffer, John. *Catlin's Lament: Indians, Manifest Destiny, and the Ethics of Nature*. Lawrence: University Press of Kansas, 2009.

Hess, Stephen, and Milton Kaplan. *The Ungentlemanly Art*. New York: Macmillan, 1975.

Hoffman, Werner. *Caricature from Leonardo to Picasso*. New York: Crown, 1957.

Horsman, Reginald. "Well-Trodden Paths and Fresh Byways: Recent Writing on Native American History," in "The Promise of American History: Progress and Prospects," ed. Stanley I. Kutler and Stanley N. Katz, special issue, *Reviews in American History* 10:4 (1982): 234–244.

Hosmer, Brian C. *American Indians in the Marketplace: Persistence and Innovation among the Menominees and Metlakatlans, 1870–1920*. Lawrence: University Press of Kansas, 1999.

Hyde, George E. *Life of George Bent, Written from His Letters*. Edited by Savoie Lottinville. Norman: University of Oklahoma Press, 1968.

"The Indian: The Forgotten American." *Harvard Law Review* 81:8 (June 1968): 1818–1858.

Irwin, Lee. *The Dream Seekers: Native American Visionary Traditions of the Great Plains*. Norman: University of Oklahoma Press, 1994.

Iverson, Peter. *Carlos Montezuma and the Changing World of American Indians*. Albuquerque: University of New Mexico Press, 1982.

———. *Diné: A History of the Navajos*. Albuquerque: University of New Mexico Press, 2002.

———. *For Our Navajo People: Diné Letters, Speeches and Petitions, 1900–1960*. Albuquerque: University of New Mexico Press, 2002.

———. "Legal Council and the Navajo Nation since 1945." *American Indian Quarterly* 3:1 (Spring 1977): 1–15.

———. *The Navajo Nation*. Westport, CT: Greenwood, 1981.

———. *"We Are Still Here": American Indians in the Twentieth Century*. Wheeling, IL: Harland Davidson, 1998.

Iverson, Peter, and Monty Roessel. *Diné: A History of the Navajos*. Albuquerque: University of New Mexico Press, 2002.

Jacoby, Karl. *Shadows at Dawn*. New York: Penguin, 2009.

Janik, Viki J., ed. *Fools and Jesters in Literature, Art, and History: A Bio-Bibliographical Sourcebook*. Westport, CT: Greenwood, 1998.

Jenkins, Myra Ellen, Ward Allen Minge, and Frank Driver Reeve. *Navajo Activities Affecting the Acoma-Laguna Area, 1746–1910*. New York: Garland, 1974.

Johnson, Isabel Simeral. "Cartoons." *Public Opinion Quarterly* 1:3 (1937): 21–44.

Josephy, Alvin M. *The Civil War in the American West*. New York: Knopf, 1991.

———. *Red Power: The American Indians' Fight for Freedom*. New York: American Heritage, 1971.

Kalt, Joseph P., and Joseph William Singer. "Myths and Realities of Tribal Sovereignty: The Law and Economics of Indian Self-Rule." Presentation at the Native Issues Research Symposium at Harvard University, Boston, MA, December 4–5, 2003 (revised January 2004).

Kammer, Jerry. "The Navajo and Hopi Dispute over Land and Life." *American Indian Journal* 5:9 (September 1979): 2–8.

———. *The Second Long Walk: The Navajo-Hopi Land Dispute*. Albuquerque: University of New Mexico Press, 1980.

Kelley, Klara Bonsack, and Harris Francis. *Navajo Sacred Places*. Bloomington: Indiana University Press, 1994.

Kelley, Klara Bonsack, and Peter Whitely. *Navajoland: Family, Settlement, and Land Use*. Tsaile, AZ: Navajo Community College Press, 1989.

Kelly, Lawrence C. *The Navajo Indians and Federal Indian Policy, 1900–1935*. Tucson: University of Arizona Press, 1968.

———. *Navajo Roundup: Selected Correspondence of Kit Carson's Expedition against the Navajo, 1863–1865*. Boulder, CO: Pruett, 1970.

Kennedy, Gary D. "Tribal Elections: An Appraisal after the Indian Civil Rights Act." *American Indian Law Review* 3:2 (1975): 497–508.

Keur, Dorothy. "A Chapter in Navajo-Pueblo Relations." *American Antiquity* 10:1 (1944): 75–86.

Keyser, James D. "A Lexicon for Historic Plains Indian Rock Art: Increasing Interpretive Potential." *Plains Anthropologist* 32:115 (1987): 43–71.

Keyser, James D., and Timothy J. Brady. "A War Shirt from the Schoch Collection: Documenting Individual Artistic Expression." *Plains Anthropologist* 38:142 (1993): 5–20.

Knaut, Andrew. *The Pueblo Revolt of 1680: Conquest and Resistance in Seventeenth-Century New Mexico* Norman: University of Oklahoma Press, 1964.

Kotlowski, Dean J. "From Backlash to Bingo: Ronald Reagan and Federal Indian Policy." *Pacific Historical Review* 77:4 (2008): 617–652.

"Lakota Winter Counts: An Online Exhibition." Smithsonian National Museum of Natural History, National Anthropological Archives. N.d. http://wintercounts.si .edu/html_version/html/.

Laubin, Reginald, and Gladys Laubin. *The Indian Tipi: Its History, Construction, and Use*. Norman: University of Oklahoma Press, 1977.

Leeming, David Adams. *Creation Myths of the World: An Encyclopedia*. Santa Barbara, CA: ABC-CLIO, 2009.

Levy, Jerrold E. *In the Beginning: The Navajo Genesis*. Berkeley: University of California Press, 1998.

Lewis-Williams, J. D., ed. *New Approaches to Southern African Rock Art*. Cape Town: South African Archaeology Society, 1983.

Lincoln, Kenneth. *Indi'n Humor: Bicultural Play in Native America*. Oxford: Oxford University Press, 1993.

Lummis, C. F. *The Spanish Pioneers*. Chicago, IL: A. C. McClurg, 1909.

Lurie, Nancy Oestreich. "The Indian Claims Commission Act." *Annals of the American Academy of Political and Social Science* 311:1 (1957): 56–70.

Lyon, William H. "The Navajos in the Anglo-American Historical Imagination, 1807–1870." *Ethnohistory* 43:3 (1996): 483–509.

Madley, Benjamin. *An American Genocide: The United States and the California Indian Catastrophe, 1846–1873*. New Haven, CT: Yale University Press, 2016.

———. "Reexamining the American Genocide Debate: Meaning, Historiography, and New Methods." *American Historical Review* 120:1 (February 2015): 90–139.

Maurer, Evan M. *Visions of the People: A Pictorial History of Plains Indian Life*. Minneapolis, MN: Minneapolis Institute of Arts, 1992.

McAndrew, Stephen. "*Lyng v. Northwest*: Closing the Door to Indian Religious Sites." In *Native Americans and the Law: Contemporary and Historical Perspectives on American Indian Rights, Freedom, and Sovereignty*, ed. John R. Wunder, 225–253. New York: Garland, 1996.

McDonnell, Janet. "Carlos Montezuma's Crusade against the Indian Bureau." *Journal of Arizona History* 22:4 (1981): 429–444.

McGee, William John. "The Siouan Indians: A Preliminary Sketch." *BAER* 15 (1897): 153–204.

McNitt, Frank. *Navajo Wars: Military Campaigns, Slave Raids, and Reprisals*. Albuquerque: University of New Mexico Press, 1972.

McPherson, Robert S. *Navajo Land, Navajo Culture: The Utah Experience in the Twentieth Century*. Norman: University of Oklahoma Press, 1947.

———. *The Northern Navajo Frontier: Expansion through Adversity*. Logan: Utah State University Press, 2001.

Meek, Barbara A. "And the Injun Goes 'How!': Representations of American Indian English in White Public Space." *Language in Society* 35:1 (2006): 93–128.

Merrell, James H. *Into the American Woods: Negotiators on the Pennsylvania Frontier*. New York: Norton, 1999.

Meyer, Melissa L. *The White Earth Tragedy: Ethnicity and Dispossession at a Minnesota Anishinaabe Reservation, 1889–1920*. Lincoln: University of Nebraska Press, 1994.

Meyer, William. *Native Americans: The New Indian Resistance*. New York: International, 1971.

Miller, Charles. "The Navajo-Hopi Relocation Act and the First Amendment Free Exercise Clause." Unpublished paper, University of San Francisco School of Law, 1988.

Miller, Robert J. *Native America, Discovered and Conquered: Thomas Jefferson, Lewis and Clark, and Manifest Destiny*. Westport, CT: Praeger, 2006.

Moody, Roger. *Rocks and Hard Places: The Globalisation of Mining*. London: Zed, 2007.

Morphy, M. Howard. *Ancestral Connections: Art and an Aboriginal System of Knowledge*. Chicago, IL: University of Chicago Press, 1991.

Morton, Louis. "How the Indians Came to Carlisle." *Pennsylvania History: A Journal of Mid-Atlantic Studies* 29:1 (1962): 53–73.

Murphy, James Emmett, and Sharon Murphy. *Let My People Know: American Indian Journalism, 1828–1978*. Norman: University of Oklahoma Press, 1981.

Murray, David. *Forked Tongues: Speech, Writing, and Representation in North American Indian Texts.* Bloomington: Indiana University Press, 1991.

Nash, Gary B. *Red, White, and Black: The Peoples of Early America.* Englewood Cliffs, NJ: Prentice Hall, 1974.

"Native Americans Walk from San Francisco to Washington, D.C. for U.S. Civil Rights, 1978." Global Nonviolent Action Database. Swarthmore College. N.d. https://nvdata base.swarthmore.edu/content/native-americans-walk-san-francisco-washington -dc-us-civil-rights-1978.

Nevins, Allan, and Frank Weitenkampf. *A Century of Political Cartoons: Caricature in the United States from 1800 to 1900.* New York: Scribner's, 1944.

Nies, Judith. *Unreal City: Las Vegas, Black Mesa, and the Fate of the West.* New York: Nation Books, 2014.

O'Bryan, Aileen. *Diné: Origin Myths of the Navaho Indians.* Washington, DC: US Government Printing Office, 1956.

Oetelaar, Gerald A. "Beyond Activity Areas: Structure and Symbolism in the Organization and Use of Space inside Tipis." *Plains Anthropologist* 45:171 (2000): 35–61.

O'Neill, Colleen. *Working the Navajo Way: Labor and Culture in the Twentieth Century.* Lawrence: University of Kansas Press, 2005.

Ostler, Jeffrey. *The Plains Sioux and United States Colonialism from Lewis and Clark to Wounded Knee.* New York: Cambridge University Press, 2004.

Page, Jake. "Spider Coming Down." *Journal of Religion and Health* 42:2 (Summer 2003): 111–116.

Parins, James W., and Marion Blackburn. "Full Scope of the Trail of Tears." *Archaeology* 65:3 (May–June 2012): 8.

Parlow, Anita. "The Politics of Plunder: Navajo and Hopi Resist Relocation." *Multinational Monitor* 7:10 (June 1986): n.p.

Parsons, Elsie Clews. *The Social Organization of the Tewa of New Mexico.* 1929. Reprint, New York: Kraus Reprint Corporation, 1964.

Parsons, Elsie Clews, and Ralph L. Beals. "The Sacred Clowns of the Pueblo and Mayo-Yaqui Indians." *American Anthropologist* 36:4 (October–December 1934): 491–514.

Pasternak, Judy. *Yellow Dirt: An American Story of a Poisoned Land and a People Betrayed.* New York: Free Press, 2010.

Perdue, Theda, and Michael Greene. *The Cherokee Nation and the Trail of Tears.* New York: Penguin, 2007.

Perry, Barbara. "American Indian Victims of Campus Ethnoviolence." *Journal of American Indian Education* 41:1 (2002): 35–55.

Pettitt, Paul, and Alistair Pike. "Dating European Palaeolithic Cave Art: Progress, Prospects, Problems." *Journal of Archaeological Method and Theory* 14:1 (2007): 27–47.

Pevar, Stephen L. *The Rights of Indians and Tribes: The Basic ACLU Guide to Indian and Tribal Rights.* Carbondale: Southern Illinois University Press, 1992.

Pierce, Margaret Hunter. "The Work of the Indian Claims Commission." *American Bar Association Journal* 63:2 (1977): 228–232.

Pollock, Floyd A. *A Navajo Confrontation and Crisis.* Tsaile, AZ: Navajo Community College Press, 1984.

Poupart, Lisa M. "Crime and Justice in American Indian Communities." *Social Justice* 29:1–2 (2002): 144–159.

Pratt, Mary Louise. "Arts of the Contact Zone." *Profession* (1991): 33–40.

Preucel, R. W. *Archaeologies of the Pueblo Revolt: Identity, Meaning, and Renewal in the Pueblo World*. Albuquerque: University of New Mexico Press, 2002.

"Rainbow Prophecy." Sovereign United Nations. N.d. http://www.sun-nation.org/sun -rainbow-prophecy.html.

Redhouse, John. *Geopolitics of the Navajo-Hopi Land Dispute*. Albuquerque, NM: Redhouse/Wright, 1985.

Reff, Daniel. *Disease, Depopulation, and Culture Change in Northwestern New Spain, 1518– 1764*. Salt Lake City: University of Utah Press, 1991.

Reichl, Susanne, and Mark Stein, eds. *Cheeky Fictions: Laughter and the Postcolonial*. Amsterdam: Rodopi, 2005.

Richland, Justin B. "Hopi Sovereignty as Epistemological Limit." *Wicazo Sa Review* 24:1 (Spring 2009): 89–112.

Richter, Daniel K. *The Ordeal of the Longhouse: The Peoples of the Iroquois League in the Era of European Colonization*. Chapel Hill: University of North Carolina Press, 1992.

———. "Whose Indian History?" *William and Mary Quarterly* 50:2 (1993): 471–484.

Roberts, David. *The Pueblo Revolt: The Secret Rebellion That Drove the Spanish Out of the Southwest*. New York: Simon and Schuster, 2004.

Rosenthal, Nicolas G. "Beyond the New Indian History: Recent Trends in the Historiography on the Native Peoples of North America." *History Compass* 4:5 (2006): 962–974.

———. *Reimagining Indian Country: Native American Migration and Identity in Twentieth-Century Los Angeles*. Chapel Hill: University of North Carolina Press, 2012.

Ruiz, Ramón Eduardo. *The Mexican War—Was It Manifest Destiny?* New York: Holt, Rinehart, and Winston, 1963.

Sabin, Edwin L. *Kit Carson Days, 1809–1868*. Chicago, IL: McClurg, 1914.

Sanchez, John, and Mary E. Stuckey. "The Rhetoric of American Indian Activism in the 1960s." *Communication Quarterly* 48:2 (2000): 120–136. https://doi.org/10.1080 /01463370009385586.

Sánchez, Joseph P., Robert L. Spude, and Art Gómez. *New Mexico: A History*. Norman: University of Oklahoma Press, 2013.

Schmitt, Rory O'Neill. *Navajo and Hopi Art in Arizona: Continuing Traditions*. Charleston, SC: History Press, 2016.

Sekaquaptewa, Emory. Untitled review. *Ethnohistory* 29:1 (1982): 73–74.

Silva, Noenoe K. *Aloha Betrayed: Native Hawaiian Resistance to American Colonialism*. Durham, NC: Duke University Press, 2004.

Simpson, Audra. *Mohawk Interruptus: Political Life across the Borders of Settler States*. Durham, NC: Duke University Press, 2014.

Smith, Paul Chaat, and Robert Allen Warrior. *Like a Hurricane: The Indian Movement from Alcatraz to Wounded Knee*. New York: New Press, 1997.

Sorkin, Alan L. *The Urban American Indian*. Lexington, MA: Lexington Books, 1978.

Spicer, Edward H., ed. *Human Problems in Technological Change*. New York: Wiley Science, 1965.

Stephens, Charles H. "The Origin and History of the Hopi-Navajo Boundary Dispute in Northern Arizona." MA thesis, Brigham Young University, 1961.

Stern, Fritz. *The Failure of Illiberalism: Essays on the Political Culture of Modern Germany.* New York: Knopf, 1972.

Stern, Kenneth S. *Loud Hawk: The United States versus the American Indian Movement.* Norman: University of Oklahoma Press, 2002.

Sugarman, Jonathan R., and David C. Grossman. "Trauma among American Indians in an Urban County." *Public Health Reports* 111:4 (1997): 321–327.

Sundberg, Lawrence D. *Dinétah: An Early History of the Navajo People.* Santa Fe, NM: Sunstone, 1995.

Sweet, Jill D., and Karen E. Larson. "The Horse, Santiago, and a Ritual Game: Pueblo Indian Responses to Three Spanish Introductions." *Western Folklore* 53:1 (1994): 69–84.

Taylor, William B., and Franklin P. Y. Pease. *Violence, Resistance, and Survival in the Americas: Native Americans and the Legacy of Conquest.* Washington, DC: Smithsonian Institution Press, 1994.

Therrell, Matthew D., and Makayla J. Trotter. "Waniyetu Wówapi: American Records of Weather and Climate." *American Meteorological Society* (2011): 583–592.

Thompson, Gerald E. *The Army and the Navajo: The Bosque Redondo Reservation Experiment: 1863–1869.* Tucson: University of Arizona Press, 1976.

———. "'To the People of New Mexico': Gen. Carleton Defends the Bosque Redondo." *Arizona and the West* 14:4 (1972): 347–366.

Thompson, Judy. *The North American Indian Collection: A Catalogue.* Bern, Switzerland: Bernisches Historisches Museum, 1977.

Thornton, Russel. *American Indian Holocaust and Survival: A Population History since 1492.* Norman: University of Oklahoma Press, 1987.

———. "Cherokee Population Losses during the Trail of Tears: A New Perspective and a New Estimate." *Ethnohistory* 31:4 (1984): 289–300.

Tohe, Laura. "Hwéeldi Bééhániih: Remembering the Long Walk." *Wicazo Sa Review* 22:1 (Spring 2007): 77–82.

Trafzer, Clifford. *The Kit Carson Campaign: The Last Great Navajo War.* Norman: University of Oklahoma Press, 1982.

Trimble, Charles. *Iyeska.* Indianapolis, IN: Dog Ear, 2012.

Twitchell, Ralph Emerson. *The Leading Facts of New Mexican History,* vol. 3. Cedar Rapids, IA: Torch Press, 1917.

Udall, Stewart L. *To the Inland Empire: Coronado and Our Spanish Legacy.* New York: Doubleday, 1987.

Underhill, Ruth. *The Navajos.* Norman: University of Oklahoma Press, 1956.

Usner, Daniel H., Jr. *Indians, Settlers, and Slaves in a Frontier Exchange Economy.* Chapel Hill: University of North Carolina Press, 1992.

Vestal, Stanley. *Kit Carson: The Happy Warrior of the Old West.* Boston, MA: Houghton Mifflin, 1928.

———. *Warpath and Council Fire: The Plains Indians Struggle for Survival in War and Diplomacy.* New York: Random House, 1948.

Voyles, Traci Brynne. *Wastelanding: Legacies of Uranium Mining in Navajo Country*, Minneapolis: University of Minnesota Press, 2015.

Warrior, Robert Allen. "Intellectual Sovereignty and the Struggle for an American Indian Future: Chapter 3 of *Tribal Secrets*: Vine Deloria, John Joseph Mathews, and the Recovery of American Indian Intellectual Traditions." *Wicazo Sa Review* 8:1 (1992): 1–20.

———. *Tribal Secrets: Recovering American Indian Intellectual Traditions*. Minneapolis: University of Minnesota Press, 1995.

Waters, Frank, and Oswald White Bear Fredericks. *Book of the Hopi*. 1963. Reprint, New York: Penguin, 1977.

Weber, David J. *The Spanish Frontier in North America*. New Haven, CT: Yale University Press, 1992.

Weisiger, Marsha. *Dreaming of Sheep in Navajo Country*. Seattle: University of Washington Press, 2009.

West, Richard Samuel. *Satire on Stone: The Political Cartoons of Joseph Keppler*. Urbana: University of Illinois Press, 1988.

White, Richard. *The Middle Ground: Indians, Empires, and Republics in the Great Lakes Region, 1650–1815*. New York: Cambridge University Press, 1991.

———. *The Roots of Dependency: Subsistence, Environment, and Social Change among the Choctaws, Pawnees, and Navajos*. Lincoln: University of Nebraska Press, 1983.

Wilcox, Michael Vincent. *The Pueblo Revolt and the Mythology of Conquest: An Indigenous Archaeology of Contact*. Berkeley: University of California Press, 2009.

Wilkins, David E. *The Navajo Political Experience*. New York: Rowman and Littlefield, 2003.

Wilkinson, Charles F. *Fire on the Plateau: Conflict and Endurance in the American Southwest*. Washington, DC: Shearwater, 1999.

Wilson, John P. *Military Campaigns in the Navajo Country, Northwestern New Mexico, 1800–1846*. Santa Fe: Museum of New Mexico Press, 1967.

Worcester, Donald E. "Early History of the Navaho Indians." PhD diss., University of California, Berkeley, 1947.

Wright, Barton. *Clowns of the Hopi: Tradition Keepers and Delight Makers*. Flagstaff, AZ: Northland, 2004.

Wrobel, David M. *Global West, American Frontier: Travel, Empire, and Exceptionalism from Manifest Destiny to the Great Depression*. Albuquerque: University of New Mexico Press, 2013.

Yazzie, Ethelou, ed. *Navajo History*. Tsaile, AZ: Navajo Community College Press, 1971.

Zah, Peterson, and Peter Iverson. *We Will Secure Our Future: Empowering the Navajo Nation*. Tucson: University of Arizona Press, 2012.

Zolbrod, Paul G. *Diné Bahané: The Navajo Creation Story*. Albuquerque: University of New Mexico Press, 1984.

Index